Watercolor
SUCCESS IN FOUR STEPS

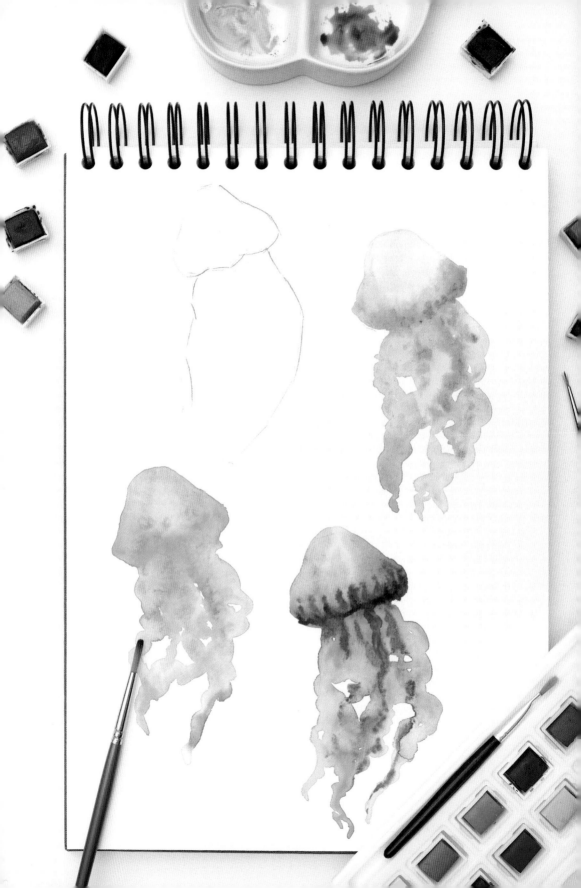

Watercolor
SUCCESS IN FOUR STEPS

Marina Bakasova

DESIGN ORIGINALS
an Imprint of Fox Chapel Publishing
www.d-originals.com

A QUARTO BOOK

ISBN 978-1-4972-0449-2

This edition published in 2020 by New Design Originals Corporation, www.d-originals.com, an imprint of Fox Chapel Publishing, 800-457-9112, 903 Square Street, Mount Joy, PA 17552.

Library of Congress Control Number: 2019952393

We are always looking for talented authors. To submit an idea, please send a brief inquiry to acquisitions@foxchapelpublishing.com.

Conceived, edited, and designed by Quarto Publishing plc an imprint of The Quarto Group The Old Brewery 6 Blundell Street London N7 9BH www.quartoknows.com

QUAR: 325424

Editor & designer: Michelle Pickering
Digital illustrations: Olya Kamieshkova
Photographer: Phil Wilkins
Editorial assistant: Charlene Fernandes
Art director: Gemma Wilson
Publisher: Samantha Warrington

Printed in China
Seventh printing

MIX
Paper from responsible sources
FSC® C016973
www.fsc.org

Contents

Meet Marina page 6

Tools and Materials page 8

Techniques page 10

Project Selector

Go to pages 16–25 to see all of the projects pictured together, to help you choose which one to paint next.

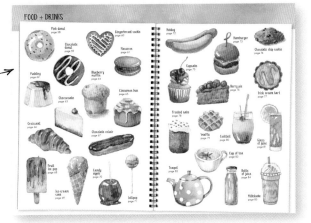

Projects

Meet Marina

My name is Marina Bakasova. I was born in Bryansk, Russia, and have been fond of drawing and painting from early childhood. After graduating from Moscow State Stroganov Art University, I began working as a freelance illustrator. I am obsessed with art and painting.

Nature is my inspiration and I also like to paint food and different desserts. In this book I want to teach people watercolor painting in an easy way. All of the projects are based on my own experience—and mistakes. I have been improving my painting skills for more than ten years, four of them at an art academy in Moscow. During all that time I was trying to devise some kind of formula or sequence for creating a successful artwork. I tried working with different materials and techniques, and found out which of them were best for me. And now I am ready to share my knowledge with everyone in four steps.

I hope this book will help not only the professional artist, but also every person who wants to learn watercolor painting but doesn't know what to start with. I have tried to include many art topics and objects, so you will get the opportunity to experiment with different pigments, techniques, and subjects, and learn the combinations that you like best and that produce the effects you want. After learning them, I think it is highly likely that the desire to create will fill your heart, as it does mine. Maybe one day you will start making celebration cards or something else with your own illustrations—and I hope this book will inspire it.

◎ **@marinabksv**
I would love to see your artworks inspired by this book.

◄ My little pug Lilou ☺ also likes to paint. Here she's helping me to paint a dragon fruit.

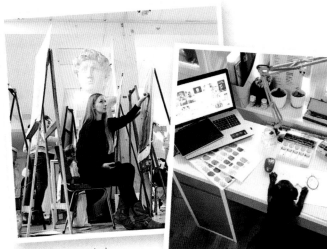

▲ Learning my art at the academy.

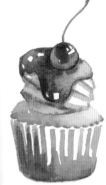

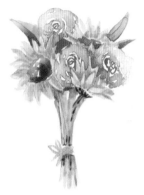

▼ Flowers are a lovely subject for watercolor painting, from single blooms to big bouquets.

◀ I love painting food, but especially delicious desserts!

▼ I painted the little sailboat after spending a lovely day on the water.

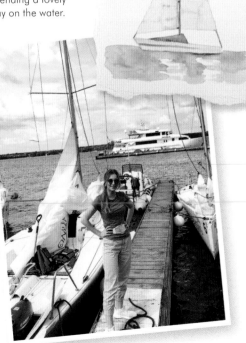

Tools and Materials

Apart from paints, brushes, and paper, you will only require a few additional bits and pieces, many of which you will probably have around the house already, such as jars for water.

Watercolor paints

Watercolor paints are made from pigment suspended in a binding agent. There are two main types available: dry (in pans, or cuvettes) and liquid (in tubes). Tubes of paint are good for large-scale work, but many artists find pans more convenient, as they fit within a paintbox and can be carried around easily. Watercolors also come in two qualities: professional (or artist's) colors, which contain richer pigment but are more expensive, and student's colors.

Good-quality watercolor paints contain bright pigments and don't lose this brightness very much after drying. Be aware that all pigments are different. They have different levels of transparency, and some granulate (produce a grainy effect) while others do not. You will find information about each paint on its package or the manufacturer's website.

It is best to build up your color palette gradually, buying new colors to suit the subject. Remember also that you can mix pigments to create new colors.

Paper

Ordinary paper will buckle if you apply wet paint to it. Special watercolor paper is designed to absorb water well, so that you can apply multiple layers of paint. It is available in both sheet and pad form, in a wide range of sizes. If using loose sheets of paper, you will need a drawing board for support—a piece of plywood cut to size will do.

Watercolor paper is made in three different surfaces: smooth (or hot-pressed), medium (or cold-pressed, also known as Not, meaning not hot-pressed), and rough. Cold-pressed is the most commonly used, as it has sufficient texture to hold the paint but is smooth enough to enable you to paint fine detail. Watercolor paper also comes in different thicknesses, or weights. In general, any paper lighter than about 140lb (300gsm) will buckle unless it has been pre-stretched (there are instructional videos online). The paper used in most watercolor pads is 168lb (250gsm).

There are also different colors of paper available, which can be useful—beige paper can act as the first layer of color when painting light skintones, for example.

Setting up your workspace

Set up your workspace with everything you need close by—paints, water jars, palettes, brushes, and so on. Watercolor paints dry quickly, so you need everything to hand before you start painting. Keep your water jars next to your mixing palette to prevent water from dripping onto your painting.

However, most artists paint on white paper, because it reflects through the transparent paint to give the painting a luminous quality. You can also leave areas of white paper free from paint to act as highlights.

Drawing pencil

Pencils have different levels of hardness: B—soft, HB—medium, and H—hard. I recommend using a hard pencil, at least H, but take care to use a light touch when drawing to avoid indenting the paper. I use a mechanical pencil (because I hate to sharpen them) with 2H lead. Sometimes I draw with a watercolor pencil, so that the pencil lines blend in with the wet paint. If you need to remove pencil marks, use a kneaded eraser that won't scuff the paper.

Paintbrushes

Brushes come in a range of shapes (round, flat, etc), fibers (natural sable, synthetic, etc), and sizes (the lower the number, the smaller the brush tip). The traditional choice for watercolor painting are natural-fiber brushes, because they can hold a large amount of water and paint while retaining their shape. I prefer round squirrel-hair brushes with a pointed tip, and use sizes 8, 4, and 2 most often.

If you are a beginner, start with round brushes with sharp tips in these sizes:
- Size 00/01—thin brush for small details
- Size 2/3—medium brush
- Size 8–20—big brush for big spaces

A ¼in (6mm) flat brush is also useful for painting straight-edged shapes.

Mixing palette

You will need a mixing palette, ideally with multiple recessed slots, for preparing paints and mixing colors. There are two types: plastic and ceramic. Plastic palettes are cheaper and lighter to carry around, but will absorb pigment and stain. Ceramic palettes are easy to clean and allow paints to stay wet for longer, but they are heavier to carry if you want to work outside. If you store your paints in a paintbox, many of them have a lid designed for use as a palette.

Water jars

It is a good idea to start collecting glass jars at every opportunity—you will need them for rinsing brushes so you don't contaminate colors on the page. Most artists use transparent glass jars at home and transparent plastic containers outside. You can also buy a non-spill water pot if you wish. The most important thing is not the jar but the water in it: don't forget to change dirty water.

Extras

- Masking fluid can be used to retain an area of white on the paper for highlights, since white is difficult to replicate in watercolor. Colored masking fluid is easier to see on the white paper. Keep an old, thin brush for use with masking fluid, because you will not be able to clean it completely.
- White ink can be used to add highlights after you have finished painting. I use a pen with white ink that will produce thin, smooth lines.
- Cotton swabs are useful for lifting out paint and softening edges.
- Salt can be used to achieve some beautiful texture effects. Ordinary kitchen table salt or sea salt will do.

Techniques

Watercolor painting is rich and unpredictable, and there is no single method for painting a particular object. Most watercolor paintings use a combination of techniques.

Drawing a pencil sketch

Start by making a pencil drawing of the project. A simple outline is all you need. You can sketch it freehand or trace the drawing provided, using tracing paper or a lightbox. Your drawing should be light and easy to erase, because watercolor paint is transparent.

Locating the light source

Decide from which direction the light is falling on the object you are painting. All highlights should be placed where the light hits the object. The most common method of creating a highlight is to leave areas of the paper free from paint. A shadow will fall on the opposite side. All highlights and shadows should be consistent on the same artwork.

Choosing the right brush

Flat brushes are designed to make flat marks. Round brushes are more versatile; you can make broader marks by applying more pressure, or paint a fine line using the point of the brush. With practice, you will learn how much pressure to apply to make thicker, thinner, lighter, or darker marks.

I recommend a size 8 brush for covering larger areas and adding large drops of color; a size 2 or 3 brush for smaller areas and drops; and a size 00 or 01 brush for fine details.

Preparing your paints

Prepare separate dilutions (or washes) of each of the colors required for your project. Start by putting some water into a slot in your palette, then begin to add pigment, making sure that it dissolves completely. The ratio of pigment to water determines the strength and transparency of the color. You need to use enough water to make a puddle of wet paint, while the color remains vibrant.

Note that colors always look darker in the palette than on paper, and they will dry lighter too, so test different dilutions on scrap paper until you achieve the strength of color you want. You are aiming for clear color, with the white of the paper shining through.

What is a wash?

The term "wash" simply means watercolor pigment diluted with water to achieve the desired intensity of tone—the more water you use, the paler the wash will be. A single color laid evenly so that it dries to the same overall tone is known as a "flat" wash. A single color applied so that it graduates from dark to light is known as a "graded" or "graduated" wash. A "variegated" wash involves two or more colors that bleed softly into each other.

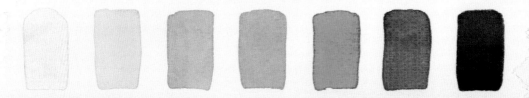

The same pigment at different dilutions. The more layers you intend to use, the more dilute the pigment should be in order to preserve the color's transparency.

Applying the first wash

To apply a flat, even wash of color, dip your brush into the prepared color and spread it on the shape. Don't try to cover the shape in one go; start with a medium-sized drop of paint, then while the paint is still wet, add more until you have covered the shape. For a softer outline, brush clean water over the shape and then apply the paint, starting in the center and working outward to the edges. With both methods, if you don't finish before some areas have dried, wait until everything is dry, then carefully cover the shape with clean water. You can then add more color as needed.

To apply a graded or variegated wash, simply apply different dilutions of pigment (or different colors) so that they just touch each other, working quickly while everything is still wet. The colors will blend softly where they meet. Another method is to paint the whole shape with the lighter tone or color, and then, working on wet, apply the darker tone or color over the areas that you want to be darker. You can also lighten areas by adding drops of water.

◀ The chicken begins with a graded wash of sienna, with the strongest pigment at the head graduating to very dilute sienna near the tail.

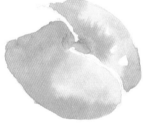

◀ The first stage for painting the candle is to apply a flat, even wash of pink.

▶ The flat peach begins with a variegated wash of orange, yellow, and green, with all three colors bleeding softly into each other.

▼ The sheep is painted with a single color, but not as an even wash. Drops of water are used to lighten the sheep's rear, and stronger pigment is applied to create shaded areas on the head, neck, chest, and belly.

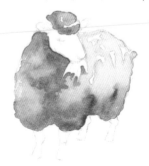

▲ The first layer of the dolphin is a variegated wash of indigo and blue, fading to areas of white paper. The paper is dampened with clean water before applying the paint in order to achieve a very soft, diffuse edge where the colors fade to white.

Building up the picture

A damp base allows watercolor to spread; a dry base contains it. If you work on wet, either on damp paper or a damp wash, the wetness of the underlying surface allows the paint to bleed outward and to dry with a soft, blurry edge. If you work on dry, either on dry paper or a dry wash, the paint will be contained within the area to which it has been applied, so that it dries with a hard edge. Note that different pigments have different qualities and thus behave in different ways—some are opaque, some more translucent, for example. When painting fine details and edges, you can work on wet, half-wet, or dry. Just choose the method that suits your artwork best.

► The pink donut is worked entirely on dry, using glazes of flat color to build up volume.

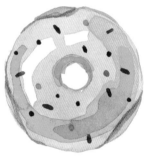

► The jellyfish is worked entirely on wet, starting with a flat blue wash onto which various colors are dropped to mimic the anatomy of the creature.

◄ Like the donut, the pear also uses glazes to build up volume, but with layers of variegated washes. Notice how in both the donut and pear, the edges of each dried layer remain visible, helping to enhance the illusion of a three-dimensional object.

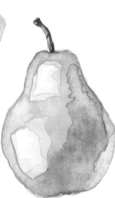

◄ The balloon is worked on wet (except the string), starting with a variegated blue/green wash onto which color is carefully dropped around the edges to create the balloon's rounded shape.

► Like the balloon, the contours of the cactus plant are painted on wet to create softly diffused shading, but then stronger pigment is overlaid on dry for finer, more defined edges. Working on dry is also used to paint the crisp geometric pattern on the plant pot.

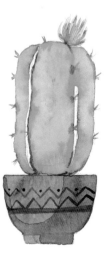

Light pink and blue mixed in the palette.

Overlaid glazes of light pink and blue.

The same colors mixed by working on wet.

Colors dropped onto a wet wash.

Mixing colors in the palette

Whenever a project requires colors to be mixed in the palette prior to painting, the instructions refer to this as a "mix"—for example, "pink + blue mix." I have used just two colors in each mix, because mixing too many colors together can produce a muddy result.

To make a color mix, prepare separate dilutions of each color in your palette. Then, in a clean slot, blend the two colors to make a third. Test your color mixes on scrap paper.

Working on wet or on half-wet

Working on wet means applying color to a wet surface, which can be either dampened plain paper or a previous wash that is not fully dry. Working on wet produces soft edges and allows adjacent colors to blend softly into each other. The wetter the paper, the more the colors will flow into each other in an unpredictable way. Wait until the paper has lost its sheen and is only slightly damp (half-wet) for a subtler effect.

Working on wet means that you must work fast. However, even if the underlying wash has already dried, you can just re-wet the surface with clean water and then continue working on wet. If you find that a color runs too much, or bleeds into an area where you don't want it, you can gently lift out the excess color with a dry brush, cotton swab, or tissue.

Dropping in color

Dropping spots of color onto a wet wash is a way of creating surface texture. The drops will spread and feather out on their edges, and the colors will blend. The brush can be touched to the surface for more control, or droplets can be allowed to fall from above. Larger droplets are made by using more paint, smaller ones by using less. Experiment first on scrap paper.

Working on dry

Working on dry means applying color to a dry surface, which can be either plain paper or a previous wash that has fully dried. Working on dry produces crisp, clean edges and allows you to build up depth of color and tone by glazing (see below). Working on dry allows you greater control than working on wet, because the layer beneath will not move and colors won't bleed.

Glazing

Glazing is the technique of layering a wash (or glaze) of transparent watercolor over another that has fully dried. The underlying color will alter the one you place on top, and vice versa. Always work from light to dark, and the more layers you are going to apply, the more water you should mix with the pigment to preserve transparency.

Edges painted on dry.

Edges painted on half-wet.

Dry paint re-wetted with clean water.

Edges painted on wet.

Backruns made by dropping in color.

Backruns made by dropping in water.

Backruns

If you apply a brush loaded with a more watery color to a damp wash, the first color will "run away" from the water in the new color, causing intriguing shapes with jagged edges. The shape will be lighter in the center (where the brush was placed) and surrounded by a fringe of concentrated pigment. You can create similar effects by dropping clean water onto a dampened wash. Note that if the initial wash is too wet, the colors will blend together. For a backrun, the wash needs to have started to dry. The water content of the dropped-in color must also be higher than that of the previous color.

Granulation

Some pigments dissolve entirely in water, while others tend to granulate—that is, the particles (or grains) of pigment separate from the water, producing a speckled finish. Granulation can also occur when a wet wash is laid over a dry one. Another way to create granulation is to fill a shape with color and then, while still wet, add a drop of water.

Masking fluid and white ink

Masking fluid is a way of reserving areas of the paper as highlights. It forms a waterproof seal that protects the paper underneath, and you can then paint washes over the dried masking

fluid without having to carefully leave areas unpainted. Use an old brush to apply the fluid. Putting the brush in some soapy water before dipping it in the fluid will help stop the fluid from clinging to the bristles. When the paint is dry, remove the mask by gently rubbing with a finger or an eraser.

If you want to add extra highlights to a finished painting, simply draw them with a white ink pen.

Salt

Dropping table or sea salt onto wet paint can produce some interesting textures. The grains of salt soak up the wetness of the paint from the immediate area, speeding up the drying process there. As the paint dries, little star shapes appear as the water floods out of the crystals and pushes the color away to create feathered edges. Larger salt grains produce distinct star shapes; smaller salt grains produce a finer texture. You can also experiment with using sea water to dilute your pigments.

Granulation where the two colors overlap.

Adding drops of water to cause granulation.

Sea salt dropped onto a wet wash.

Paint diluted with sea water.

Following the four steps

Watercolors are unpredictable, and you will never get the same result each time. For this reason I have painted each project three times, starting from a freehand sketch and stopping at the end of step 2, then step 3, and finally step 4. You will see how the paint acts slightly differently each time. This is part of the fun and excitement of working with watercolor—enjoy!

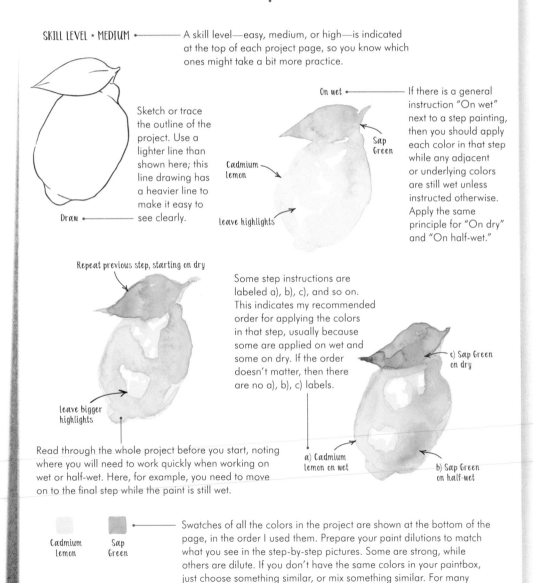

SKILL LEVEL * MEDIUM •——————— A skill level—easy, medium, or high—is indicated at the top of each project page, so you know which ones might take a bit more practice.

Draw •—————

Sketch or trace the outline of the project. Use a lighter line than shown here; this line drawing has a heavier line to make it easy to see clearly.

On wet •—————— If there is a general instruction "On wet" next to a step painting, then you should apply each color in that step while any adjacent or underlying colors are still wet unless instructed otherwise. Apply the same principle for "On dry" and "On half-wet."

Cadmium lemon

Sap Green

leave highlights

Repeat previous step, starting on dry

leave bigger highlights

Some step instructions are labeled a), b), c), and so on. This indicates my recommended order for applying the colors in that step, usually because some are applied on wet and some on dry. If the order doesn't matter, then there are no a), b), c) labels.

c) Sap Green on dry

a) Cadmium lemon on wet

b) Sap Green on half-wet

Read through the whole project before you start, noting where you will need to work quickly when working on wet or half-wet. Here, for example, you need to move on to the final step while the paint is still wet.

Cadmium lemon

Sap Green

Swatches of all the colors in the project are shown at the bottom of the page, in the order I used them. Prepare your paint dilutions to match what you see in the step-by-step pictures. Some are strong, while others are dilute. If you don't have the same colors in your paintbox, just choose something similar, or mix something similar. For many projects, you can use completely different colors if you prefer.

FRUIT + VEGETABLES

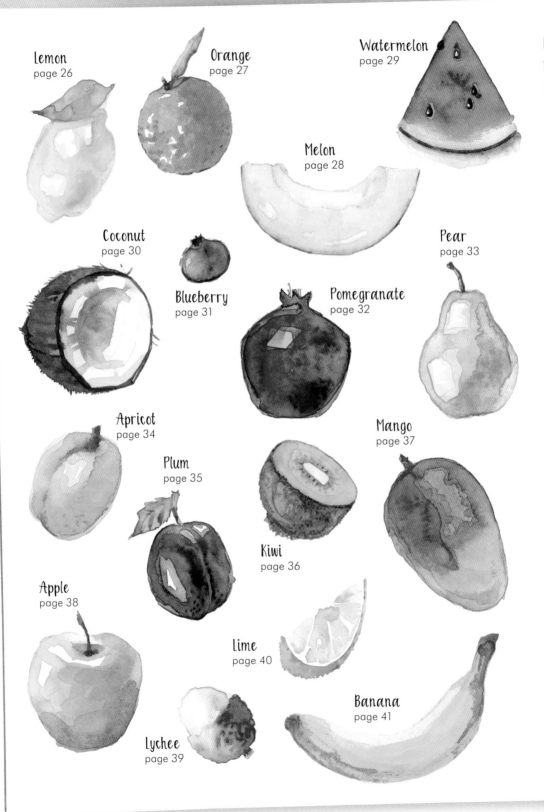

Lemon
page 26

Orange
page 27

Watermelon
page 29

Melon
page 28

Coconut
page 30

Blueberry
page 31

Pomegranate
page 32

Pear
page 33

Apricot
page 34

Plum
page 35

Kiwi
page 36

Mango
page 37

Apple
page 38

Lime
page 40

Banana
page 41

Lychee
page 39

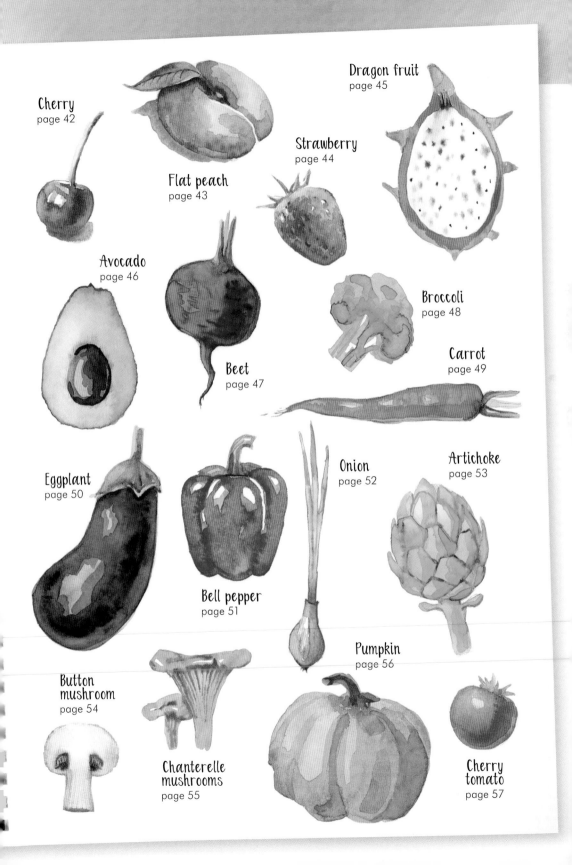

Cherry
page 42

Flat peach
page 43

Dragon fruit
page 45

Strawberry
page 44

Avocado
page 46

Beet
page 47

Broccoli
page 48

Carrot
page 49

Eggplant
page 50

Bell pepper
page 51

Onion
page 52

Artichoke
page 53

Button
mushroom
page 54

Chanterelle
mushrooms
page 55

Pumpkin
page 56

Cherry
tomato
page 57

FOOD + DRINKS

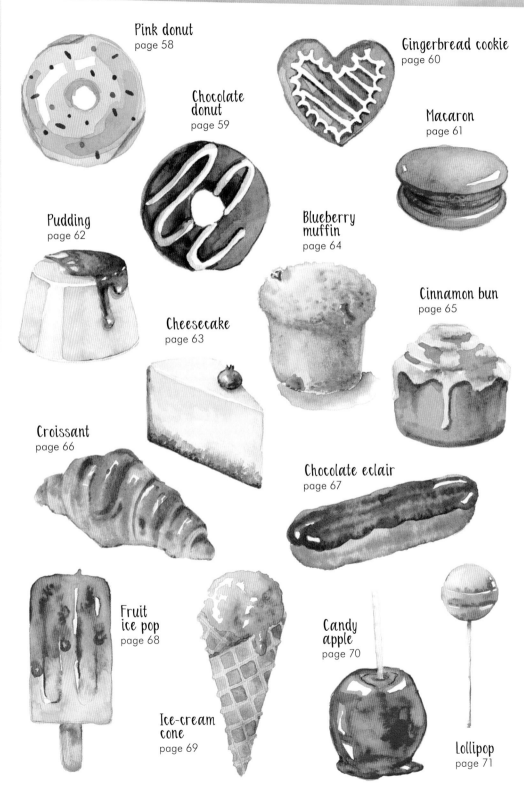

Pink donut
page 58

Gingerbread cookie
page 60

Chocolate donut
page 59

Macaron
page 61

Pudding
page 62

Blueberry muffin
page 64

Cinnamon bun
page 65

Cheesecake
page 63

Croissant
page 66

Chocolate eclair
page 67

Fruit ice pop
page 68

Candy apple
page 70

Ice-cream cone
page 69

Lollipop
page 71

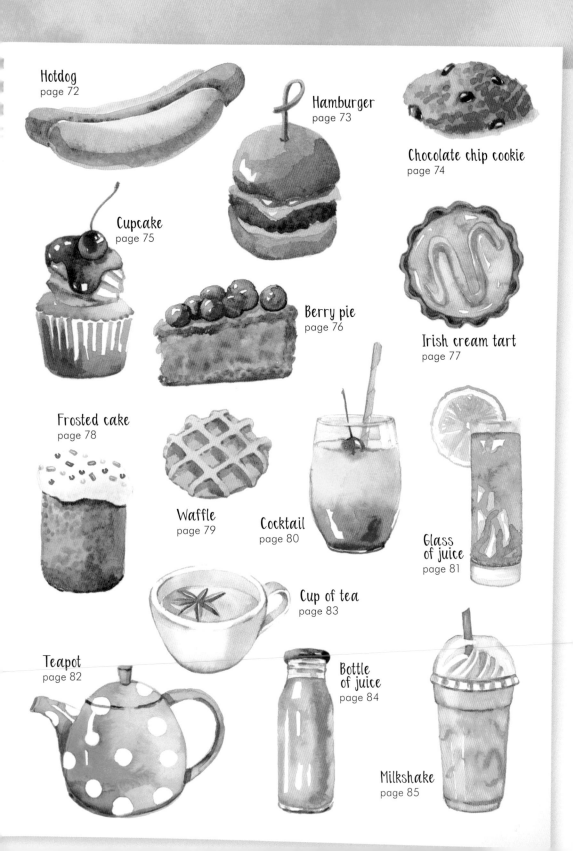

Hotdog
page 72

Hamburger
page 73

Chocolate chip cookie
page 74

Cupcake
page 75

Berry pie
page 76

Irish cream tart
page 77

Frosted cake
page 78

Waffle
page 79

Cocktail
page 80

Glass of juice
page 81

Cup of tea
page 83

Teapot
page 82

Bottle of juice
page 84

Milkshake
page 85

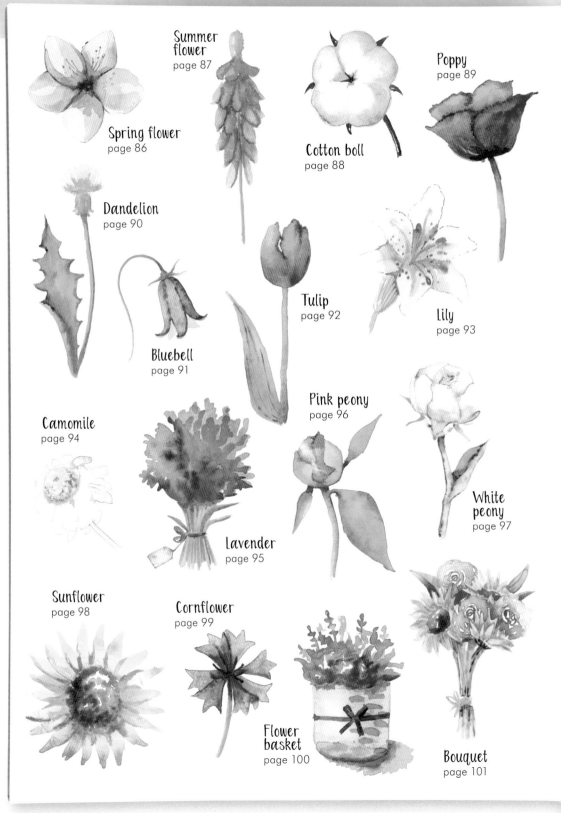

Spring flower
page 86

Summer
flower
page 87

Cotton boll
page 88

Poppy
page 89

Dandelion
page 90

Bluebell
page 91

Tulip
page 92

Lily
page 93

Camomile
page 94

Lavender
page 95

Pink peony
page 96

White
peony
page 97

Sunflower
page 98

Cornflower
page 99

Flower
basket
page 100

Bouquet
page 101

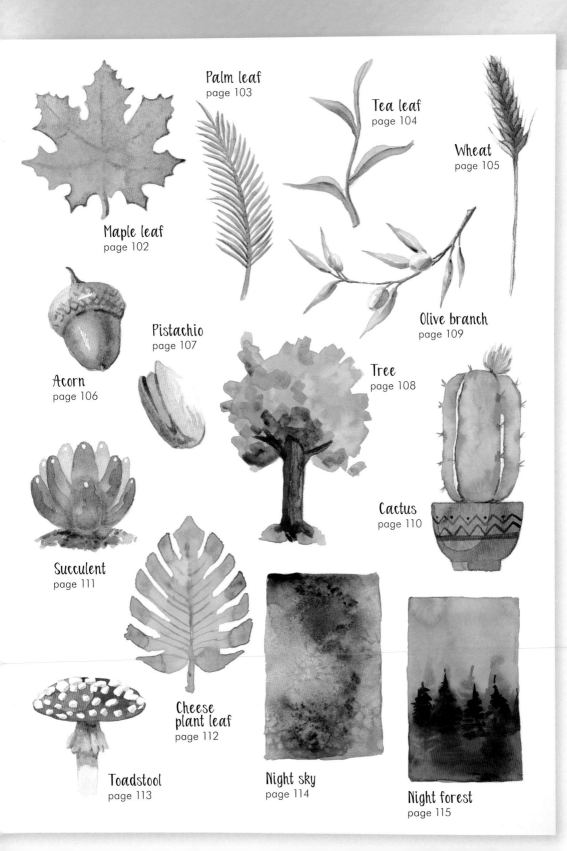

Palm leaf
page 103

Tea leaf
page 104

Wheat
page 105

Maple leaf
page 102

Olive branch
page 109

Acorn
page 106

Pistachio
page 107

Tree
page 108

Cactus
page 110

Succulent
page 111

Cheese
plant leaf
page 112

Toadstool
page 113

Night sky
page 114

Night forest
page 115

INSECTS, ANIMALS, BIRDS + SEA LIFE

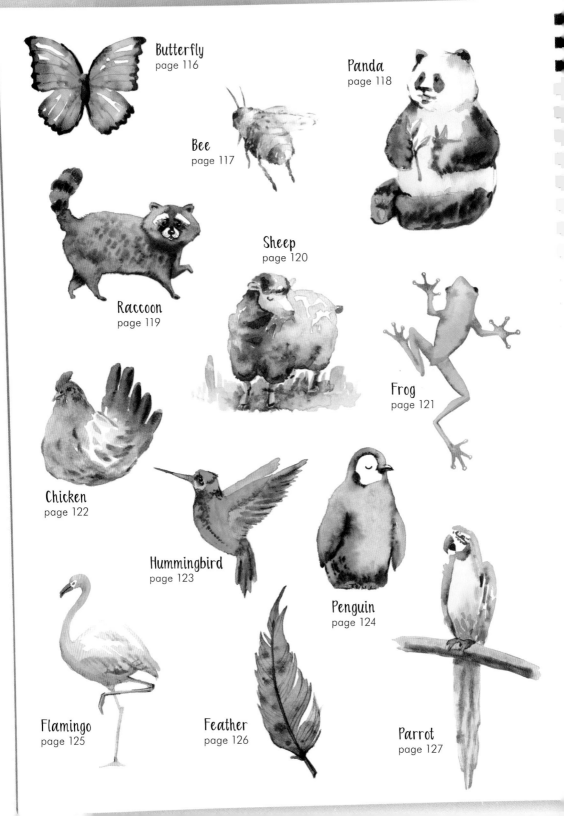

Butterfly
page 116

Bee
page 117

Panda
page 118

Raccoon
page 119

Sheep
page 120

Frog
page 121

Chicken
page 122

Hummingbird
page 123

Penguin
page 124

Flamingo
page 125

Feather
page 126

Parrot
page 127

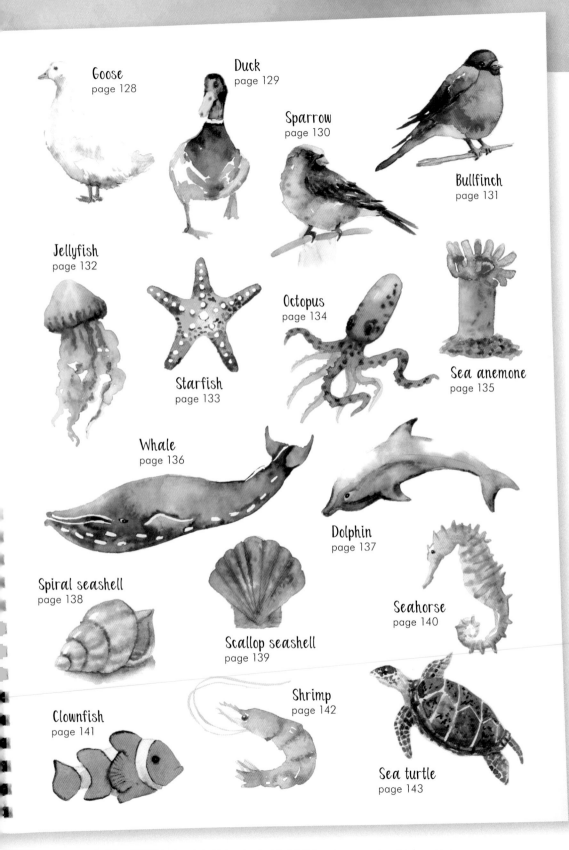

Goose
page 128

Duck
page 129

Sparrow
page 130

Bullfinch
page 131

Jellyfish
page 132

Starfish
page 133

Octopus
page 134

Sea anemone
page 135

Whale
page 136

Dolphin
page 137

Spiral seashell
page 138

Scallop seashell
page 139

Seahorse
page 140

Clownfish
page 141

Shrimp
page 142

Sea turtle
page 143

OBJECTS, TRAVEL + CELEBRATIONS

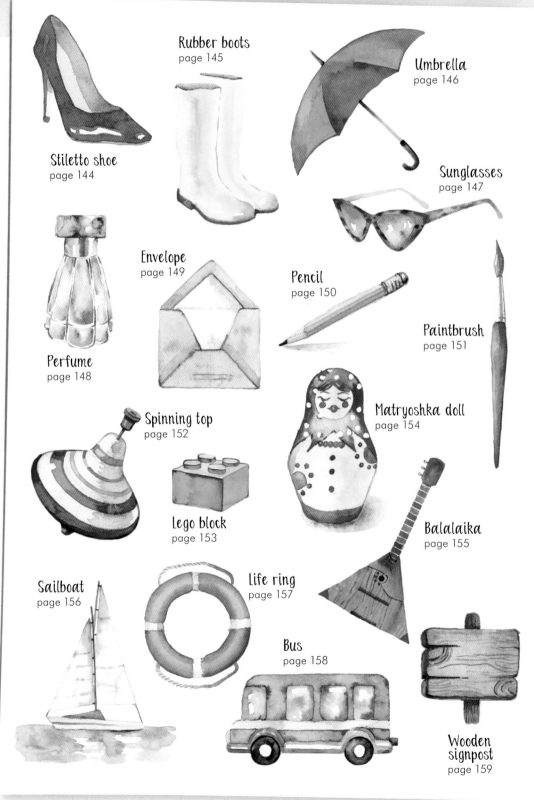

Rubber boots
page 145

Umbrella
page 146

Stiletto shoe
page 144

Sunglasses
page 147

Envelope
page 149

Pencil
page 150

Paintbrush
page 151

Perfume
page 148

Spinning top
page 152

Matryoshka doll
page 154

lego block
page 153

Balalaika
page 155

Sailboat
page 156

life ring
page 157

Bus
page 158

Wooden
signpost
page 159

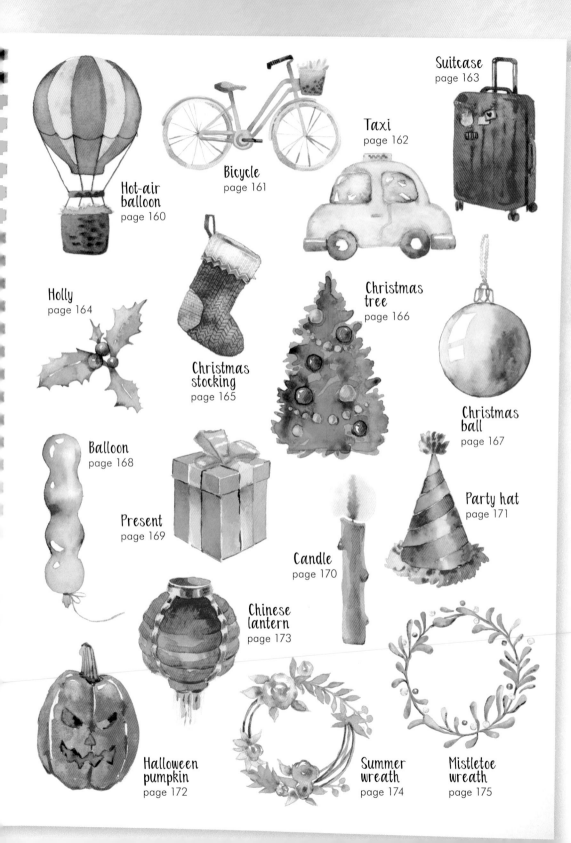

Suitcase
page 163

Taxi
page 162

Bicycle
page 161

Hot-air
balloon
page 160

Holly
page 164

Christmas
stocking
page 165

Christmas
tree
page 166

Christmas
ball
page 167

Balloon
page 168

Present
page 169

Candle
page 170

Party hat
page 171

Chinese
lantern
page 173

Halloween
pumpkin
page 172

Summer
wreath
page 174

Mistletoe
wreath
page 175

1

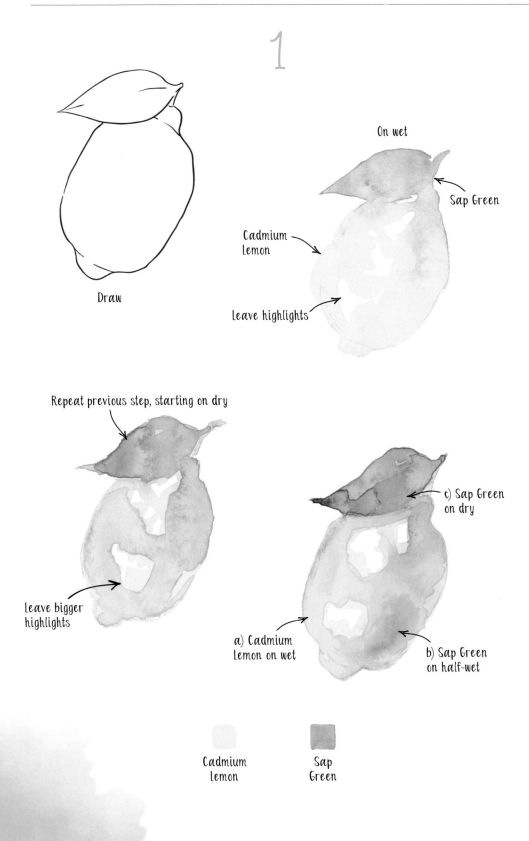

Draw

On wet

Sap Green

Cadmium
Lemon

leave highlights

Repeat previous step, starting on dry

leave bigger
highlights

c) Sap Green
on dry

a) Cadmium
Lemon on wet

b) Sap Green
on half-wet

Cadmium
Lemon

Sap
Green

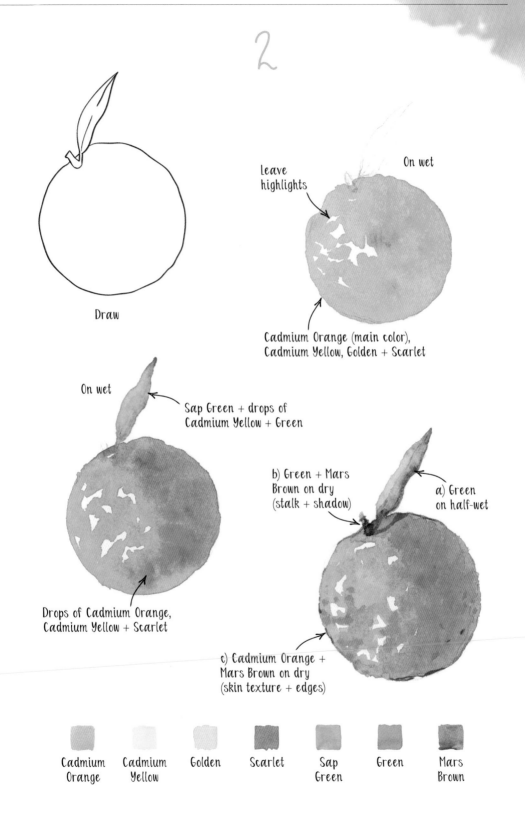

2

Draw

On wet

leave
highlights

Cadmium Orange (main color),
Cadmium Yellow, Golden + Scarlet

On wet

Sap Green + drops of
Cadmium Yellow + Green

Drops of Cadmium Orange,
Cadmium Yellow + Scarlet

b) Green + Mars
Brown on dry
(stalk + shadow)

a) Green
on half-wet

c) Cadmium Orange +
Mars Brown on dry
(skin texture + edges)

Cadmium Cadmium Golden Scarlet Sap Green Mars
Orange Yellow Green Brown

3

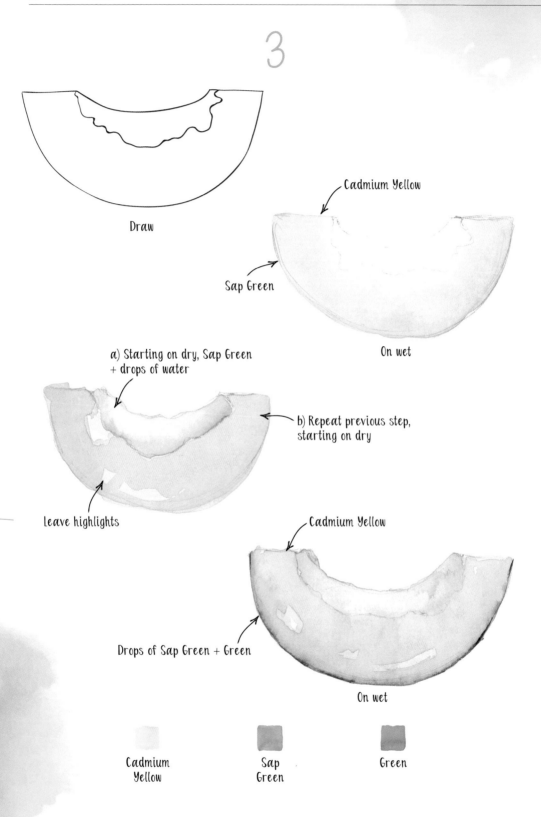

Draw

Cadmium Yellow

Sap Green

On wet

a) Starting on dry, Sap Green
+ drops of water

b) Repeat previous step,
starting on dry

leave highlights

Cadmium Yellow

Drops of Sap Green + Green

On wet

Cadmium
Yellow

Sap
Green

Green

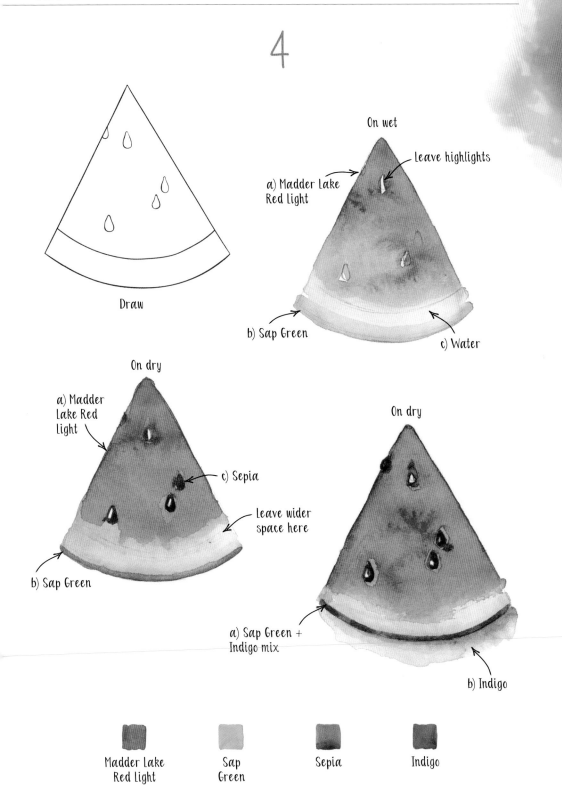

4

Draw

On wet

a) Madder Lake Red Light

leave highlights

b) Sap Green

c) Water

On dry

a) Madder Lake Red Light

c) Sepia

leave wider space here

b) Sap Green

On dry

a) Sap Green + Indigo mix

b) Indigo

Madder Lake Red light

Sap Green

Sepia

Indigo

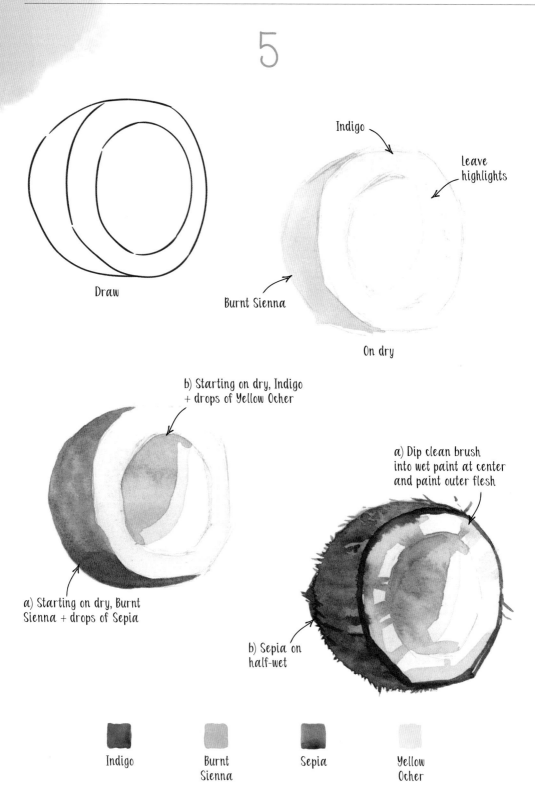

5

Draw

Indigo

leave
highlights

Burnt Sienna

On dry

b) Starting on dry, Indigo
+ drops of Yellow Ocher

a) Dip clean brush
into wet paint at center
and paint outer flesh

a) Starting on dry, Burnt
Sienna + drops of Sepia

b) Sepia on
half-wet

Indigo Burnt Sepia Yellow
 Sienna Ocher

6

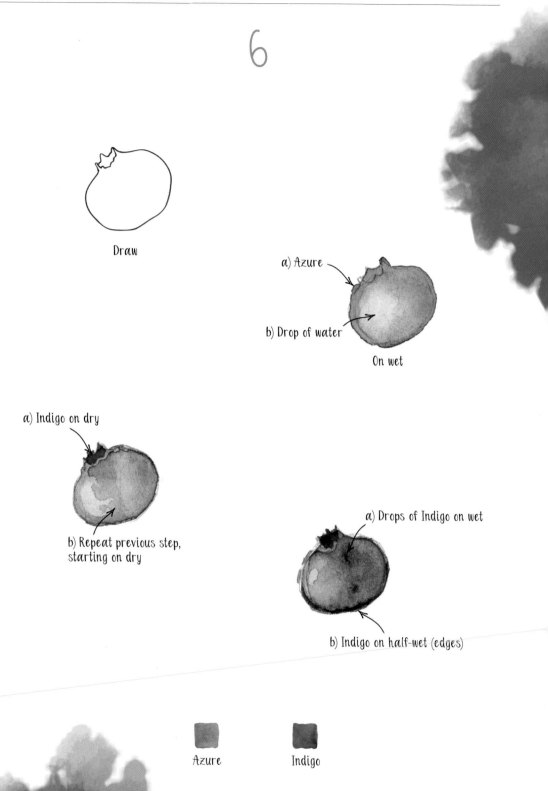

Draw

a) Azure

b) Drop of water

On wet

a) Indigo on dry

b) Repeat previous step,
starting on dry

a) Drops of Indigo on wet

b) Indigo on half-wet (edges)

Azure

Indigo

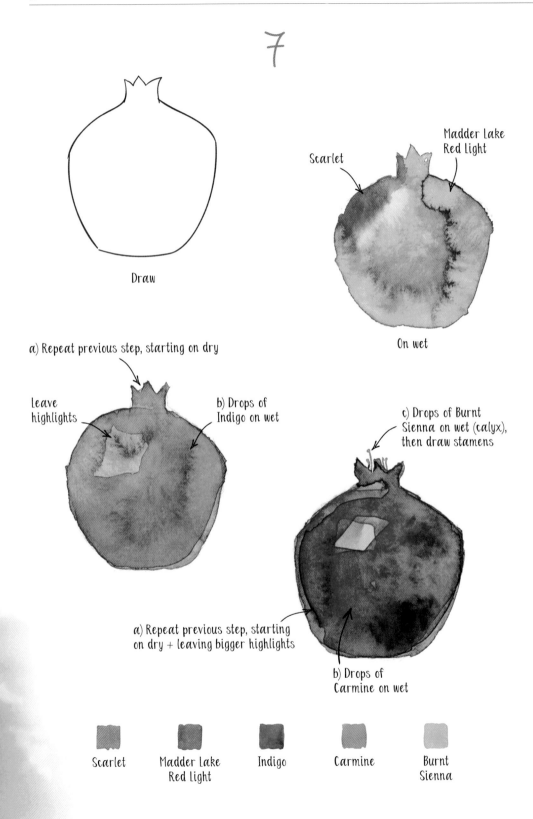

7

Draw

Scarlet

Madder Lake
Red Light

On wet

a) Repeat previous step, starting on dry

leave
highlights

b) Drops of
Indigo on wet

c) Drops of Burnt
Sienna on wet (calyx),
then draw stamens

a) Repeat previous step, starting
on dry + leaving bigger highlights

b) Drops of
Carmine on wet

Scarlet Madder Lake Indigo Carmine Burnt
 Red Light Sienna

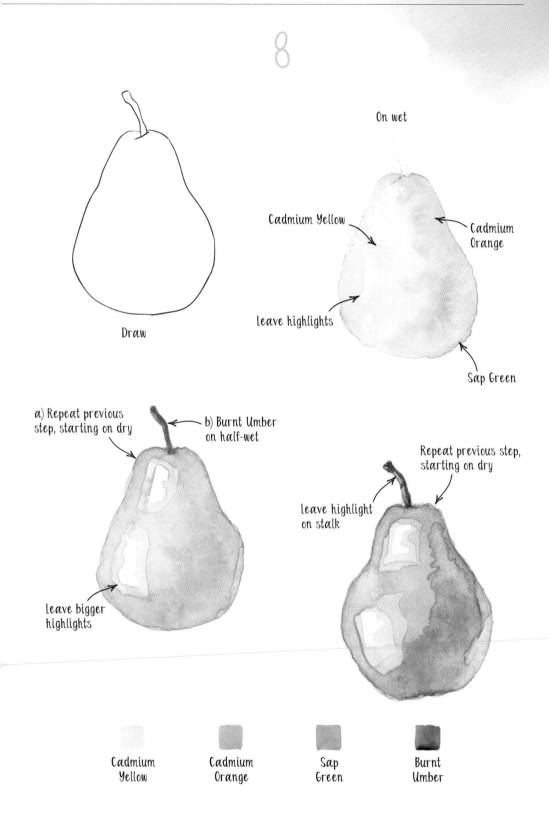

8

Draw

On wet

Cadmium Yellow

Cadmium Orange

leave highlights

Sap Green

a) Repeat previous step, starting on dry

b) Burnt Umber on half-wet

leave bigger highlights

Repeat previous step, starting on dry

leave highlight on stalk

Cadmium Yellow

Cadmium Orange

Sap Green

Burnt Umber

9

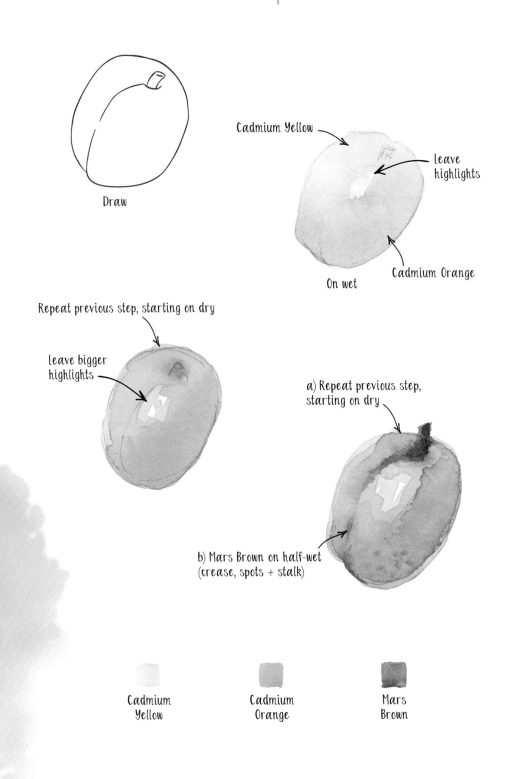

Draw

Cadmium Yellow

Leave
highlights

Cadmium Orange

On wet

Repeat previous step, starting on dry

leave bigger
highlights

a) Repeat previous step,
starting on dry

b) Mars Brown on half-wet
(crease, spots + stalk)

Cadmium
Yellow

Cadmium
Orange

Mars
Brown

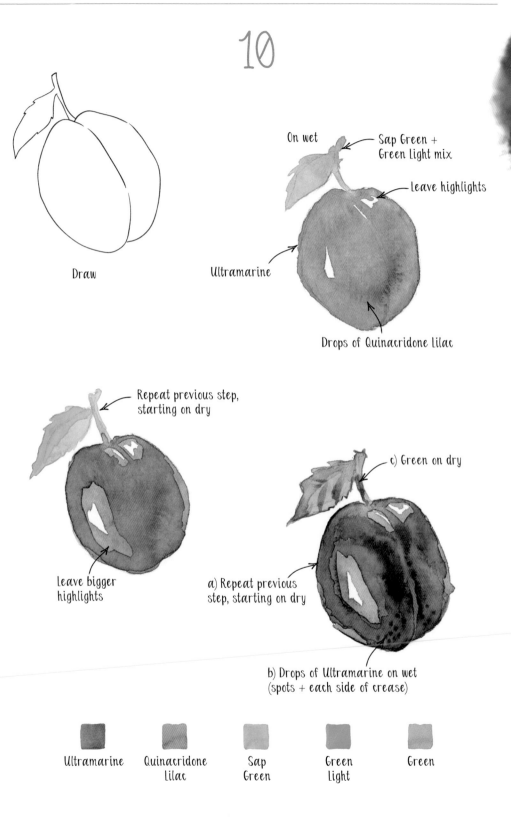

10

Draw

On wet Sap Green +
 Green Light mix

 Leave highlights

Ultramarine

Drops of Quinacridone Lilac

Repeat previous step,
starting on dry

 c) Green on dry

leave bigger
highlights

a) Repeat previous
step, starting on dry

b) Drops of Ultramarine on wet
(spots + each side of crease)

Ultramarine Quinacridone Sap Green Green
 Lilac Green Light

11

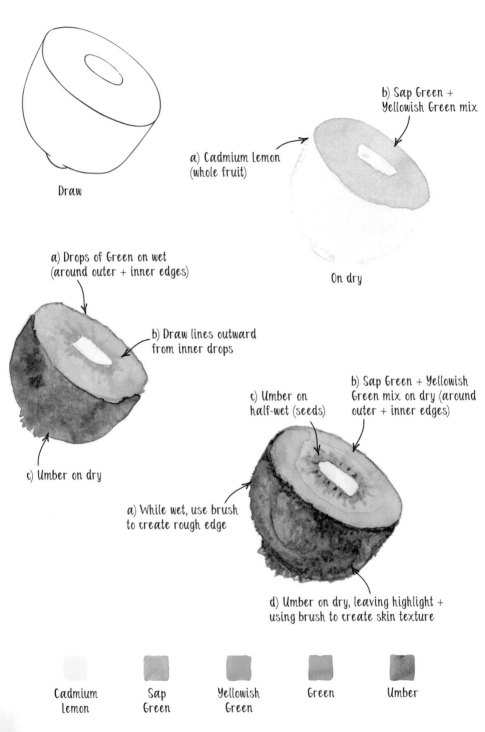

Draw

b) Sap Green +
Yellowish Green mix

a) Cadmium lemon
(whole fruit)

On dry

a) Drops of Green on wet
(around outer + inner edges)

b) Draw lines outward
from inner drops

c) Umber on dry

c) Umber on
half-wet (seeds)

b) Sap Green + Yellowish
Green mix on dry (around
outer + inner edges)

a) While wet, use brush
to create rough edge

d) Umber on dry, leaving highlight +
using brush to create skin texture

Cadmium
Lemon

Sap
Green

Yellowish
Green

Green

Umber

12

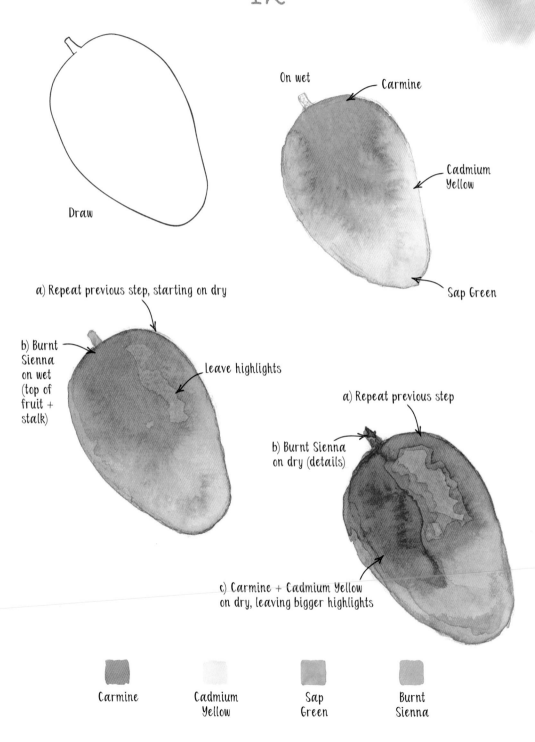

Draw

On wet

Carmine

Cadmium Yellow

Sap Green

a) Repeat previous step, starting on dry

b) Burnt Sienna on wet (top of fruit + stalk)

leave highlights

a) Repeat previous step

b) Burnt Sienna on dry (details)

c) Carmine + Cadmium Yellow on dry, leaving bigger highlights

Carmine Cadmium Sap Burnt
 Yellow Green Sienna

13

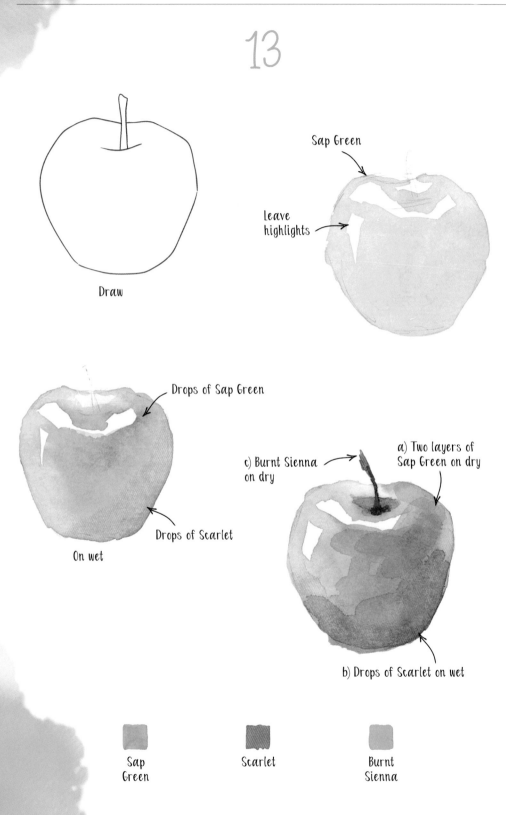

Draw

Sap Green

leave
highlights

Drops of Sap Green

Drops of Scarlet

On wet

a) Two layers of
Sap Green on dry

c) Burnt Sienna
on dry

b) Drops of Scarlet on wet

Sap
Green

Scarlet

Burnt
Sienna

14

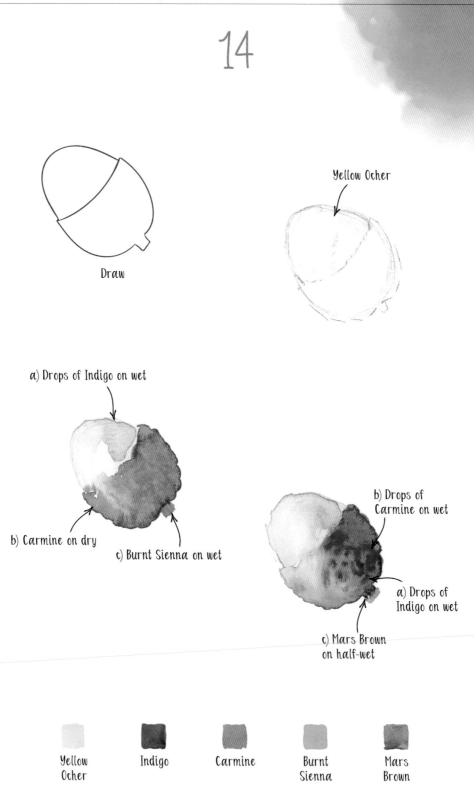

Draw

Yellow Ocher

a) Drops of Indigo on wet

b) Carmine on dry

c) Burnt Sienna on wet

b) Drops of
Carmine on wet

a) Drops of
Indigo on wet

c) Mars Brown
on half-wet

Yellow
Ocher

Indigo

Carmine

Burnt
Sienna

Mars
Brown

15

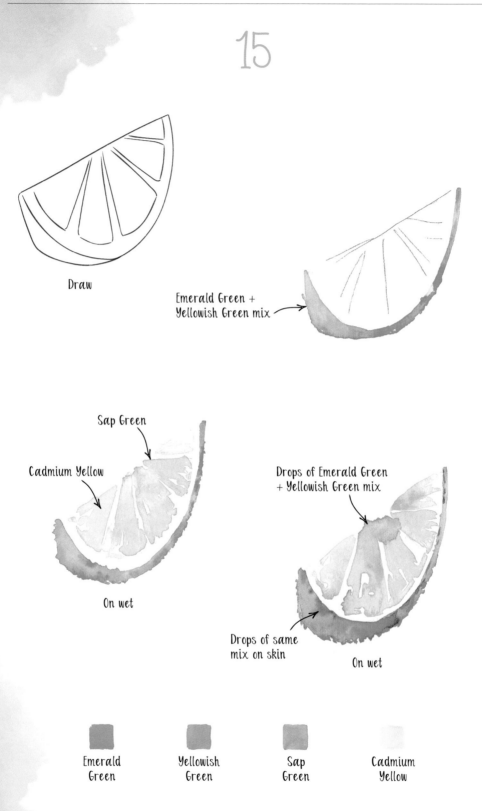

Draw

Emerald Green +
Yellowish Green mix

Sap Green

Cadmium Yellow

On wet

Drops of Emerald Green
+ Yellowish Green mix

Drops of same
mix on skin

On wet

Emerald
Green

Yellowish
Green

Sap
Green

Cadmium
Yellow

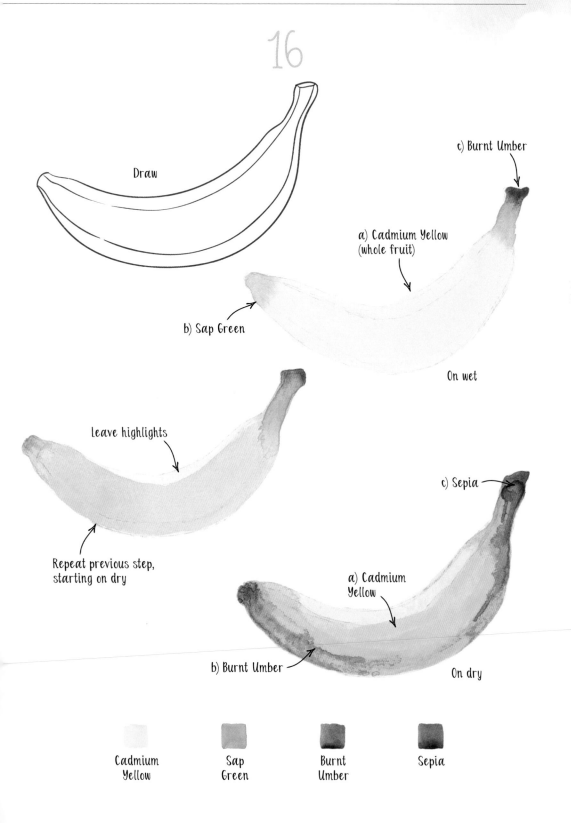

16

Draw

c) Burnt Umber

a) Cadmium Yellow
(whole fruit)

b) Sap Green

On wet

leave highlights

c) Sepia

a) Cadmium
Yellow

Repeat previous step,
starting on dry

b) Burnt Umber

On dry

| Cadmium Yellow | Sap Green | Burnt Umber | Sepia |

17

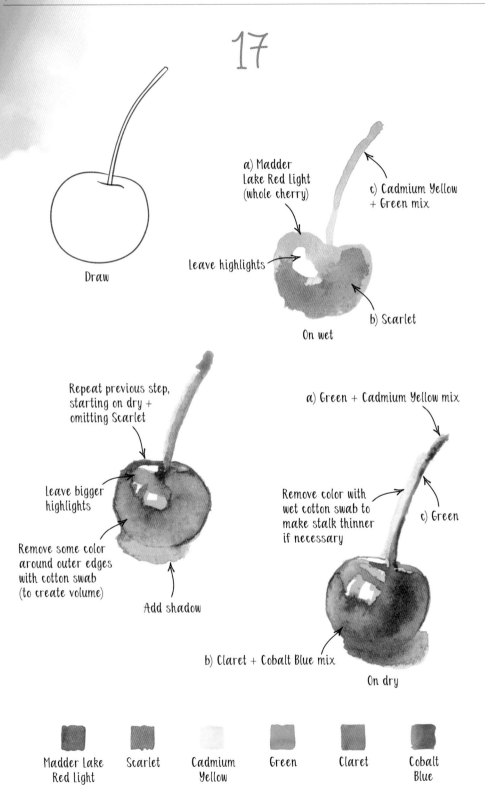

Draw

a) Madder
Lake Red Light
(whole cherry)

c) Cadmium Yellow
+ Green mix

Leave highlights

b) Scarlet

On wet

Repeat previous step,
starting on dry +
omitting Scarlet

a) Green + Cadmium Yellow mix

leave bigger
highlights

Remove color with
wet cotton swab to
make stalk thinner
if necessary

c) Green

Remove some color
around outer edges
with cotton swab
(to create volume)

Add shadow

b) Claret + Cobalt Blue mix

On dry

Madder Lake Scarlet Cadmium Green Claret Cobalt
Red light Yellow Blue

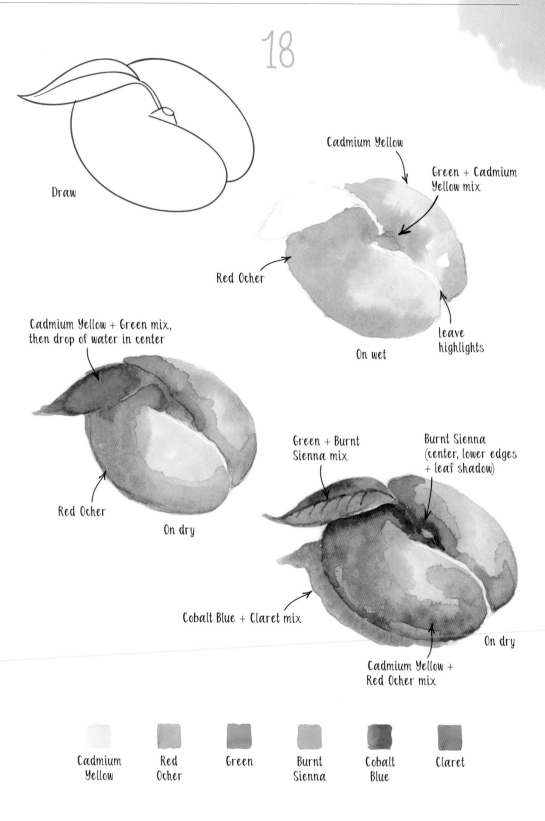

18

Draw

Cadmium Yellow

Green + Cadmium
Yellow mix

Red Ocher

leave
highlights

On wet

Cadmium Yellow + Green mix,
then drop of water in center

Red Ocher

On dry

Green + Burnt
Sienna mix

Burnt Sienna
(center, lower edges
+ leaf shadow)

Cobalt Blue + Claret mix

On dry

Cadmium Yellow +
Red Ocher mix

Cadmium
Yellow

Red
Ocher

Green

Burnt
Sienna

Cobalt
Blue

Claret

19

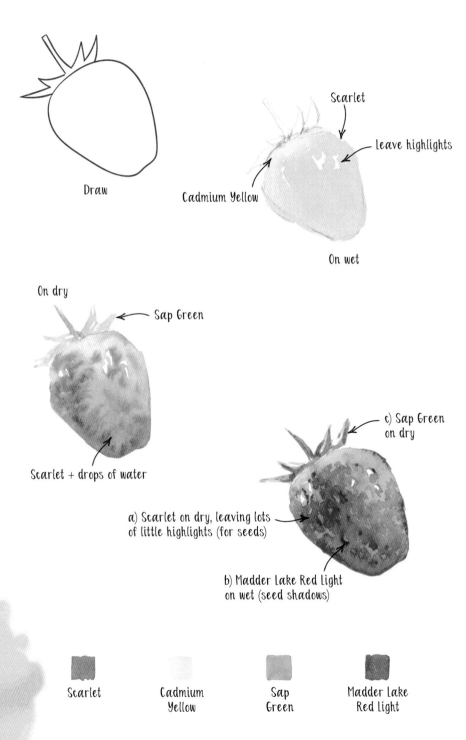

Draw

Scarlet

leave highlights

Cadmium Yellow

On wet

On dry

Sap Green

Scarlet + drops of water

c) Sap Green
on dry

a) Scarlet on dry, leaving lots
of little highlights (for seeds)

b) Madder Lake Red Light
on wet (seed shadows)

Scarlet Cadmium Sap Madder Lake
 Yellow Green Red Light

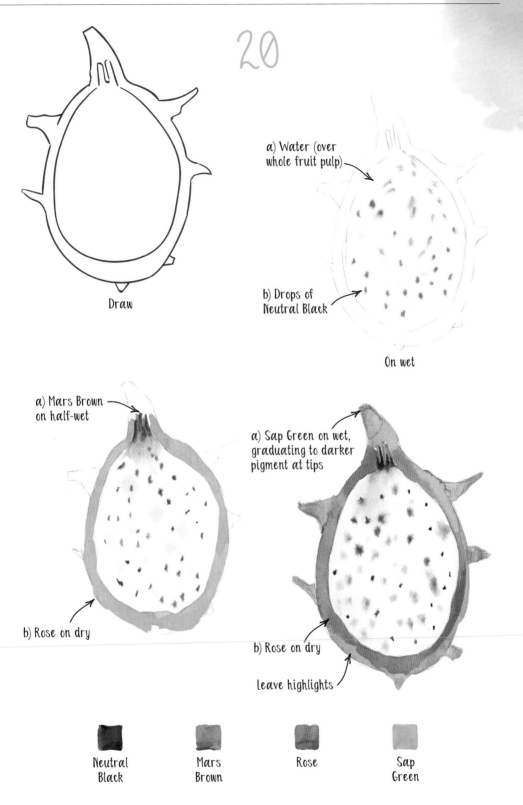

20

Draw

a) Water (over whole fruit pulp)

b) Drops of Neutral Black

On wet

a) Mars Brown on half-wet

b) Rose on dry

a) Sap Green on wet, graduating to darker pigment at tips

b) Rose on dry

leave highlights

Neutral Black

Mars Brown

Rose

Sap Green

21

Draw

b) Sap Green +
Green Light mix
on dry

c) Drops of
Yellow Ocher
on wet

a) Burnt Umber

leave
highlights

Repeat previous step, but
use Burnt Sienna for stone

a) Drops of Green
on wet (edges)

b) Burnt Sienna
on dry (stone)

c) Burnt Umber
on half-wet
(edges)

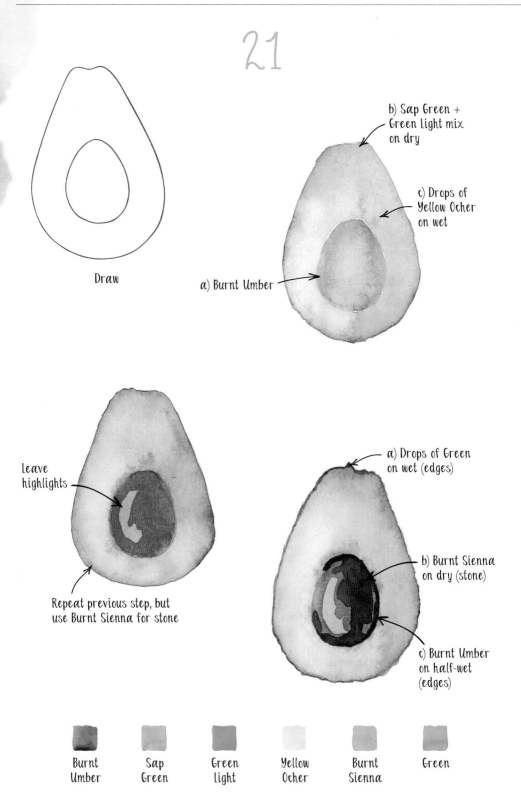

| Burnt Umber | Sap Green | Green Light | Yellow Ocher | Burnt Sienna | Green |

22

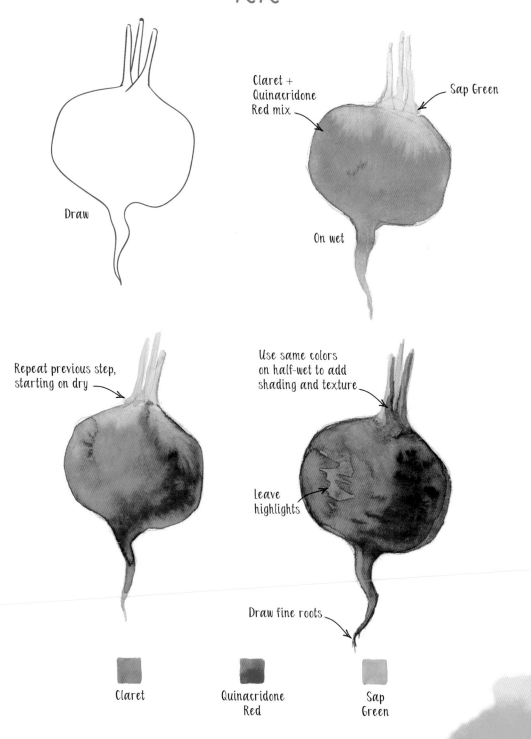

Draw

Claret +
Quinacridone
Red mix

Sap Green

On wet

Repeat previous step,
starting on dry

Use same colors
on half-wet to add
shading and texture

leave
highlights

Draw fine roots

Claret

Quinacridone
Red

Sap
Green

23

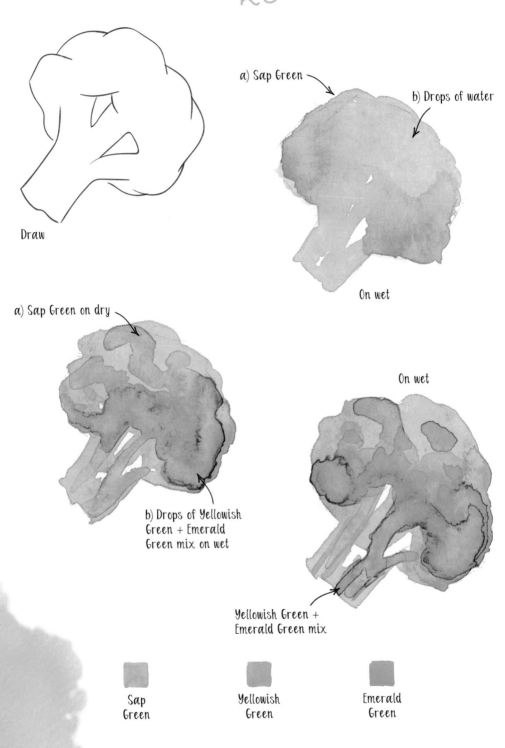

Draw

a) Sap Green

b) Drops of water

On wet

a) Sap Green on dry

On wet

b) Drops of Yellowish
Green + Emerald
Green mix on wet

Yellowish Green +
Emerald Green mix

Sap
Green

Yellowish
Green

Emerald
Green

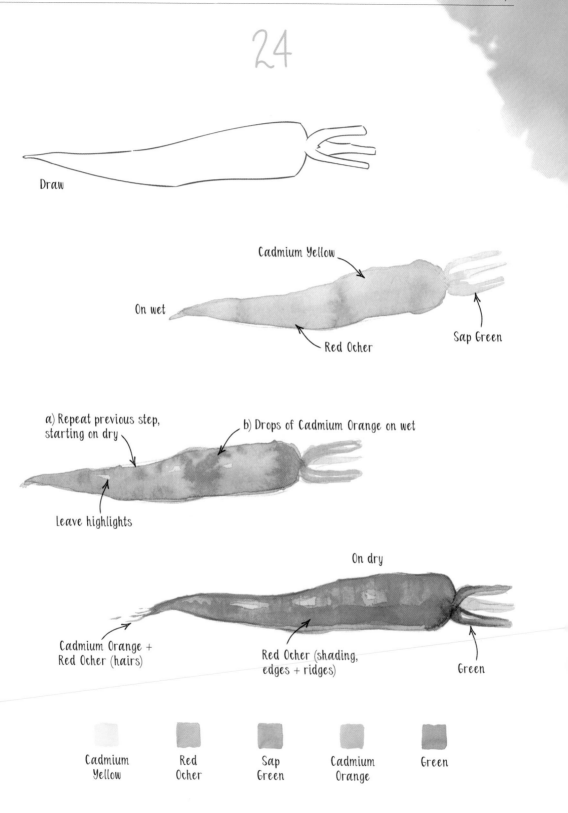

24

Draw

Cadmium Yellow

On wet

Red Ocher

Sap Green

a) Repeat previous step, starting on dry

b) Drops of Cadmium Orange on wet

leave highlights

On dry

Cadmium Orange +
Red Ocher (hairs)

Red Ocher (shading,
edges + ridges)

Green

Cadmium
Yellow

Red
Ocher

Sap
Green

Cadmium
Orange

Green

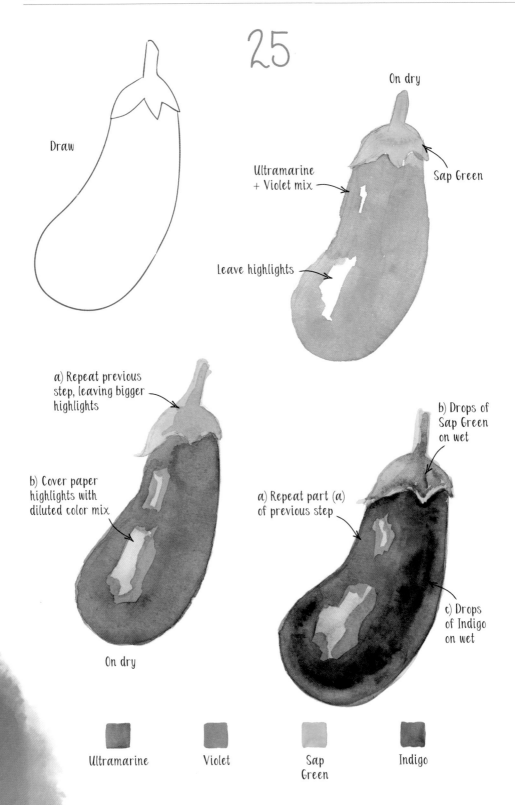

25

Draw

On dry

Ultramarine
+ Violet mix

Sap Green

Leave highlights

a) Repeat previous
step, leaving bigger
highlights

b) Cover paper
highlights with
diluted color mix

b) Drops of
Sap Green
on wet

a) Repeat part (a)
of previous step

c) Drops
of Indigo
on wet

On dry

Ultramarine Violet Sap Indigo
 Green

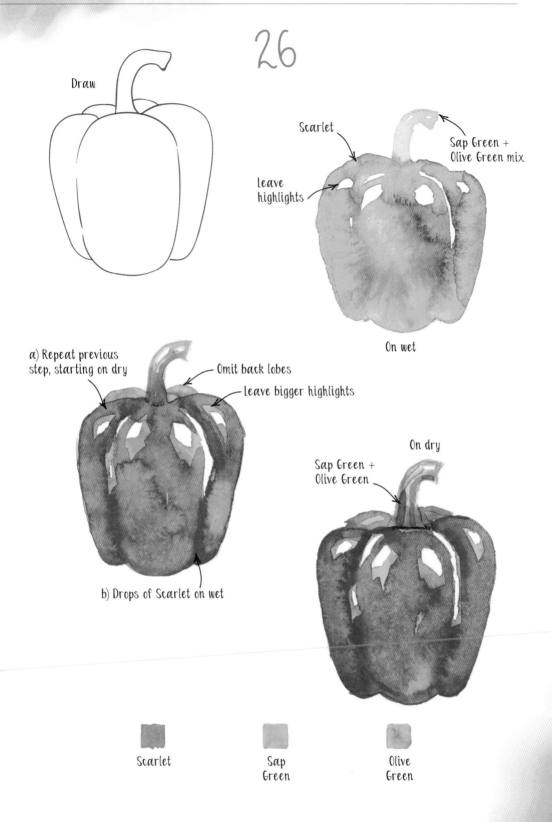

26

Draw

Scarlet

leave
highlights

Sap Green +
Olive Green mix

On wet

a) Repeat previous
step, starting on dry

Omit back lobes

Leave bigger highlights

On dry

Sap Green +
Olive Green

b) Drops of Scarlet on wet

Scarlet

Sap
Green

Olive
Green

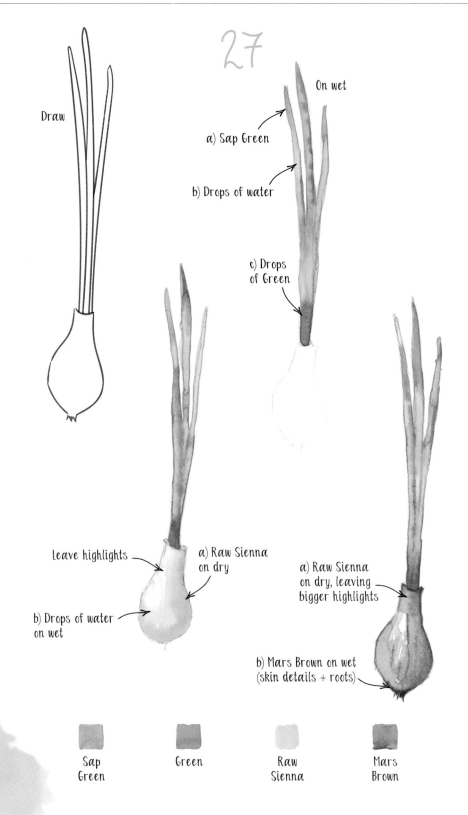

Draw

27

On wet

a) Sap Green

b) Drops of water

c) Drops
of Green

leave highlights

a) Raw Sienna
on dry

b) Drops of water
on wet

a) Raw Sienna
on dry, leaving
bigger highlights

b) Mars Brown on wet
(skin details + roots)

Sap
Green

Green

Raw
Sienna

Mars
Brown

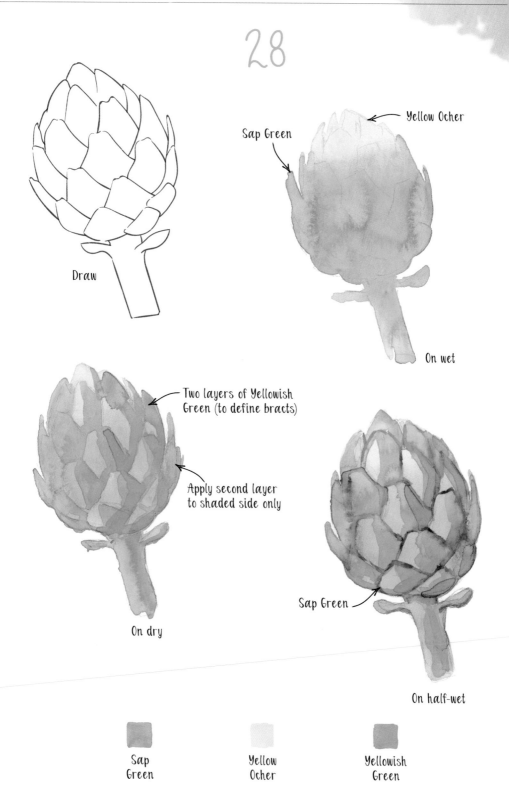

28

Draw

Sap Green

Yellow Ocher

On wet

Two layers of Yellowish
Green (to define bracts)

Apply second layer
to shaded side only

On dry

Sap Green

On half-wet

Sap
Green

Yellow
Ocher

Yellowish
Green

29

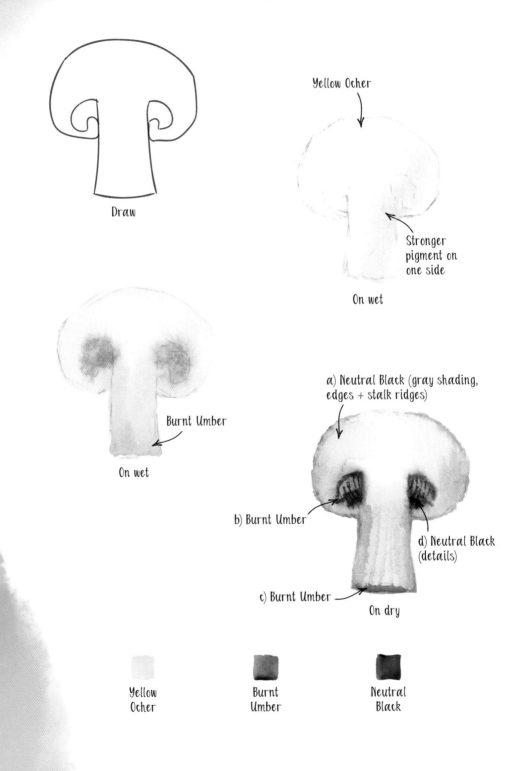

Draw

Yellow Ocher

Stronger
pigment on
one side

On wet

On wet

Burnt Umber

a) Neutral Black (gray shading,
edges + stalk ridges)

b) Burnt Umber

d) Neutral Black
(details)

c) Burnt Umber

On dry

Yellow
Ocher

Burnt
Umber

Neutral
Black

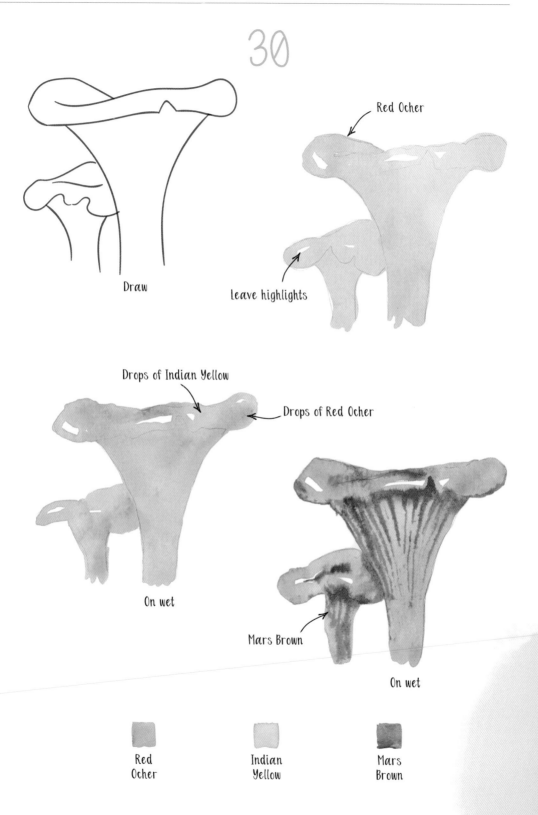

30

Draw

Red Ocher

leave highlights

Drops of Indian Yellow

Drops of Red Ocher

On wet

Mars Brown

On wet

Red
Ocher

Indian
Yellow

Mars
Brown

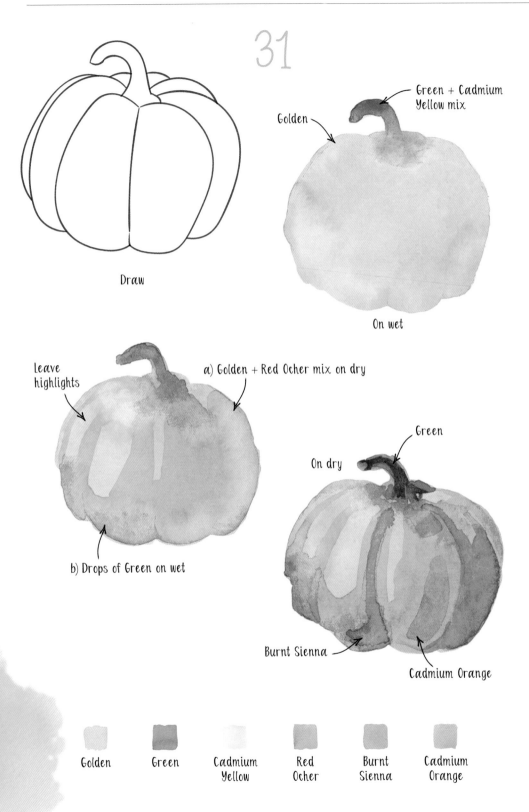

31

Draw

Green + Cadmium
Yellow mix

Golden

On wet

leave
highlights

a) Golden + Red Ocher mix on dry

Green

On dry

b) Drops of Green on wet

Burnt Sienna

Cadmium Orange

Golden Green Cadmium Red Burnt Cadmium
 Yellow Ocher Sienna Orange

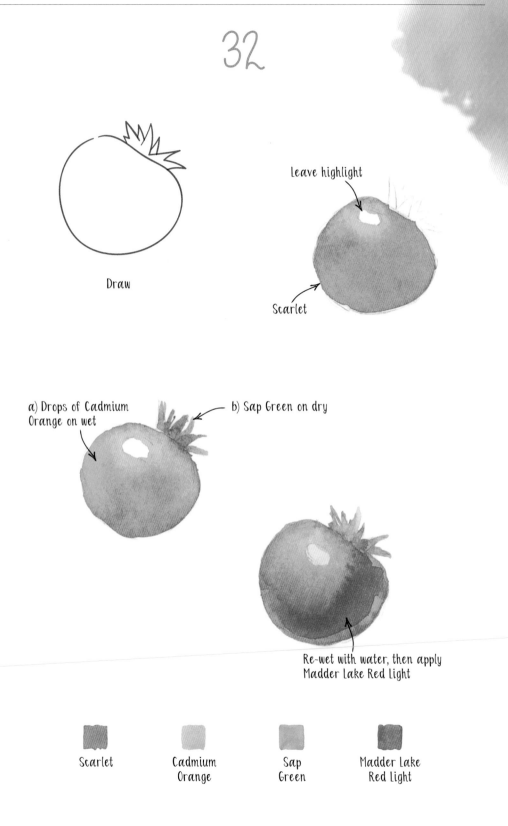

32

Draw

Leave highlight

Scarlet

a) Drops of Cadmium
Orange on wet

b) Sap Green on dry

Re-wet with water, then apply
Madder Lake Red Light

Scarlet

Cadmium
Orange

Sap
Green

Madder Lake
Red Light

33

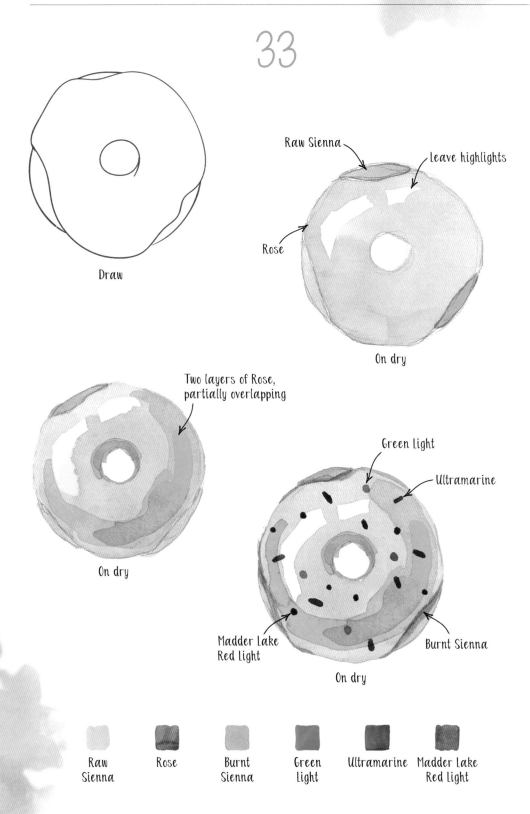

Draw

Raw Sienna

leave highlights

Rose

On dry

Two layers of Rose,
partially overlapping

On dry

Green light

Ultramarine

Madder Lake
Red light

Burnt Sienna

On dry

Raw
Sienna

Rose

Burnt
Sienna

Green
light

Ultramarine

Madder Lake
Red light

34

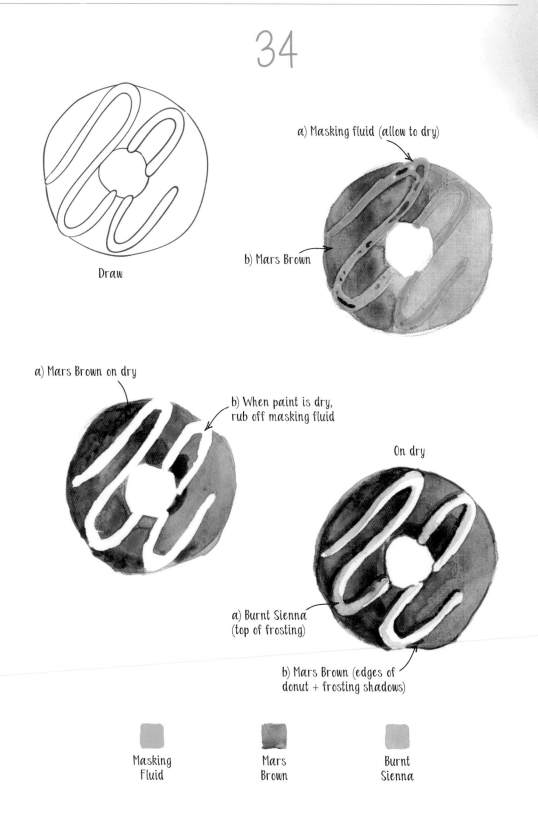

Draw

a) Masking fluid (allow to dry)

b) Mars Brown

a) Mars Brown on dry

b) When paint is dry,
rub off masking fluid

On dry

a) Burnt Sienna
(top of frosting)

b) Mars Brown (edges of
donut + frosting shadows)

Masking
Fluid

Mars
Brown

Burnt
Sienna

Draw

a) Masking fluid (allow to dry)

b) Red Ocher +
Raw Sienna mix

Second layer of Red Ocher + Raw Sienna mix

leave
highlights

On dry

a) Mars Brown on dry
(edges of cookie +
frosting shadows)

b) When paint is dry,
rub off masking fluid

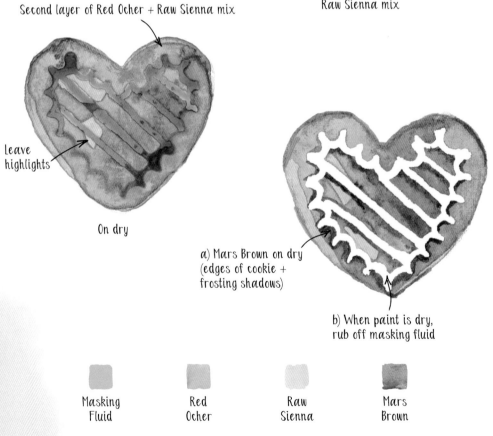

Masking Red Raw Mars
Fluid Ocher Sienna Brown

36

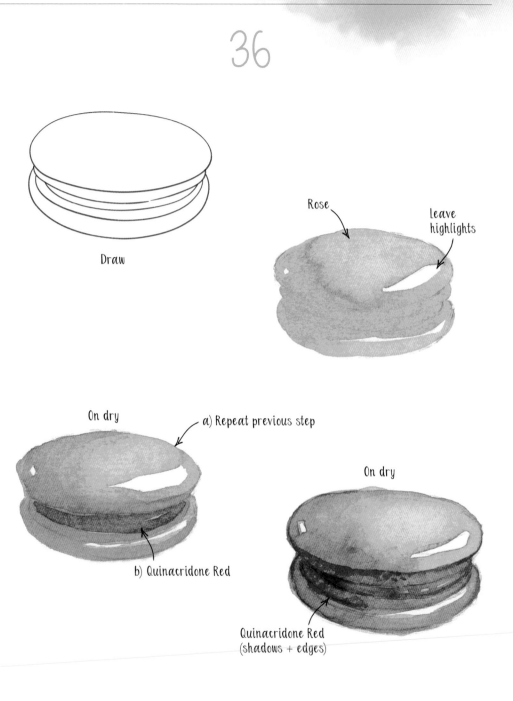

Draw

Rose

leave
highlights

On dry

a) Repeat previous step

On dry

b) Quinacridone Red

Quinacridone Red
(shadows + edges)

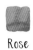

Rose

Quinacridone
Red

37

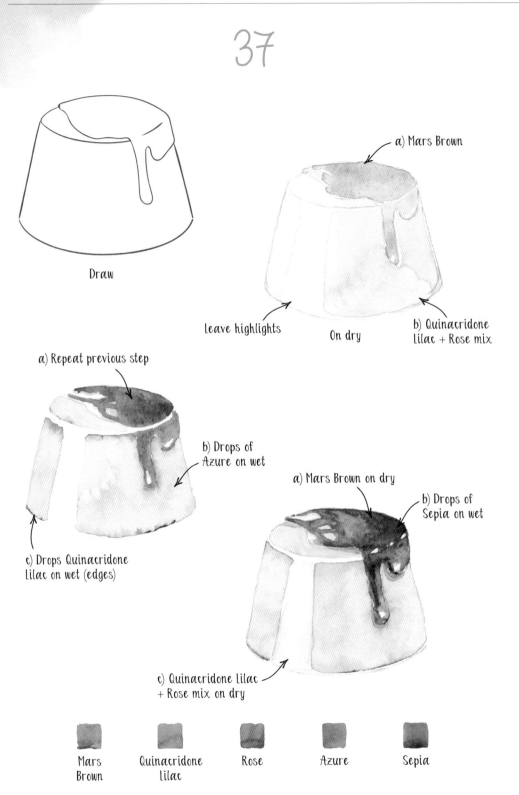

Draw

a) Mars Brown

Leave highlights On dry b) Quinacridone
 Lilac + Rose mix

a) Repeat previous step

b) Drops of
Azure on wet

c) Drops Quinacridone
Lilac on wet (edges)

a) Mars Brown on dry

b) Drops of
Sepia on wet

c) Quinacridone Lilac
+ Rose mix on dry

Mars Quinacridone Rose Azure Sepia
Brown Lilac

38

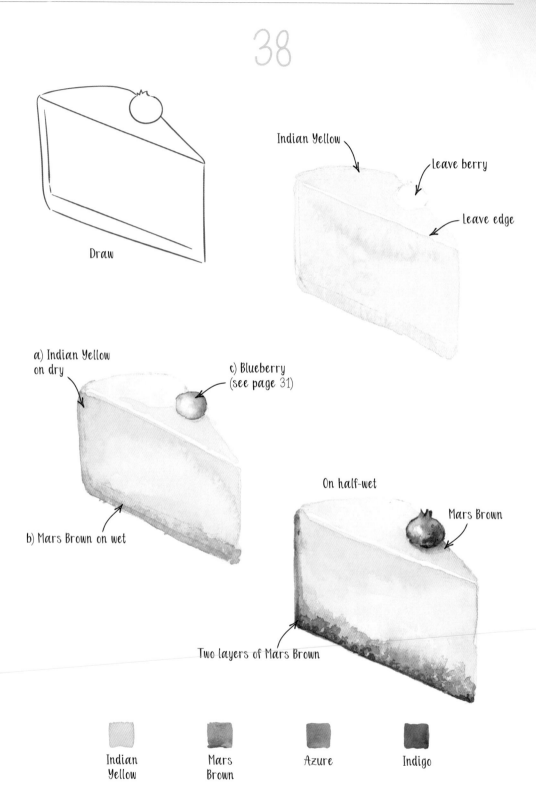

Draw

Indian Yellow

leave berry

leave edge

a) Indian Yellow
on dry

c) Blueberry
(see page 31)

b) Mars Brown on wet

On half-wet

Mars Brown

Two layers of Mars Brown

Indian
Yellow

Mars
Brown

Azure

Indigo

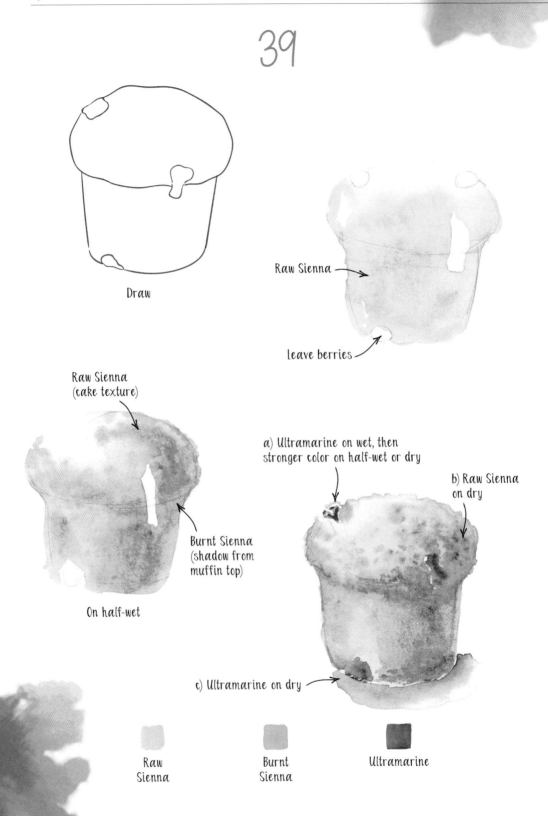

39

Draw

Raw Sienna

leave berries

Raw Sienna
(cake texture)

a) Ultramarine on wet, then
stronger color on half-wet or dry

b) Raw Sienna
on dry

Burnt Sienna
(shadow from
muffin top)

On half-wet

c) Ultramarine on dry

Raw
Sienna

Burnt
Sienna

Ultramarine

40

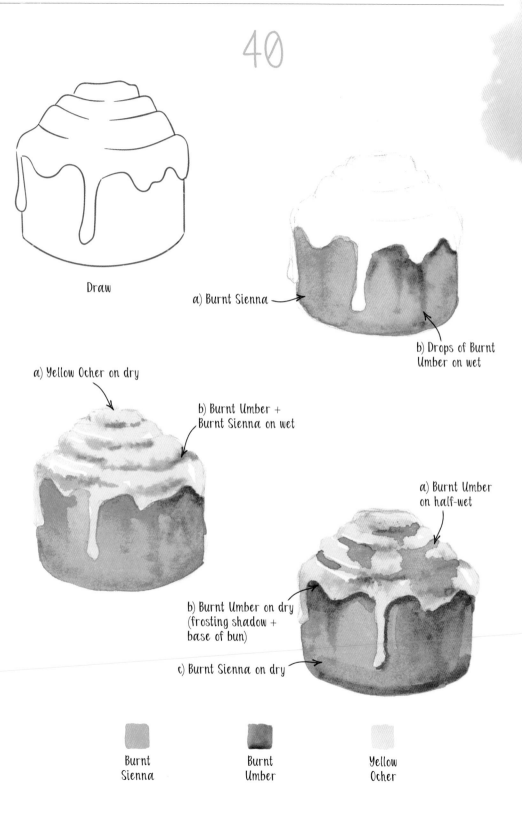

Draw

a) Burnt Sienna

b) Drops of Burnt
Umber on wet

a) Yellow Ocher on dry

b) Burnt Umber +
Burnt Sienna on wet

a) Burnt Umber
on half-wet

b) Burnt Umber on dry
(frosting shadow +
base of bun)

c) Burnt Sienna on dry

Burnt
Sienna

Burnt
Umber

Yellow
Ocher

41

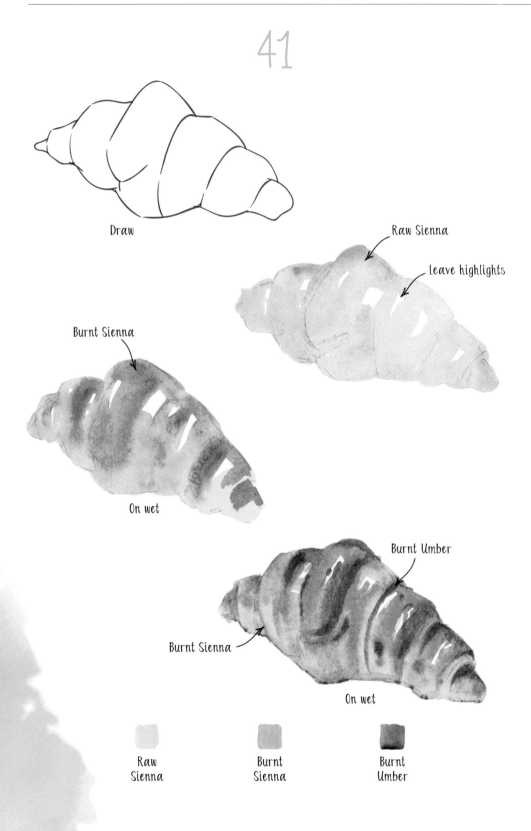

Draw

Raw Sienna

leave highlights

Burnt Sienna

On wet

Burnt Umber

Burnt Sienna

On wet

Raw
Sienna

Burnt
Sienna

Burnt
Umber

42

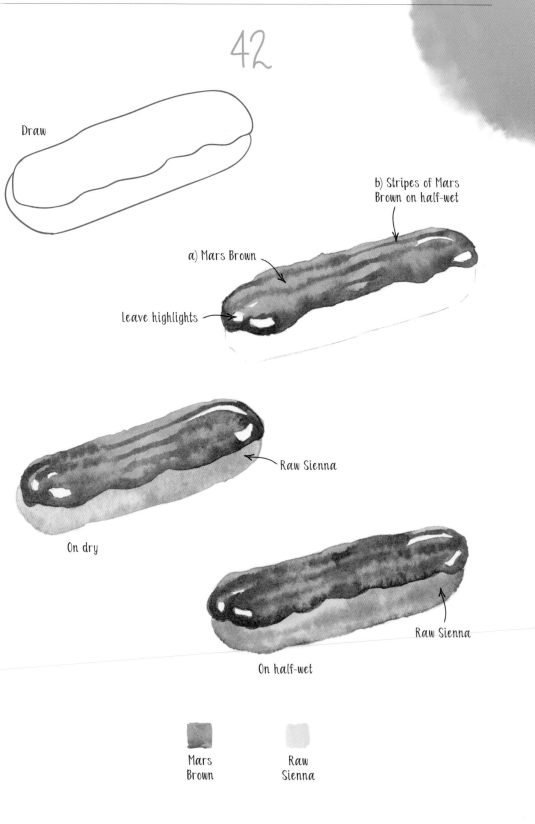

Draw

b) Stripes of Mars
Brown on half-wet

a) Mars Brown

leave highlights

Raw Sienna

On dry

Raw Sienna

On half-wet

Mars
Brown

Raw
Sienna

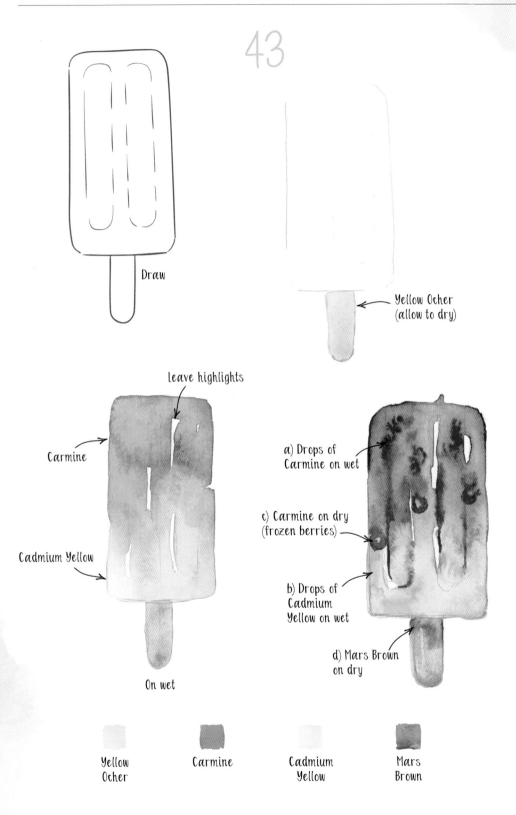

43

Draw

Yellow Ocher
(allow to dry)

leave highlights

Carmine

Cadmium Yellow

On wet

a) Drops of
Carmine on wet

c) Carmine on dry
(frozen berries)

b) Drops of
Cadmium
Yellow on wet

d) Mars Brown
on dry

Yellow
Ocher

Carmine

Cadmium
Yellow

Mars
Brown

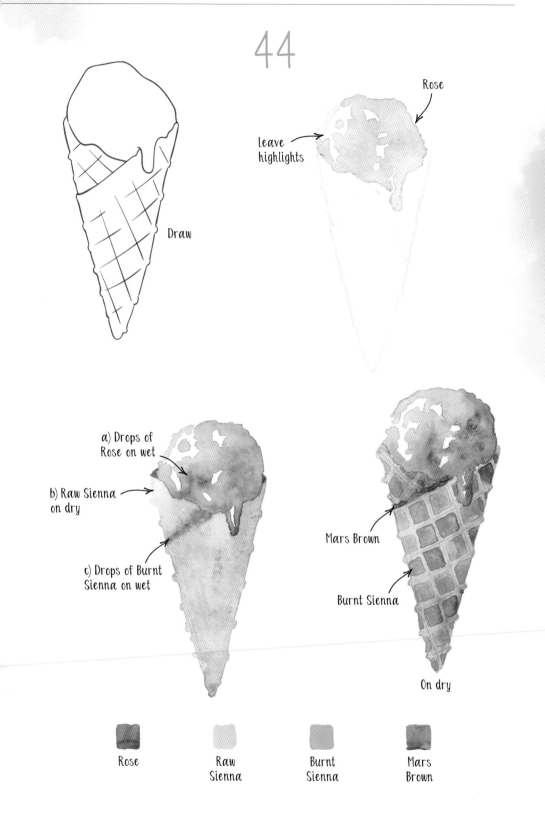

44

Draw

Rose

leave
highlights

a) Drops of
Rose on wet

b) Raw Sienna
on dry

c) Drops of Burnt
Sienna on wet

Mars Brown

Burnt Sienna

On dry

Rose

Raw
Sienna

Burnt
Sienna

Mars
Brown

45

Draw

Raw Sienna

Sap Green

On dry

Burnt Sienna

Madder Lake
Red Light

Leave highlights

On half-wet

a) Drops of water

On dry

b) Madder Lake Red Light,
leaving bigger highlights

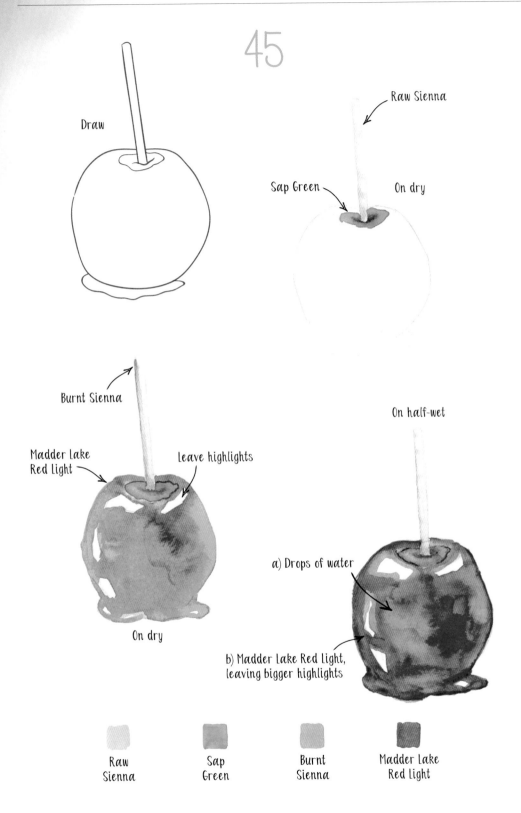

Raw
Sienna

Sap
Green

Burnt
Sienna

Madder Lake
Red Light

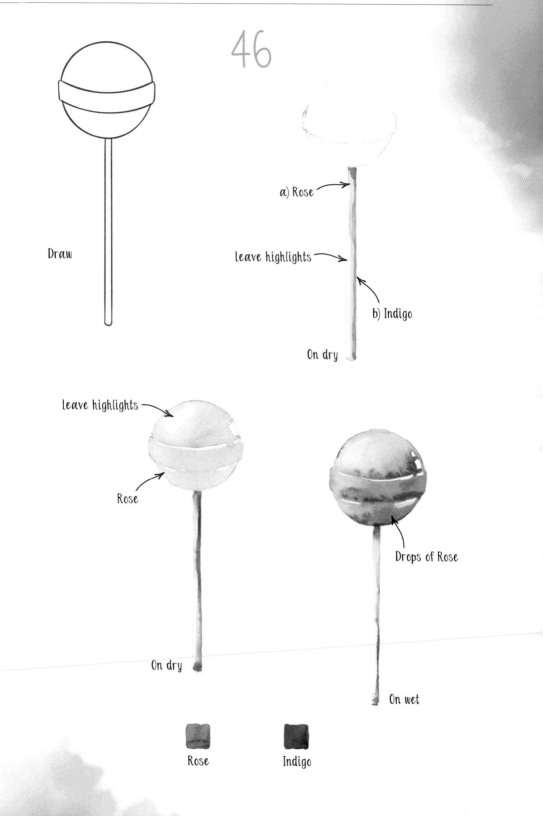

46

Draw

a) Rose

Leave highlights

b) Indigo

On dry

leave highlights

Rose

On dry

Drops of Rose

On wet

Rose

Indigo

47

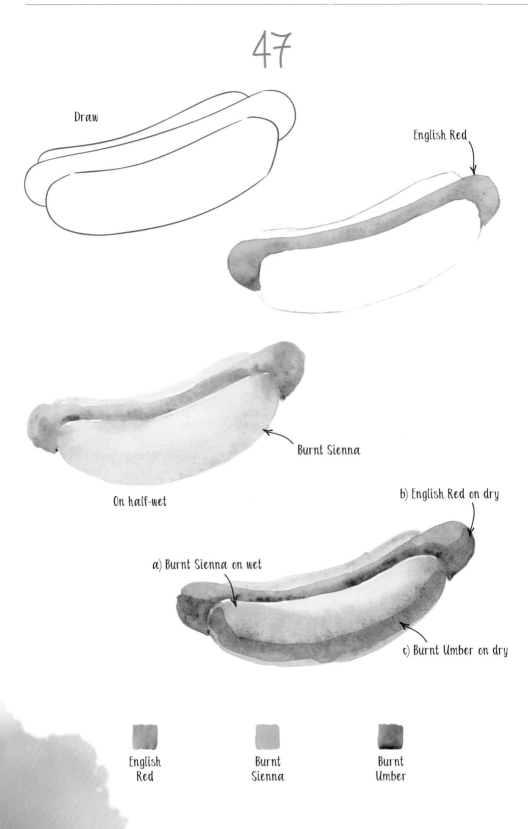

Draw

English Red

Burnt Sienna

On half-wet

a) Burnt Sienna on wet

b) English Red on dry

c) Burnt Umber on dry

English
Red

Burnt
Sienna

Burnt
Umber

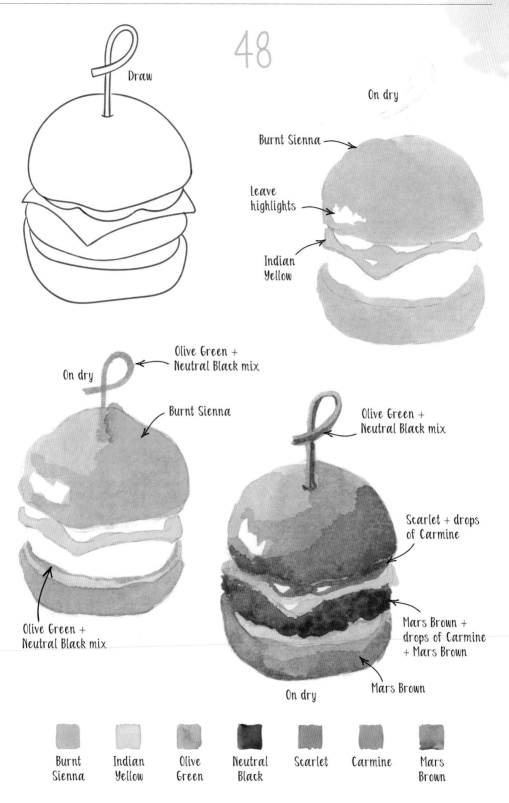

Draw

48

On dry

Burnt Sienna

leave
highlights

Indian
Yellow

Olive Green +
Neutral Black mix

On dry

Burnt Sienna

Olive Green +
Neutral Black mix

Scarlet + drops
of Carmine

Mars Brown +
drops of Carmine
+ Mars Brown

Olive Green +
Neutral Black mix

Mars Brown

On dry

Burnt
Sienna

Indian
Yellow

Olive
Green

Neutral
Black

Scarlet

Carmine

Mars
Brown

49

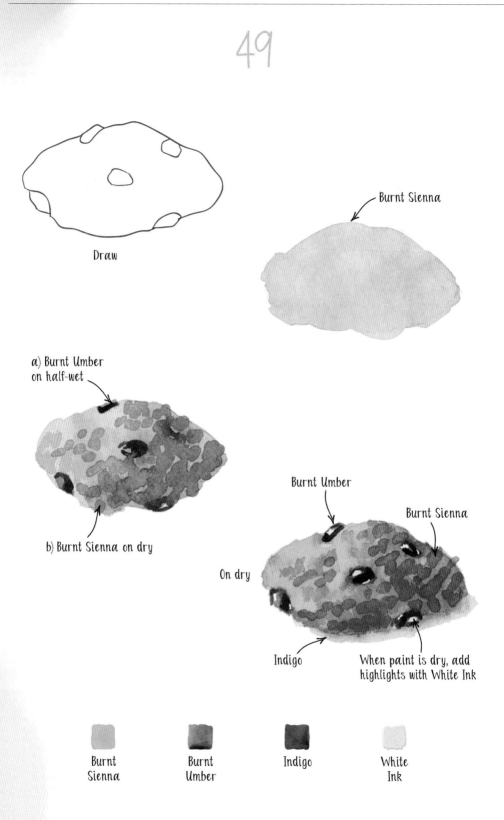

Draw

Burnt Sienna

a) Burnt Umber
on half-wet

b) Burnt Sienna on dry

Burnt Umber

Burnt Sienna

On dry

Indigo

When paint is dry, add
highlights with White Ink

Burnt
Sienna

Burnt
Umber

Indigo

White
Ink

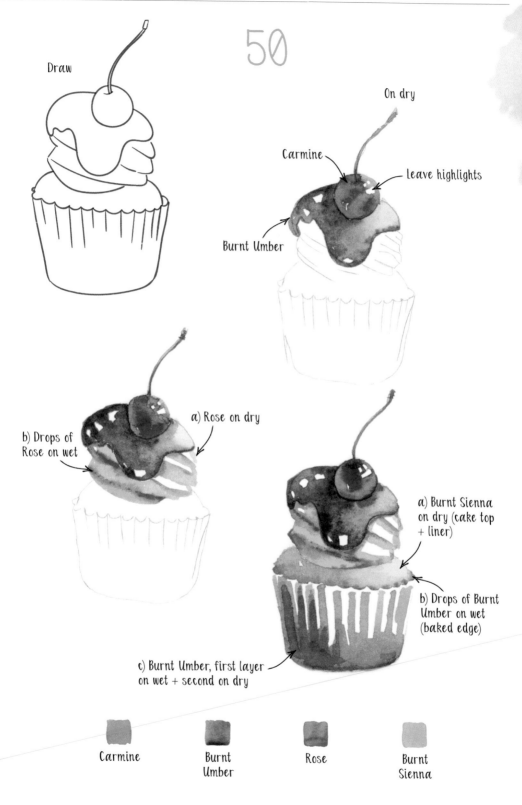

Draw

50

On dry

Carmine

Leave highlights

Burnt Umber

b) Drops of
Rose on wet

a) Rose on dry

a) Burnt Sienna
on dry (cake top
+ liner)

b) Drops of Burnt
Umber on wet
(baked edge)

c) Burnt Umber, first layer
on wet + second on dry

Carmine Burnt Rose Burnt
 Umber Sienna

51

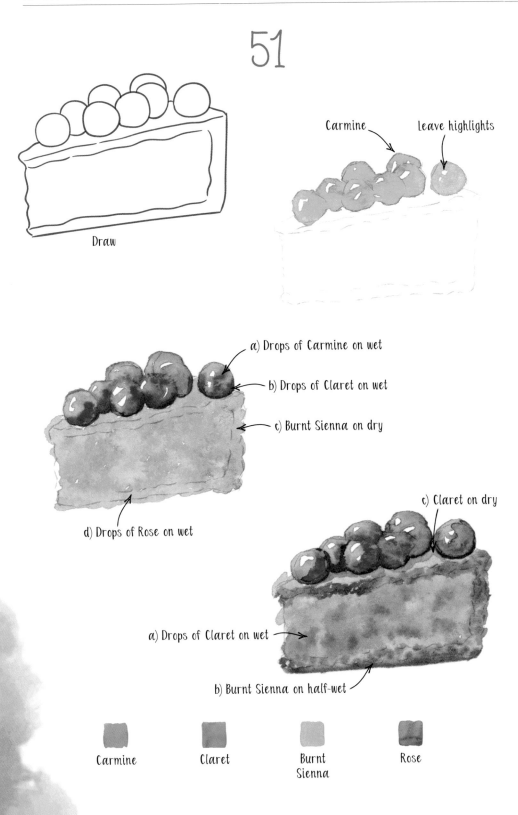

Draw

Carmine leave highlights

a) Drops of Carmine on wet

b) Drops of Claret on wet

c) Burnt Sienna on dry

d) Drops of Rose on wet

c) Claret on dry

a) Drops of Claret on wet

b) Burnt Sienna on half-wet

Carmine Claret Burnt Sienna Rose

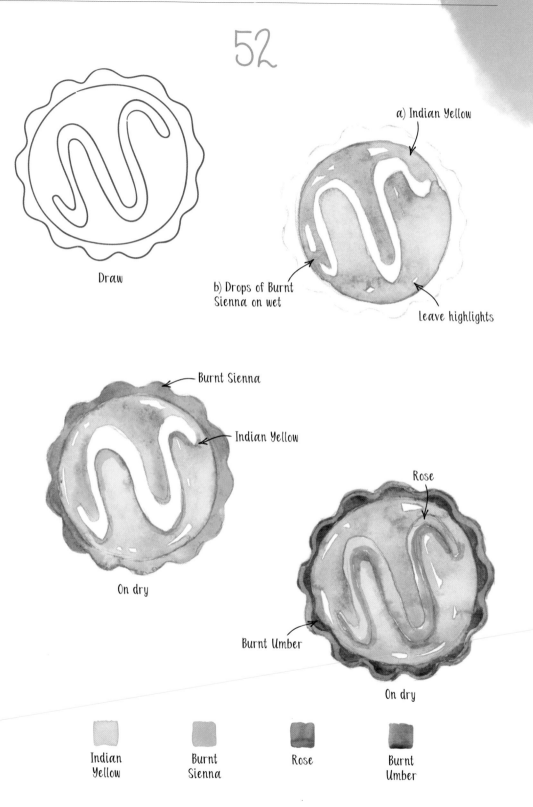

52

Draw

a) Indian Yellow

b) Drops of Burnt
Sienna on wet

leave highlights

Burnt Sienna

Indian Yellow

On dry

Rose

Burnt Umber

On dry

Indian
Yellow

Burnt
Sienna

Rose

Burnt
Umber

53

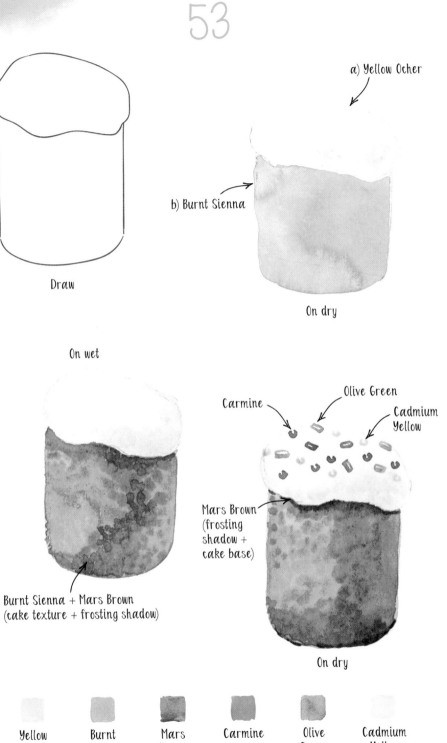

Draw

a) Yellow Ocher

b) Burnt Sienna

On dry

On wet

Carmine

Olive Green

Cadmium
Yellow

Mars Brown
(frosting
shadow +
cake base)

Burnt Sienna + Mars Brown
(cake texture + frosting shadow)

On dry

Yellow
Ocher

Burnt
Sienna

Mars
Brown

Carmine

Olive
Green

Cadmium
Yellow

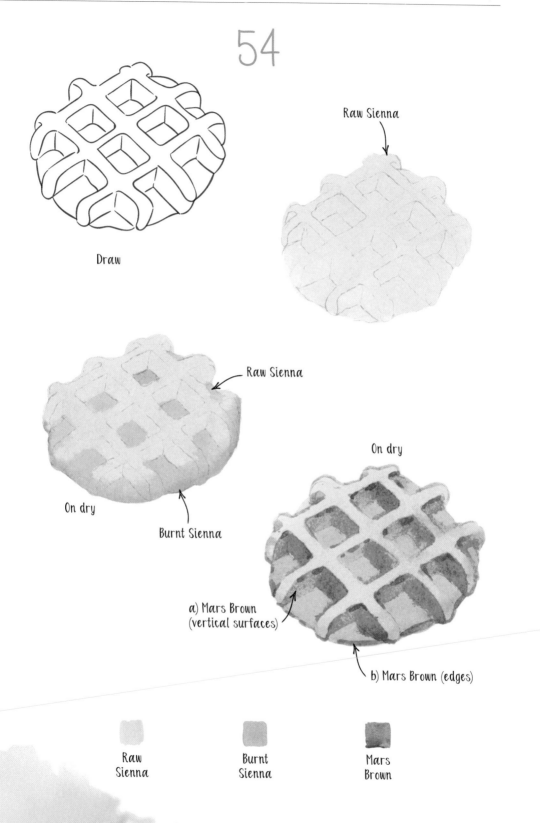

54

Draw

Raw Sienna

Raw Sienna

On dry

On dry

Burnt Sienna

a) Mars Brown
(vertical surfaces)

b) Mars Brown (edges)

Raw
Sienna

Burnt
Sienna

Mars
Brown

55

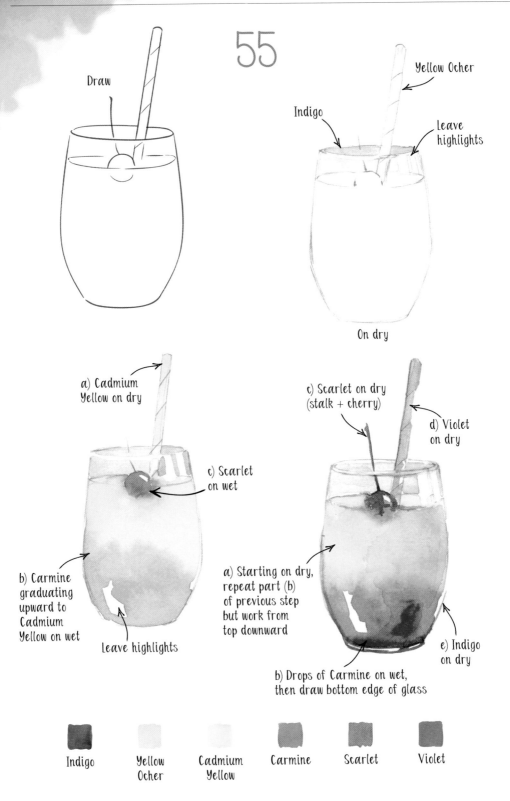

Draw

Indigo

Yellow Ocher

leave
highlights

On dry

a) Cadmium
Yellow on dry

c) Scarlet on dry
(stalk + cherry)

d) Violet
on dry

c) Scarlet
on wet

b) Carmine
graduating
upward to
Cadmium
Yellow on wet

a) Starting on dry,
repeat part (b)
of previous step
but work from
top downward

leave highlights

e) Indigo
on dry

b) Drops of Carmine on wet,
then draw bottom edge of glass

Indigo Yellow Cadmium Carmine Scarlet Violet
 Ocher Yellow

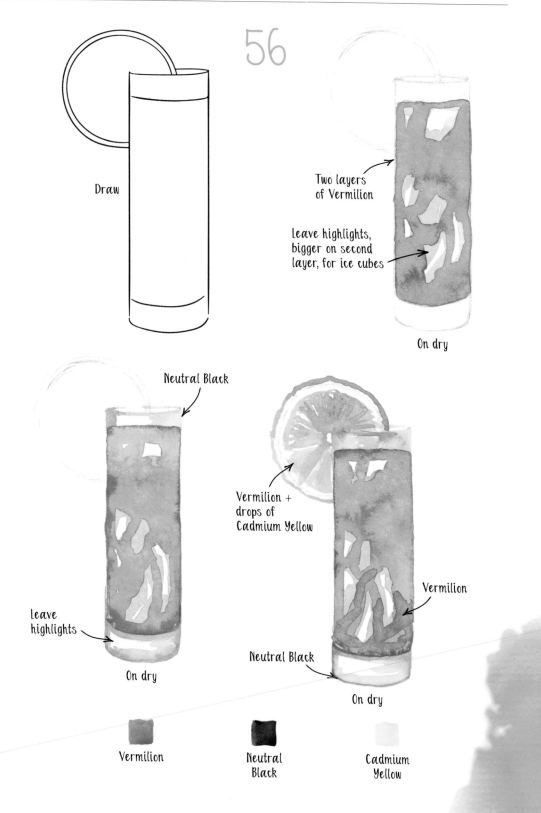

56

Draw

Two layers
of Vermilion

leave highlights,
bigger on second
layer, for ice cubes

On dry

Neutral Black

Vermilion +
drops of
Cadmium Yellow

Vermilion

leave
highlights

Neutral Black

On dry

On dry

Vermilion

Neutral
Black

Cadmium
Yellow

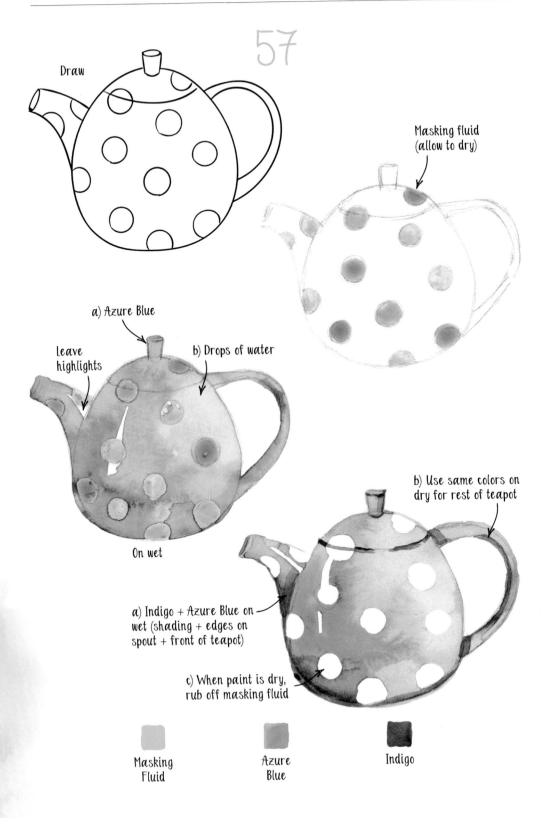

57

Draw

Masking fluid
(allow to dry)

a) Azure Blue

leave
highlights

b) Drops of water

On wet

b) Use same colors on
dry for rest of teapot

a) Indigo + Azure Blue on
wet (shading + edges on
spout + front of teapot)

c) When paint is dry,
rub off masking fluid

Masking
Fluid

Azure
Blue

Indigo

58

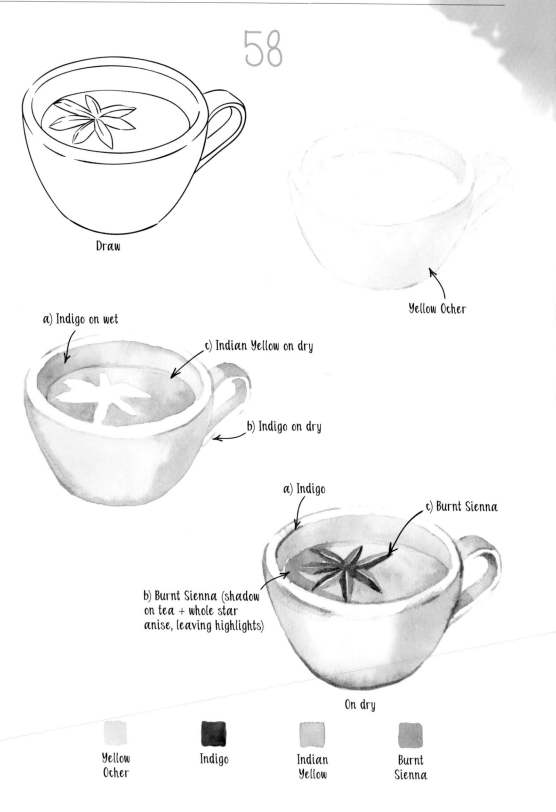

Draw

Yellow Ocher

a) Indigo on wet

c) Indian Yellow on dry

b) Indigo on dry

a) Indigo

c) Burnt Sienna

b) Burnt Sienna (shadow
on tea + whole star
anise, leaving highlights)

On dry

Yellow
Ocher

Indigo

Indian
Yellow

Burnt
Sienna

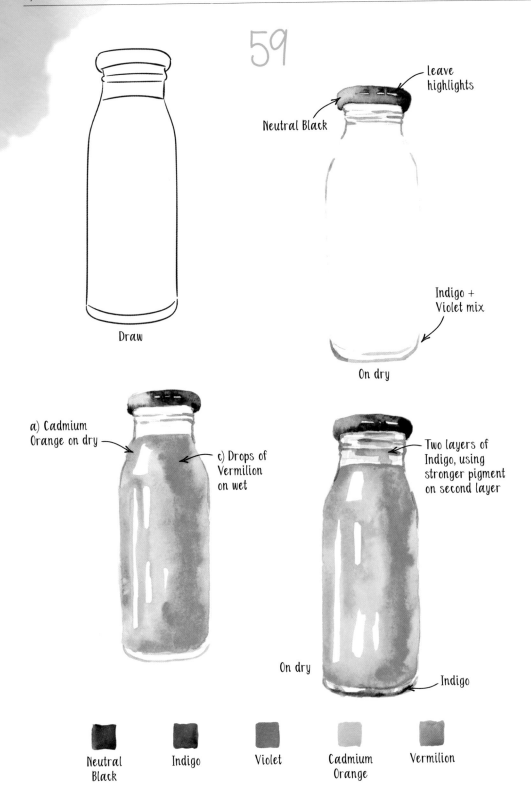

59

Draw

leave highlights

Neutral Black

Indigo + Violet mix

On dry

a) Cadmium Orange on dry

c) Drops of Vermilion on wet

Two layers of Indigo, using stronger pigment on second layer

On dry

Indigo

| Neutral Black | Indigo | Violet | Cadmium Orange | Vermilion |

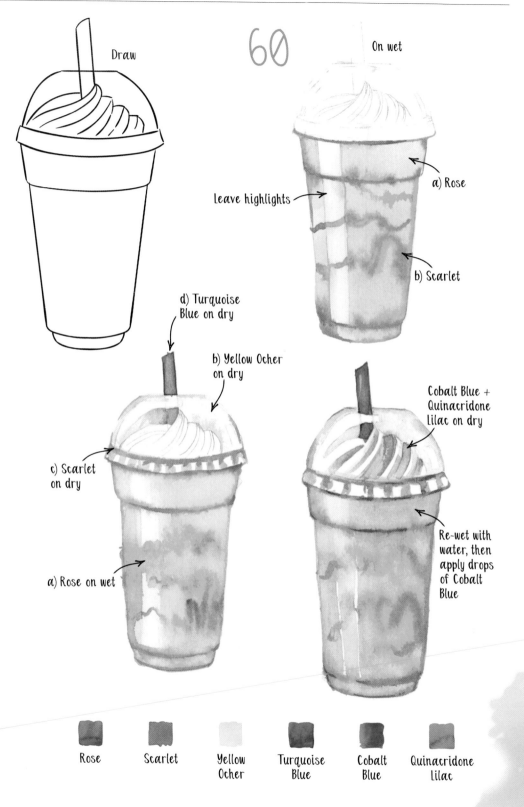

Draw

60

On wet

a) Rose

Leave highlights

b) Scarlet

d) Turquoise
Blue on dry

b) Yellow Ocher
on dry

c) Scarlet
on dry

a) Rose on wet

Cobalt Blue +
Quinacridone
Lilac on dry

Re-wet with
water, then
apply drops
of Cobalt
Blue

Rose	Scarlet	Yellow Ocher	Turquoise Blue	Cobalt Blue	Quinacridone Lilac

61

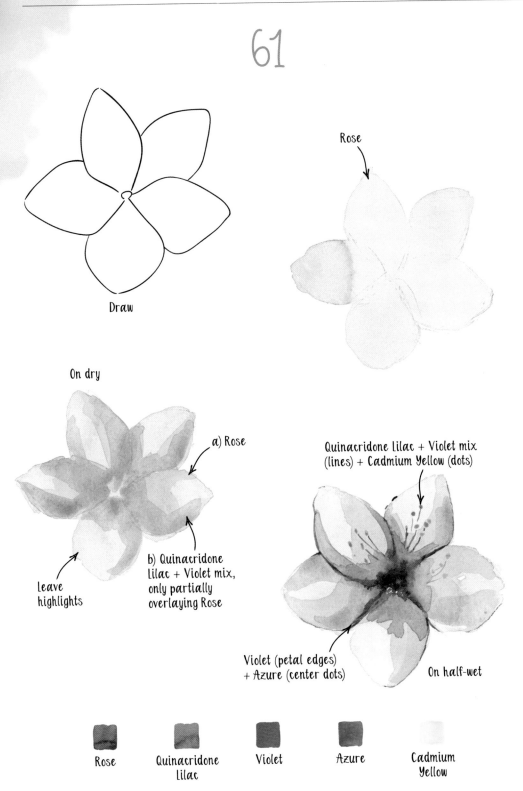

Draw

Rose

On dry

a) Rose

leave
highlights

b) Quinacridone
lilac + Violet mix,
only partially
overlaying Rose

Quinacridone Lilac + Violet mix
(lines) + Cadmium Yellow (dots)

Violet (petal edges)
+ Azure (center dots)

On half-wet

Rose Quinacridone Violet Azure Cadmium
 lilac Yellow

62

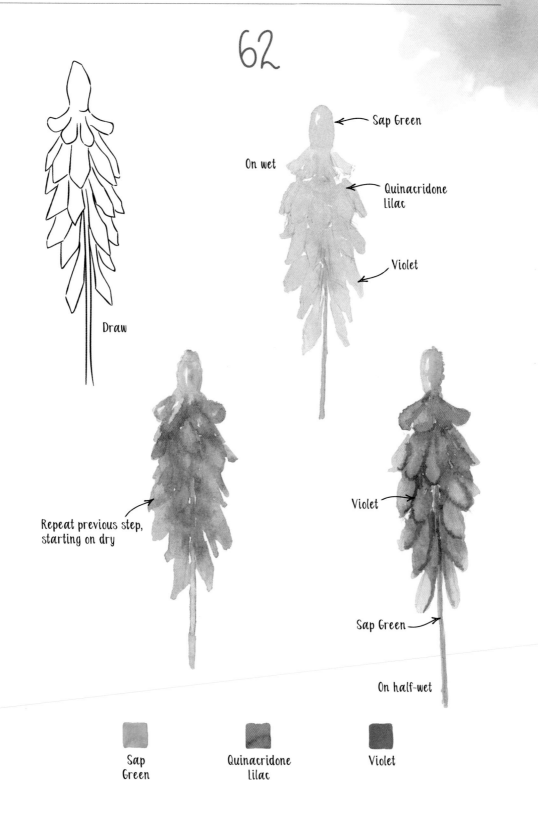

Draw

On wet

Sap Green

Quinacridone
Lilac

Violet

Repeat previous step,
starting on dry

Violet

Sap Green

On half-wet

Sap
Green

Quinacridone
Lilac

Violet

63

Draw

a) Cover with water, then work on half-wet

b) Mars Brown

c) Neutral Black (outer edges)

a) Yellow Ocher on wet (outer edges)

b) Mars Brown on wet (center)

c) Sepia on dry

a) Re-wet with water, then apply Neutral Black on half-wet (around edges + to define segments)

b) Sepia on dry (center)

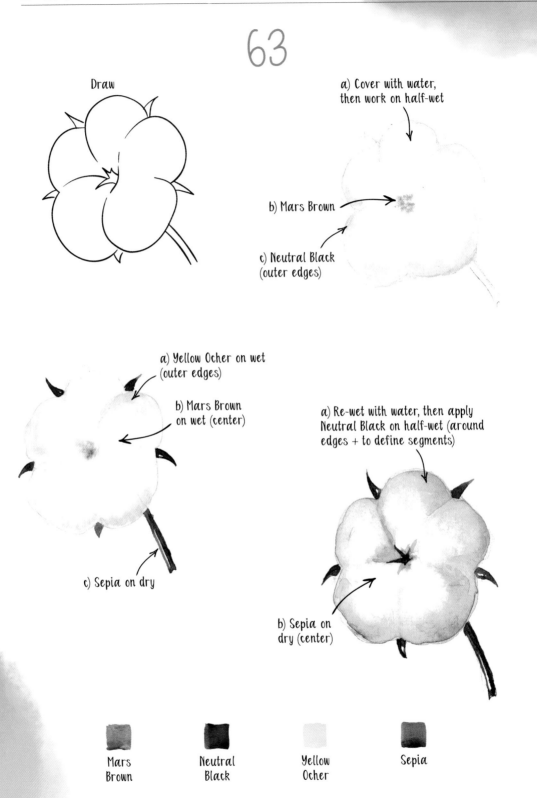

Mars Brown

Neutral Black

Yellow Ocher

Sepia

64

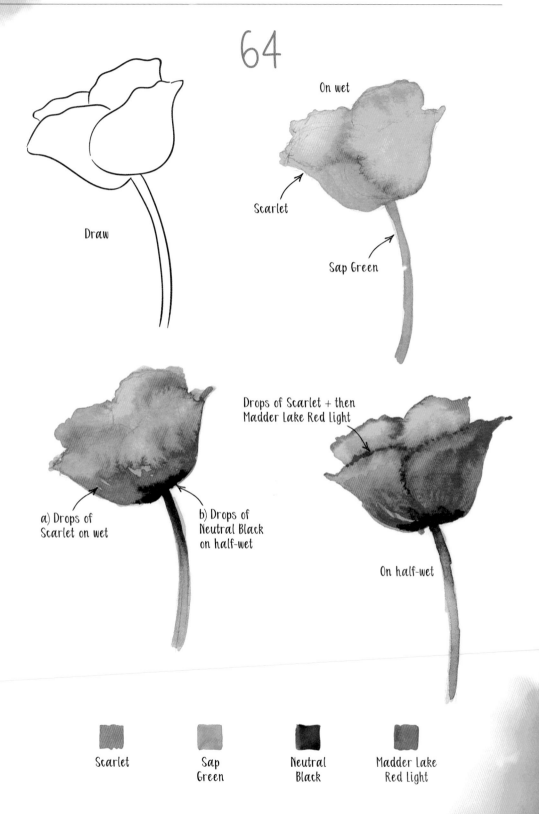

Draw

On wet

Scarlet

Sap Green

a) Drops of
Scarlet on wet

b) Drops of
Neutral Black
on half-wet

Drops of Scarlet + then
Madder Lake Red Light

On half-wet

Scarlet Sap Neutral Madder Lake
 Green Black Red Light

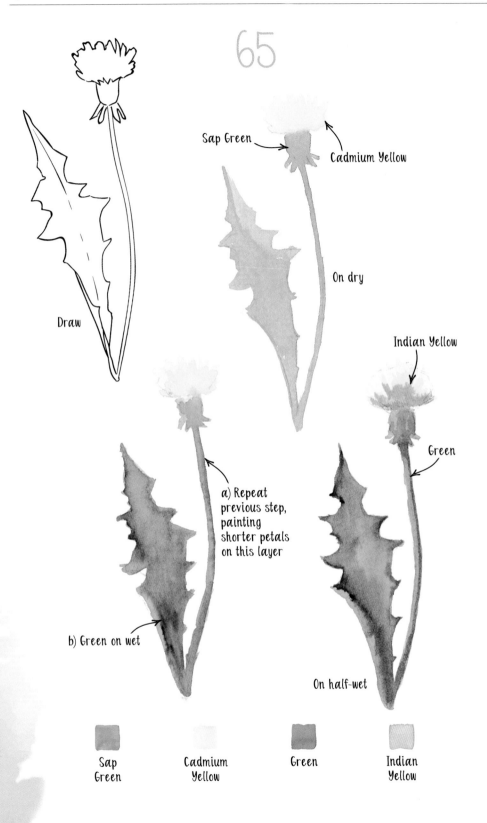

65

Draw

Sap Green

Cadmium Yellow

On dry

Indian Yellow

Green

a) Repeat previous step, painting shorter petals on this layer

b) Green on wet

On half-wet

Sap Green

Cadmium Yellow

Green

Indian Yellow

66

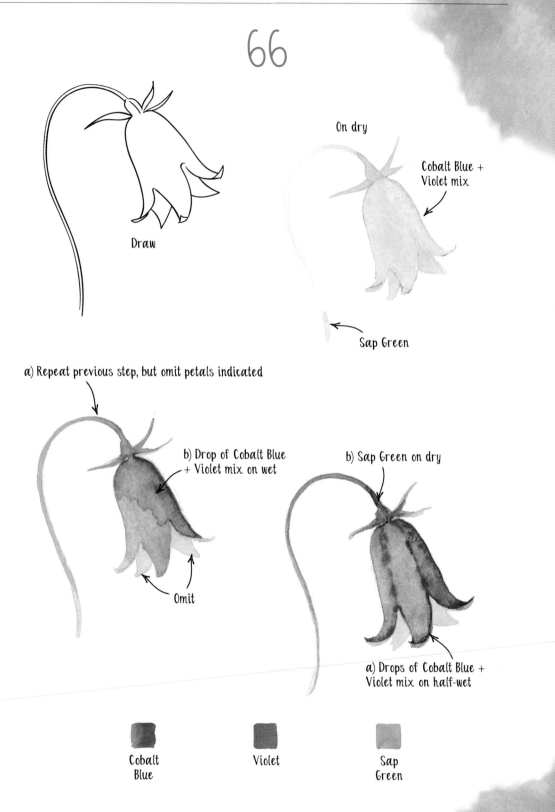

Draw

On dry

Cobalt Blue + Violet mix

Sap Green

a) Repeat previous step, but omit petals indicated

b) Drop of Cobalt Blue + Violet mix on wet

Omit

b) Sap Green on dry

a) Drops of Cobalt Blue + Violet mix on half-wet

Cobalt Blue

Violet

Sap Green

67

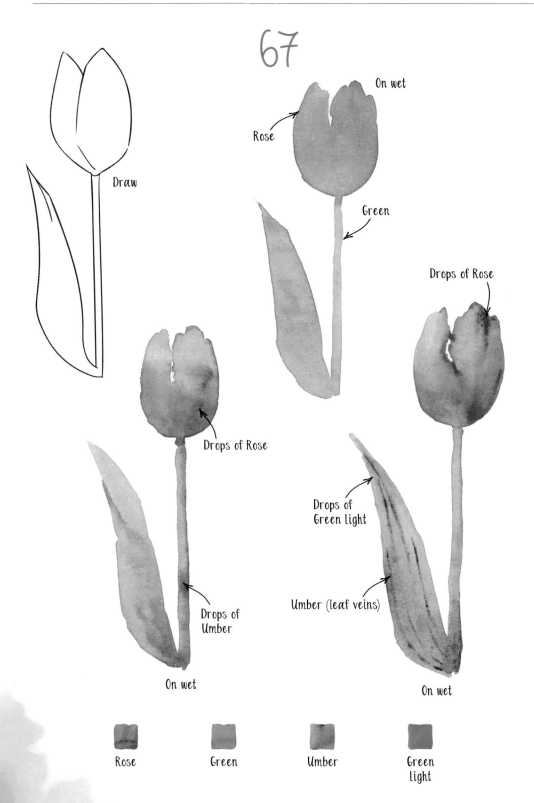

Draw

On wet

Rose

Green

Drops of Rose

Drops of Rose

Drops of
Green light

Umber (leaf veins)

Drops of
Umber

On wet

On wet

Rose Green Umber Green
 light

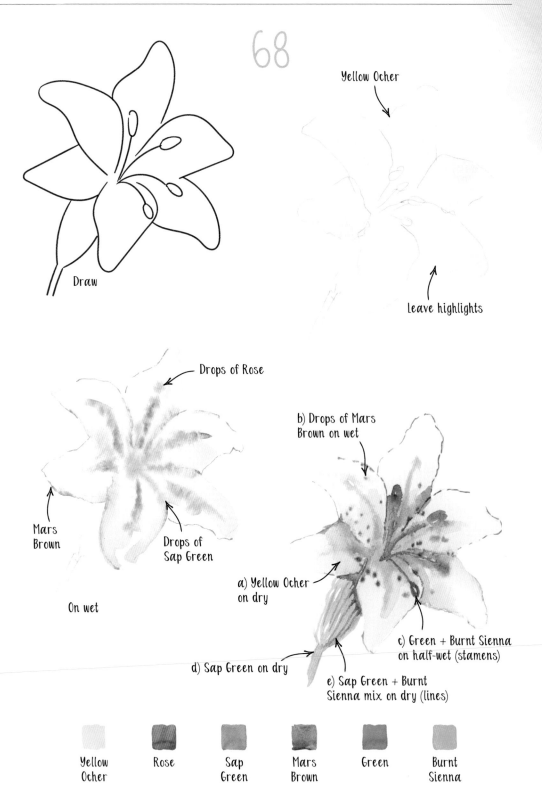

68

Draw

Yellow Ocher

leave highlights

Drops of Rose

b) Drops of Mars
Brown on wet

Mars
Brown

Drops of
Sap Green

On wet

a) Yellow Ocher
on dry

c) Green + Burnt Sienna
on half-wet (stamens)

d) Sap Green on dry

e) Sap Green + Burnt
Sienna mix on dry (lines)

| Yellow Ocher | Rose | Sap Green | Mars Brown | Green | Burnt Sienna |

69

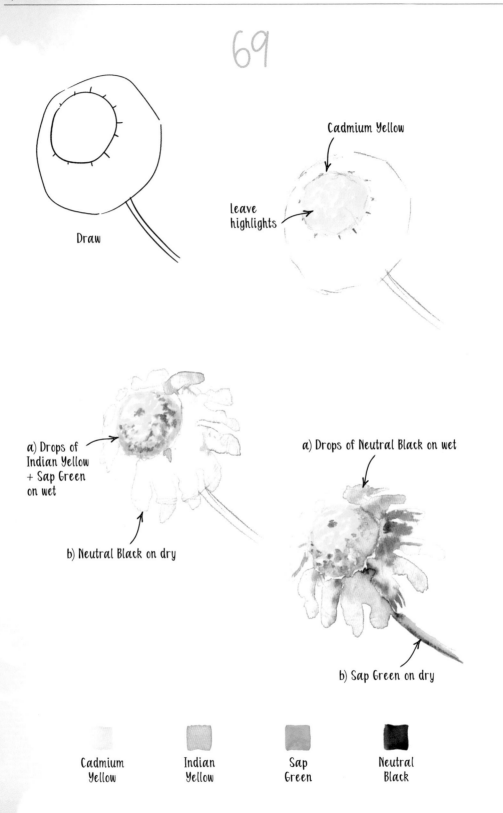

Draw

Cadmium Yellow

leave
highlights

a) Drops of
Indian Yellow
+ Sap Green
on wet

b) Neutral Black on dry

a) Drops of Neutral Black on wet

b) Sap Green on dry

Cadmium
Yellow

Indian
Yellow

Sap
Green

Neutral
Black

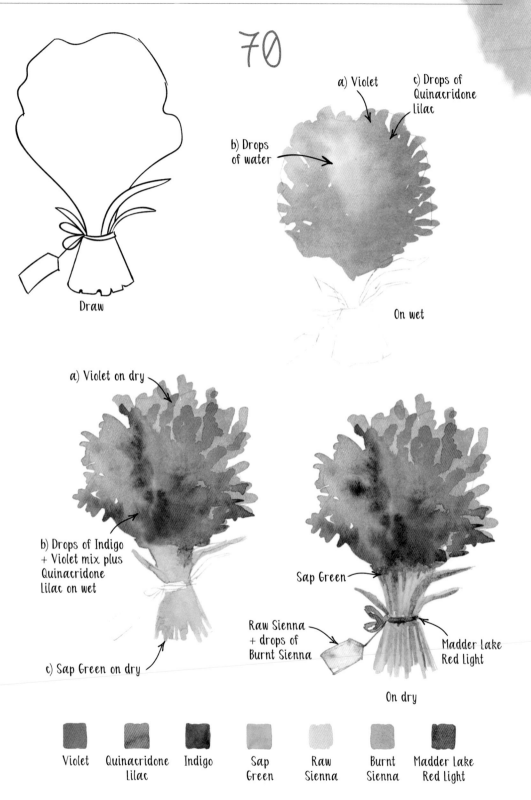

70

Draw

a) Violet

c) Drops of
Quinacridone
lilac

b) Drops
of water

On wet

a) Violet on dry

b) Drops of Indigo
+ Violet mix plus
Quinacridone
lilac on wet

c) Sap Green on dry

Sap Green

Raw Sienna
+ drops of
Burnt Sienna

Madder lake
Red light

On dry

| Violet | Quinacridone lilac | Indigo | Sap Green | Raw Sienna | Burnt Sienna | Madder lake Red light |

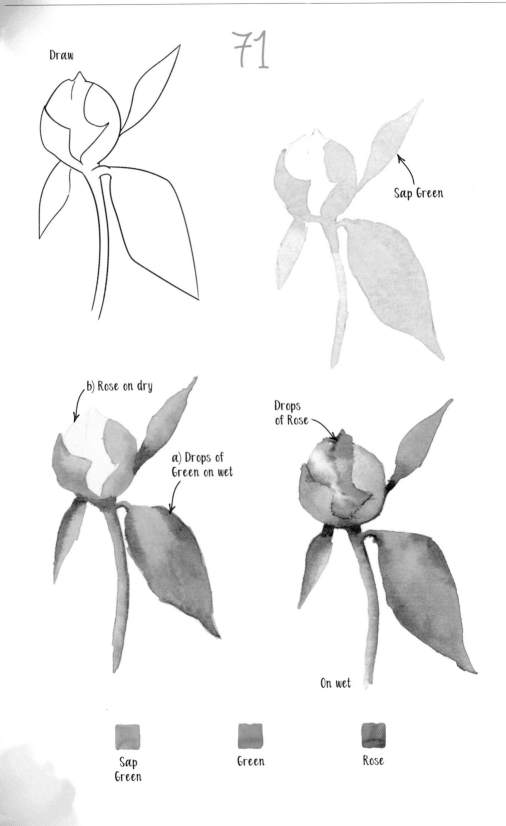

71

Draw

Sap Green

b) Rose on dry

a) Drops of
Green on wet

Drops
of Rose

On wet

Sap
Green

Green

Rose

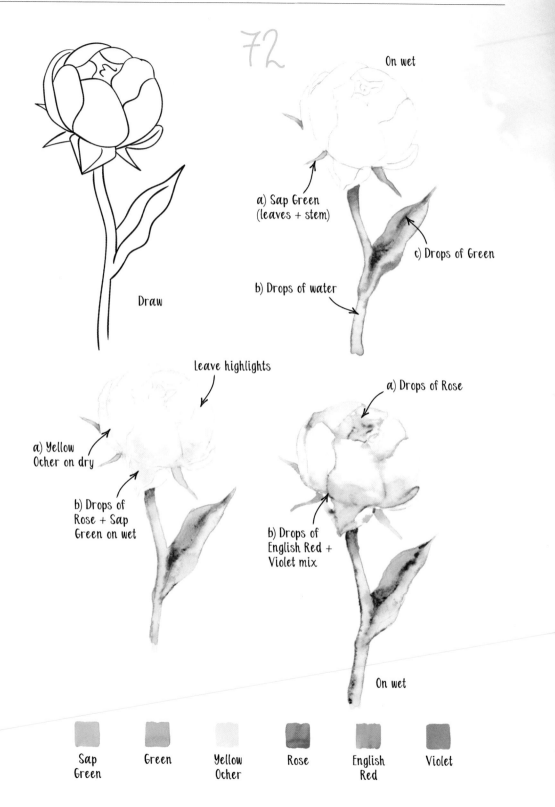

72

Draw

On wet

a) Sap Green
(leaves + stem)

c) Drops of Green

b) Drops of water

Leave highlights

a) Drops of Rose

a) Yellow
Ocher on dry

b) Drops of
Rose + Sap
Green on wet

b) Drops of
English Red +
Violet mix

On wet

| Sap Green | Green | Yellow Ocher | Rose | English Red | Violet |

73

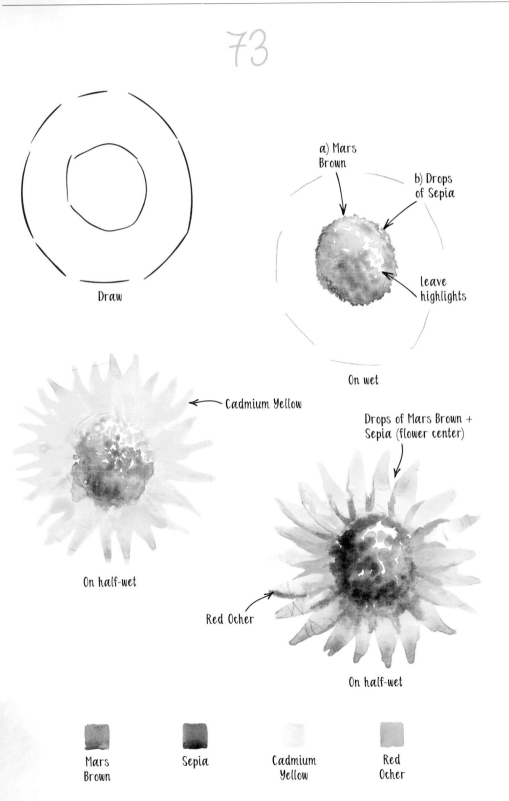

Draw

a) Mars Brown

b) Drops of Sepia

Leave highlights

On wet

Cadmium Yellow

On half-wet

Drops of Mars Brown + Sepia (flower center)

Red Ocher

On half-wet

Mars Brown

Sepia

Cadmium Yellow

Red Ocher

74

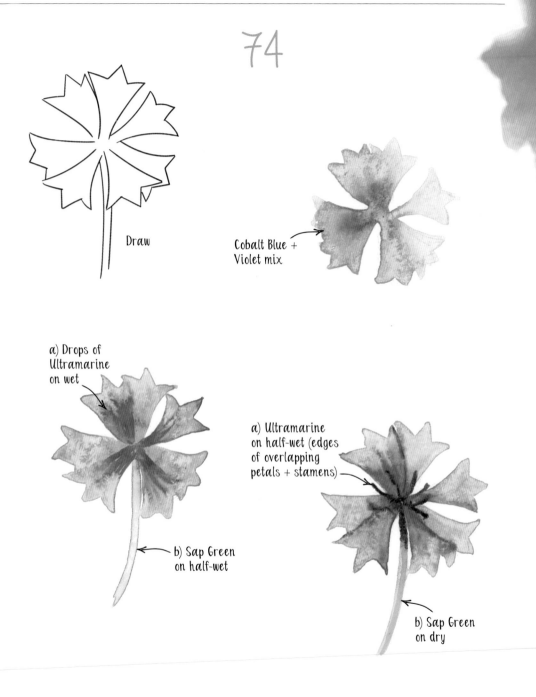

Draw

Cobalt Blue +
Violet mix

a) Drops of
Ultramarine
on wet

a) Ultramarine
on half-wet (edges
of overlapping
petals + stamens)

b) Sap Green
on half-wet

b) Sap Green
on dry

Cobalt
Blue

Violet

Ultramarine

Sap
Green

75

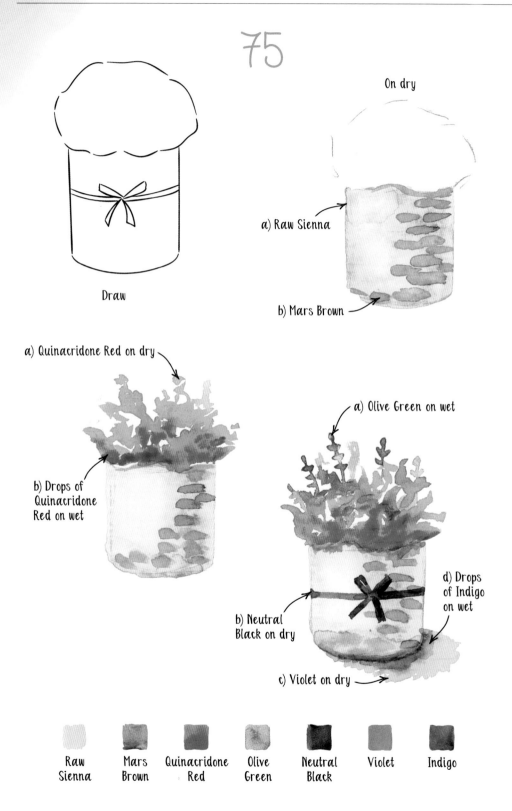

Draw

On dry

a) Raw Sienna

b) Mars Brown

a) Quinacridone Red on dry

b) Drops of Quinacridone Red on wet

a) Olive Green on wet

b) Neutral Black on dry

c) Violet on dry

d) Drops of Indigo on wet

Raw Sienna

Mars Brown

Quinacridone Red

Olive Green

Neutral Black

Violet

Indigo

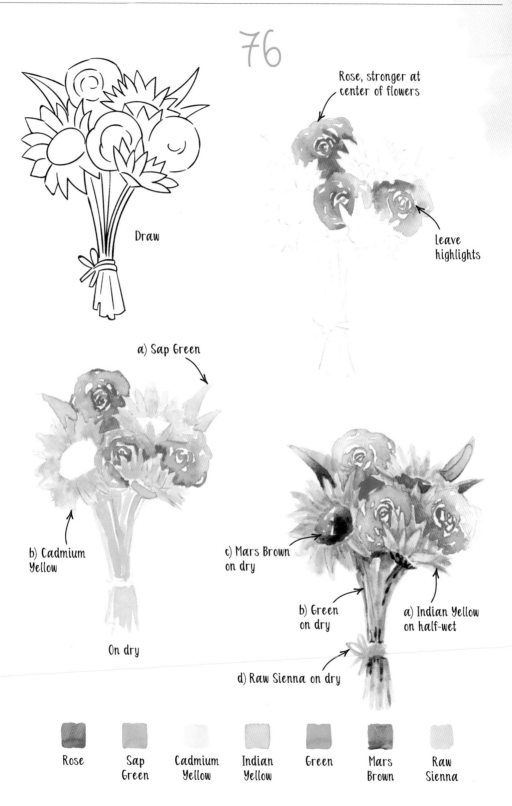

76

Draw

Rose, stronger at
center of flowers

leave
highlights

a) Sap Green

b) Cadmium
Yellow

On dry

c) Mars Brown
on dry

b) Green
on dry

a) Indian Yellow
on half-wet

d) Raw Sienna on dry

Rose

Sap
Green

Cadmium
Yellow

Indian
Yellow

Green

Mars
Brown

Raw
Sienna

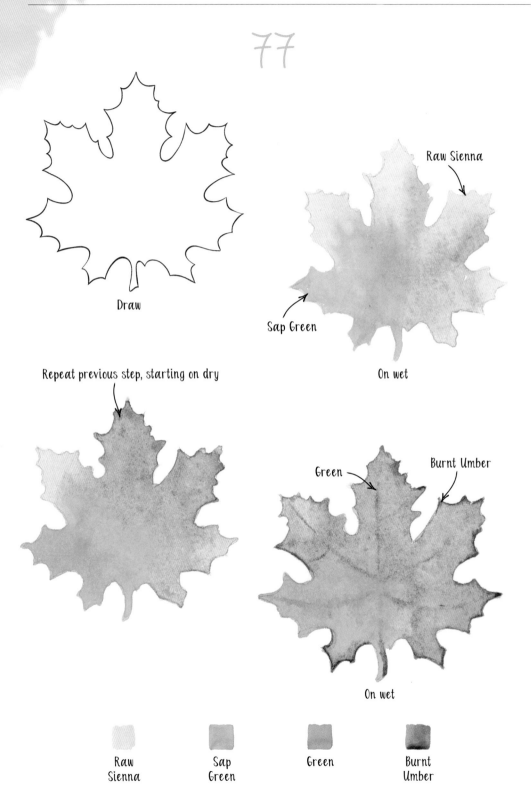

77

Draw

Raw Sienna

Sap Green

On wet

Repeat previous step, starting on dry

Green Burnt Umber

On wet

Raw Sap Green Burnt
Sienna Green Umber

78

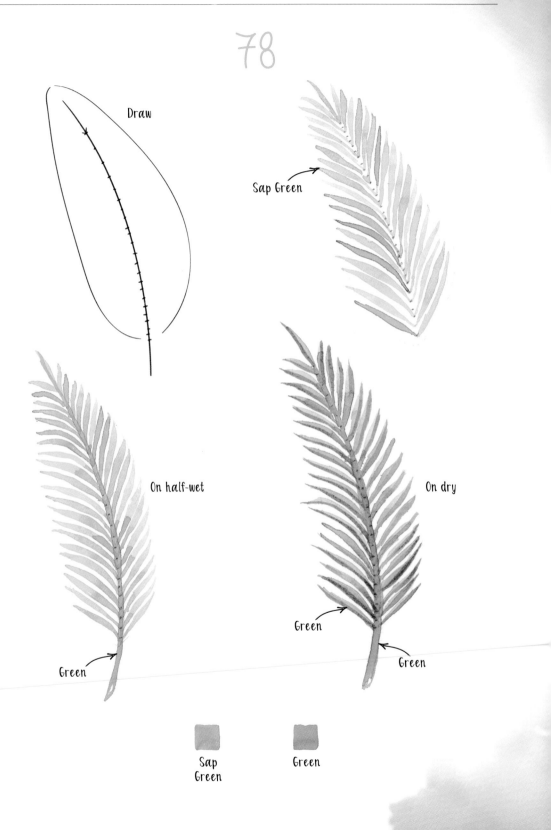

Draw

Sap Green

On half-wet

On dry

Green

Green

Green

Sap
Green

Green

79

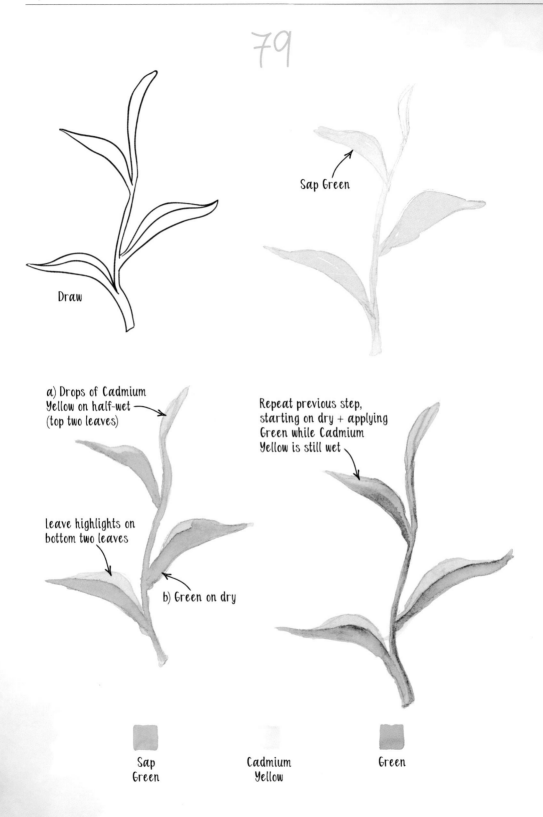

Draw

Sap Green

a) Drops of Cadmium
Yellow on half-wet
(top two leaves)

leave highlights on
bottom two leaves

b) Green on dry

Repeat previous step,
starting on dry + applying
Green while Cadmium
Yellow is still wet

Sap
Green

Cadmium
Yellow

Green

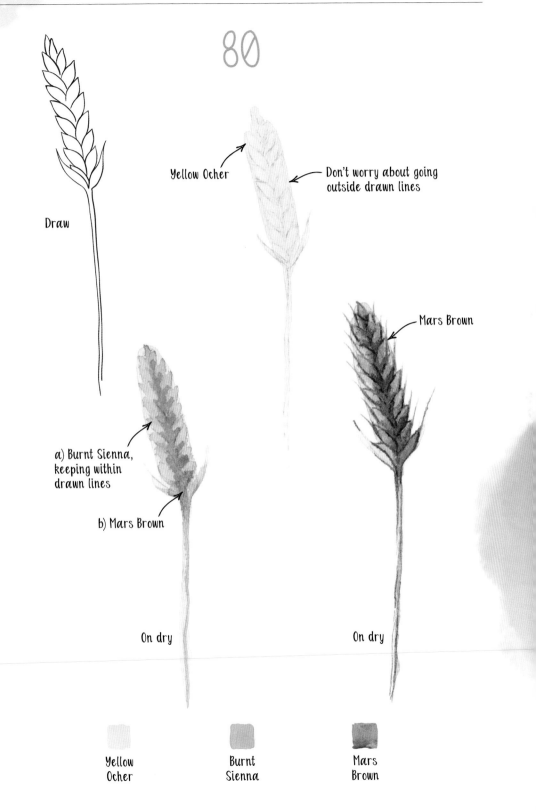

80

Draw

Yellow Ocher

Don't worry about going
outside drawn lines

Mars Brown

a) Burnt Sienna,
keeping within
drawn lines

b) Mars Brown

On dry

On dry

Yellow
Ocher

Burnt
Sienna

Mars
Brown

81

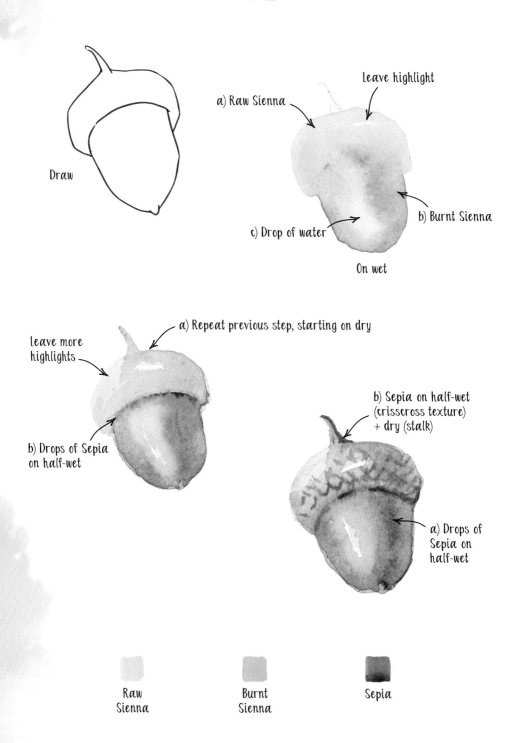

Draw

Leave highlight

a) Raw Sienna

b) Burnt Sienna

c) Drop of water

On wet

a) Repeat previous step, starting on dry

leave more
highlights

b) Drops of Sepia
on half-wet

b) Sepia on half-wet
(crisscross texture)
+ dry (stalk)

a) Drops of
Sepia on
half-wet

Raw
Sienna

Burnt
Sienna

Sepia

82

Draw

b) Drops of Yellow
Ocher on wet

c) Two layers of Yellow
Ocher on dry, leaving
highlights on second layer

a) Sap Green

b) Paint texture of shell using wet paint
from second layer of Yellow Ocher

a) Drops of
Burnt Sienna

On wet

Burnt
Sienna

Burnt Sienna

On dry

Sap
Green

Yellow
Ocher

Burnt
Sienna

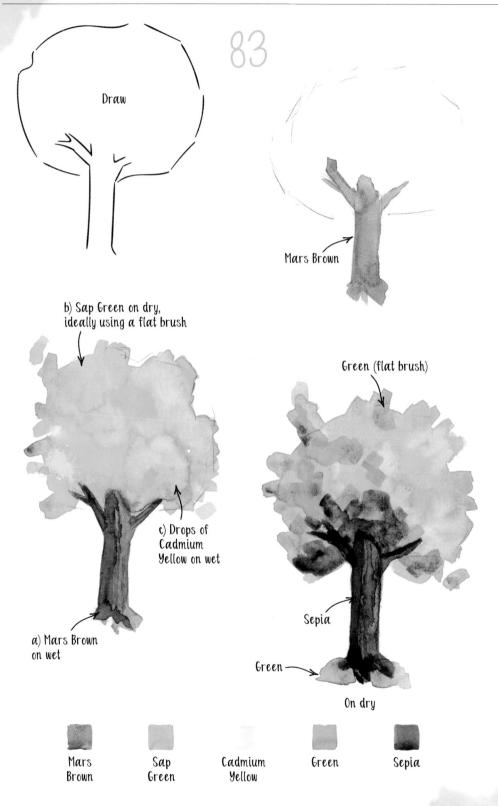

Draw

83

Mars Brown

b) Sap Green on dry,
ideally using a flat brush

Green (flat brush)

c) Drops of
Cadmium
Yellow on wet

Sepia

a) Mars Brown
on wet

Green

On dry

| Mars Brown | Sap Green | Cadmium Yellow | Green | Sepia |

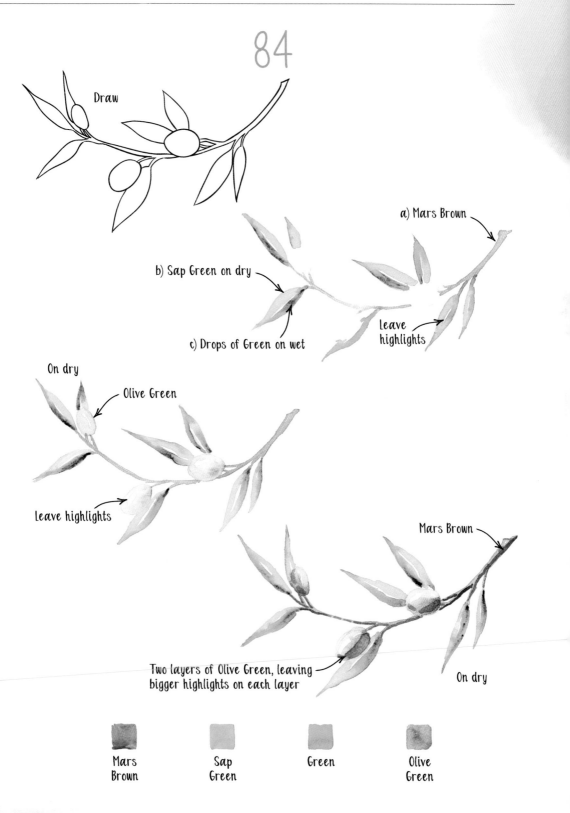

84

Draw

a) Mars Brown

b) Sap Green on dry

c) Drops of Green on wet

leave highlights

On dry

Olive Green

leave highlights

Mars Brown

Two layers of Olive Green, leaving bigger highlights on each layer

On dry

Mars Brown

Sap Green

Green

Olive Green

85

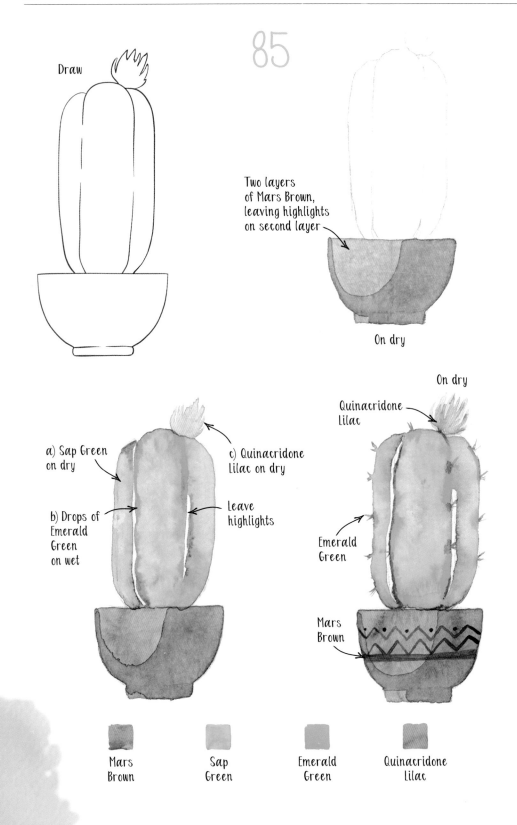

Draw

Two layers
of Mars Brown,
leaving highlights
on second layer

On dry

a) Sap Green
on dry

c) Quinacridone
Lilac on dry

b) Drops of
Emerald
Green
on wet

leave
highlights

On dry

Quinacridone
Lilac

Emerald
Green

Mars
Brown

Mars
Brown

Sap
Green

Emerald
Green

Quinacridone
Lilac

86

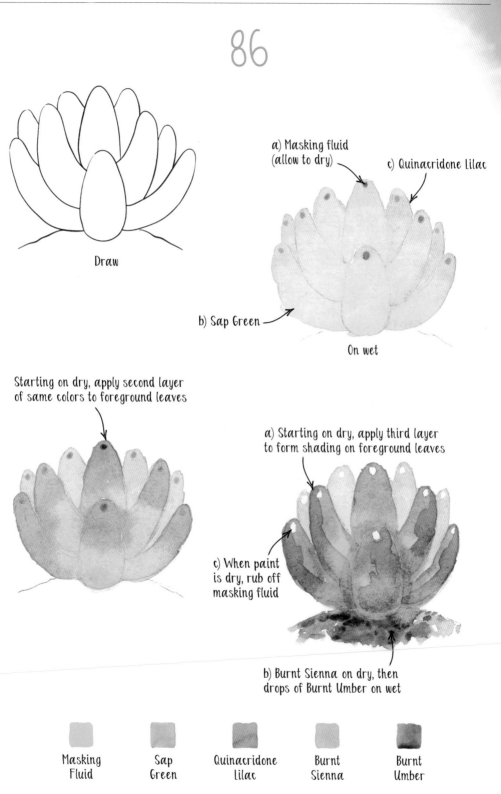

Draw

a) Masking fluid
(allow to dry)

c) Quinacridone Lilac

b) Sap Green

On wet

Starting on dry, apply second layer
of same colors to foreground leaves

a) Starting on dry, apply third layer
to form shading on foreground leaves

c) When paint
is dry, rub off
masking fluid

b) Burnt Sienna on dry, then
drops of Burnt Umber on wet

Masking
Fluid

Sap
Green

Quinacridone
Lilac

Burnt
Sienna

Burnt
Umber

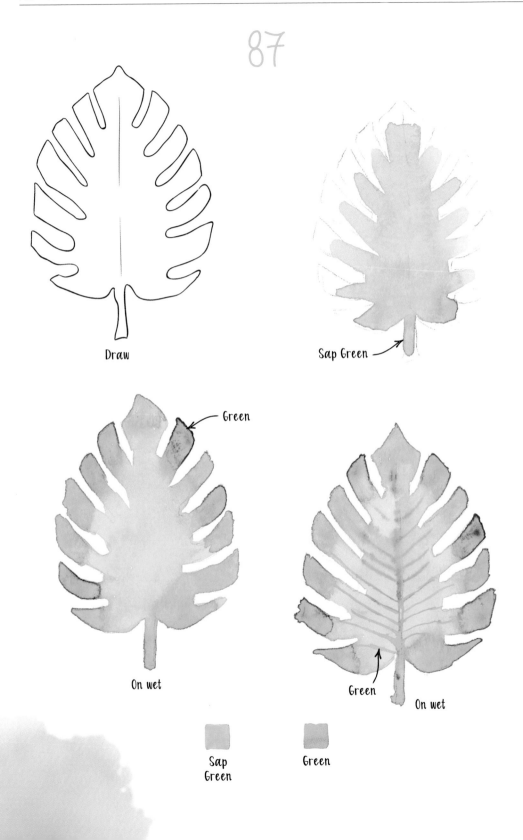

87

Draw

Sap Green

Green

On wet

Green

On wet

Sap
Green

Green

88

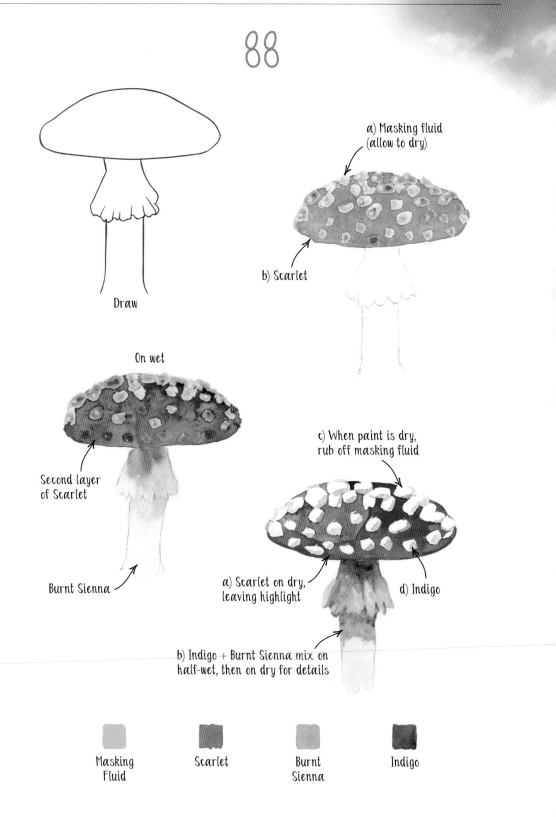

Draw

a) Masking fluid (allow to dry)

b) Scarlet

On wet

Second layer of Scarlet

Burnt Sienna

c) When paint is dry, rub off masking fluid

a) Scarlet on dry, leaving highlight

d) Indigo

b) Indigo + Burnt Sienna mix on half-wet, then on dry for details

Masking Fluid

Scarlet

Burnt Sienna

Indigo

89

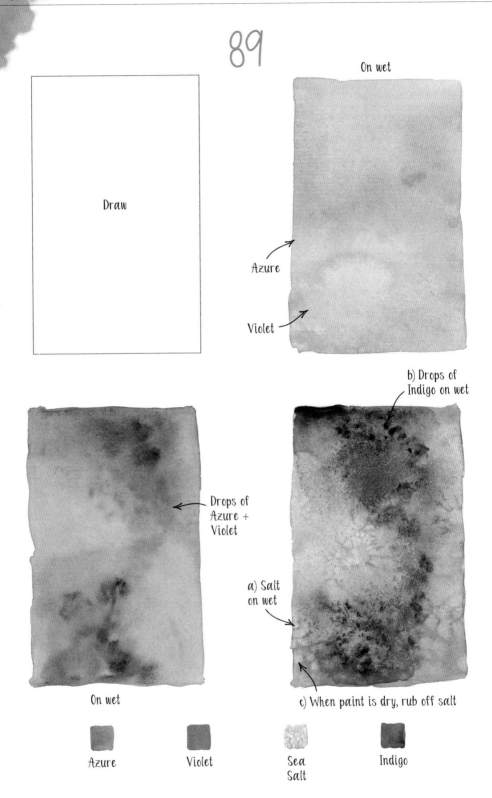

Draw

On wet

Azure

Violet

b) Drops of
Indigo on wet

Drops of
Azure +
Violet

a) Salt
on wet

On wet

c) When paint is dry, rub off salt

Azure Violet Sea
Salt Indigo

90

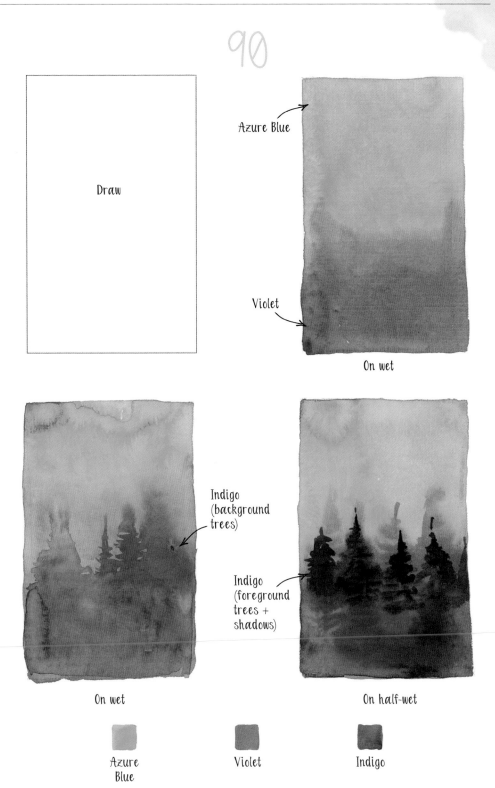

Draw

Azure Blue

Violet

On wet

Indigo
(background
trees)

Indigo
(foreground
trees +
shadows)

On wet

On half-wet

Azure
Blue

Violet

Indigo

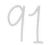

Draw

a) Azure Blue

On wet

leave highlights

b) Drops of Azure Blue

Drops of Neutral Black

On wet

Neutral Black (antennae, body + wing edges)

Azure Blue

On half-wet

Azure
Blue

Neutral
Black

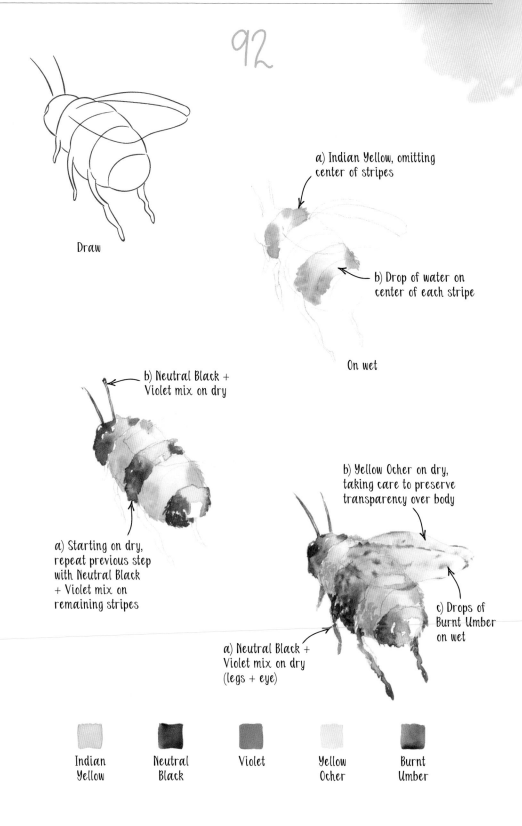

92

Draw

a) Indian Yellow, omitting center of stripes

b) Drop of water on center of each stripe

On wet

b) Neutral Black + Violet mix on dry

a) Starting on dry, repeat previous step with Neutral Black + Violet mix on remaining stripes

b) Yellow Ocher on dry, taking care to preserve transparency over body

c) Drops of Burnt Umber on wet

a) Neutral Black + Violet mix on dry (legs + eye)

| Indian Yellow | Neutral Black | Violet | Yellow Ocher | Burnt Umber |

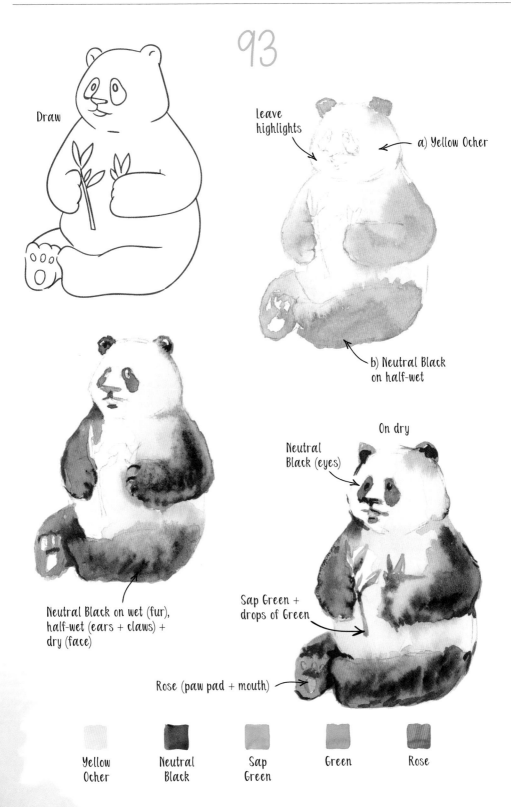

93

Draw

leave
highlights

a) Yellow Ocher

b) Neutral Black
on half-wet

On dry

Neutral
Black (eyes)

Sap Green +
drops of Green

Neutral Black on wet (fur),
half-wet (ears + claws) +
dry (face)

Rose (paw pad + mouth)

Yellow
Ocher

Neutral
Black

Sap
Green

Green

Rose

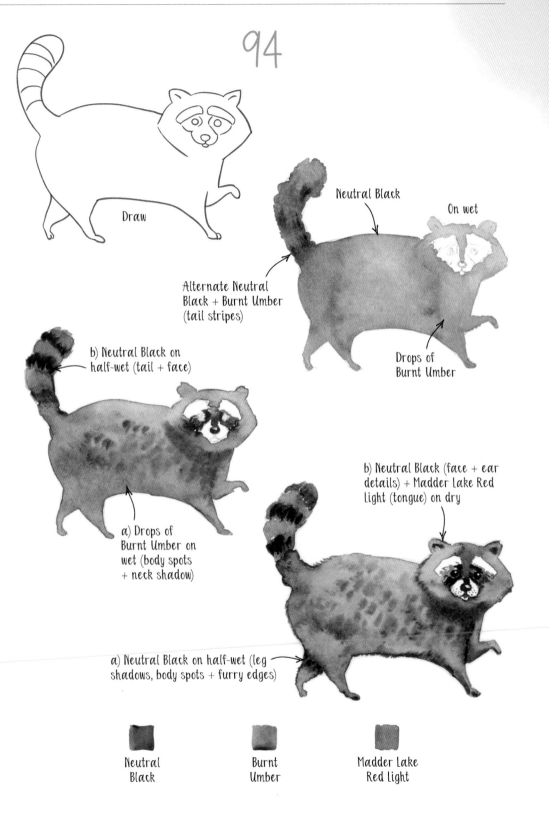

94

Draw

Neutral Black

On wet

Alternate Neutral
Black + Burnt Umber
(tail stripes)

Drops of
Burnt Umber

b) Neutral Black on
half-wet (tail + face)

b) Neutral Black (face + ear
details) + Madder Lake Red
light (tongue) on dry

a) Drops of
Burnt Umber on
wet (body spots
+ neck shadow)

a) Neutral Black on half-wet (leg
shadows, body spots + furry edges)

Neutral
Black

Burnt
Umber

Madder Lake
Red light

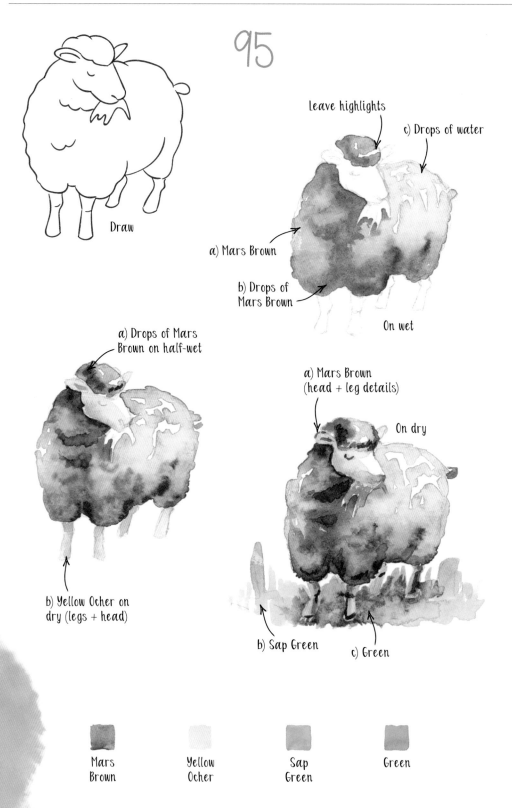

95

Draw

Leave highlights

c) Drops of water

a) Mars Brown

b) Drops of
Mars Brown

On wet

a) Drops of Mars
Brown on half-wet

a) Mars Brown
(head + leg details)

On dry

b) Yellow Ocher on
dry (legs + head)

b) Sap Green

c) Green

Mars
Brown

Yellow
Ocher

Sap
Green

Green

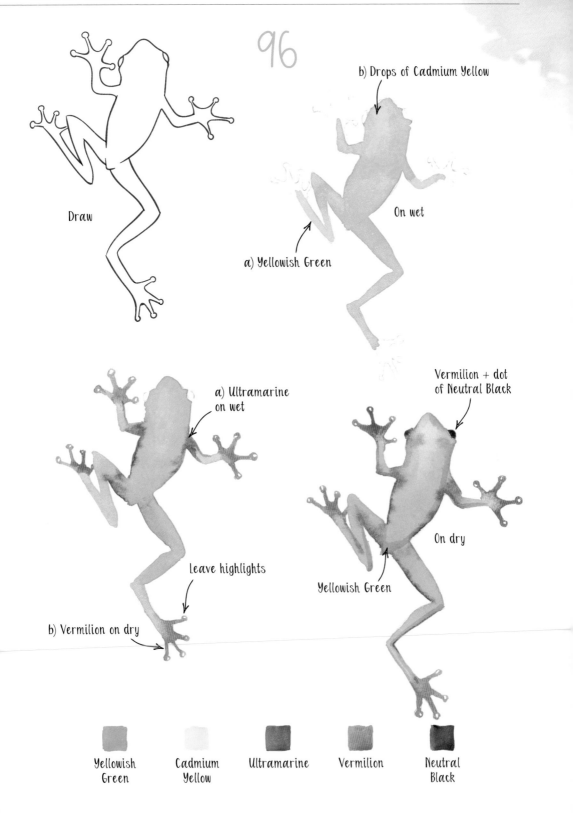

96

Draw

b) Drops of Cadmium Yellow

a) Yellowish Green

On wet

a) Ultramarine on wet

leave highlights

b) Vermilion on dry

Vermilion + dot of Neutral Black

Yellowish Green

On dry

Yellowish Green

Cadmium Yellow

Ultramarine

Vermilion

Neutral Black

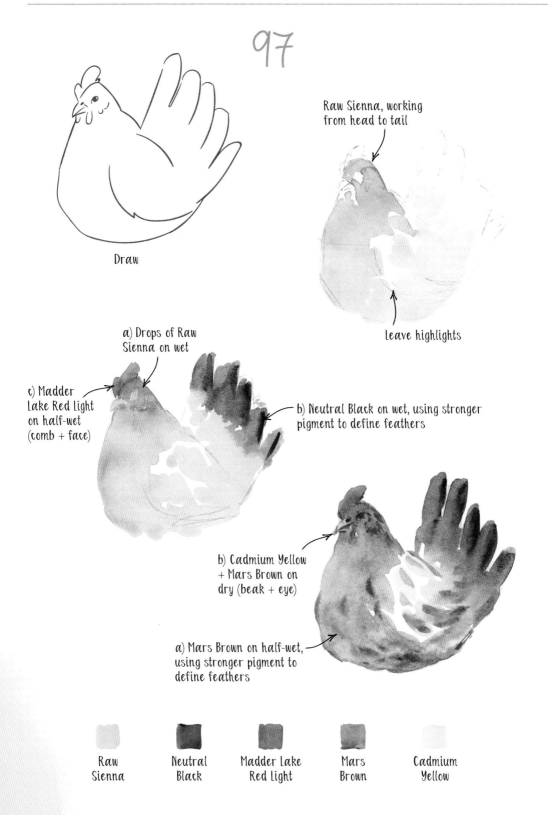

97

Draw

Raw Sienna, working
from head to tail

leave highlights

a) Drops of Raw
Sienna on wet

c) Madder
Lake Red light
on half-wet
(comb + face)

b) Neutral Black on wet, using stronger
pigment to define feathers

b) Cadmium Yellow
+ Mars Brown on
dry (beak + eye)

a) Mars Brown on half-wet,
using stronger pigment to
define feathers

Raw
Sienna

Neutral
Black

Madder Lake
Red light

Mars
Brown

Cadmium
Yellow

98

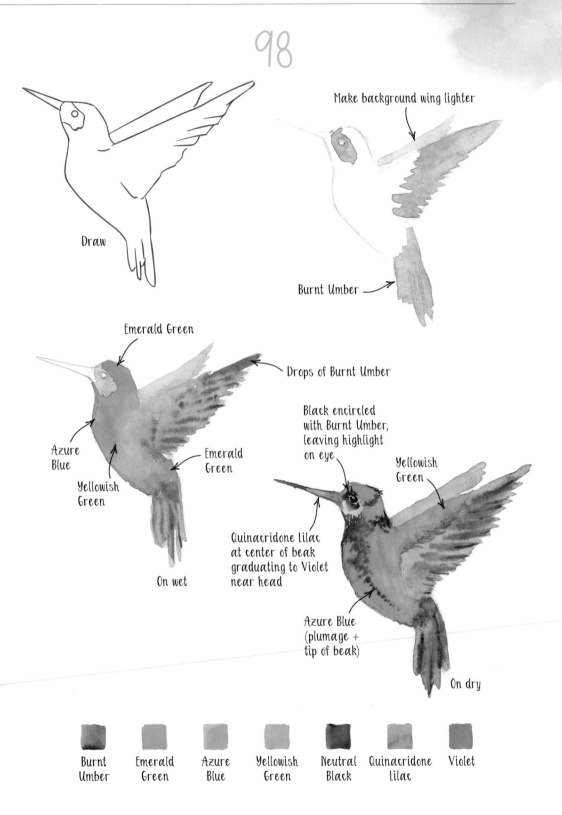

Draw

Make background wing lighter

Burnt Umber

Emerald Green

Drops of Burnt Umber

Azure
Blue

Yellowish
Green

Emerald
Green

On wet

Black encircled
with Burnt Umber,
leaving highlight
on eye

Yellowish
Green

Quinacridone lilac
at center of beak
graduating to Violet
near head

Azure Blue
(plumage +
tip of beak)

On dry

Burnt
Umber

Emerald
Green

Azure
Blue

Yellowish
Green

Neutral
Black

Quinacridone
Lilac

Violet

99

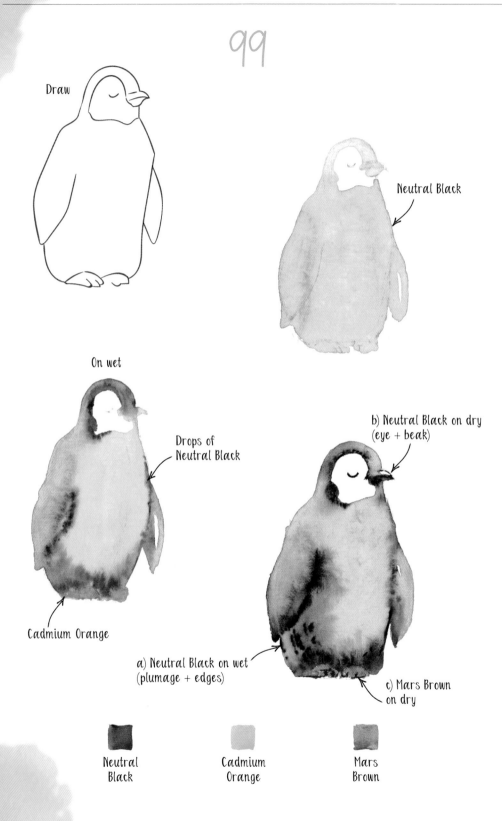

Draw

Neutral Black

On wet

Drops of
Neutral Black

Cadmium Orange

b) Neutral Black on dry
(eye + beak)

a) Neutral Black on wet
(plumage + edges)

c) Mars Brown
on dry

Neutral
Black

Cadmium
Orange

Mars
Brown

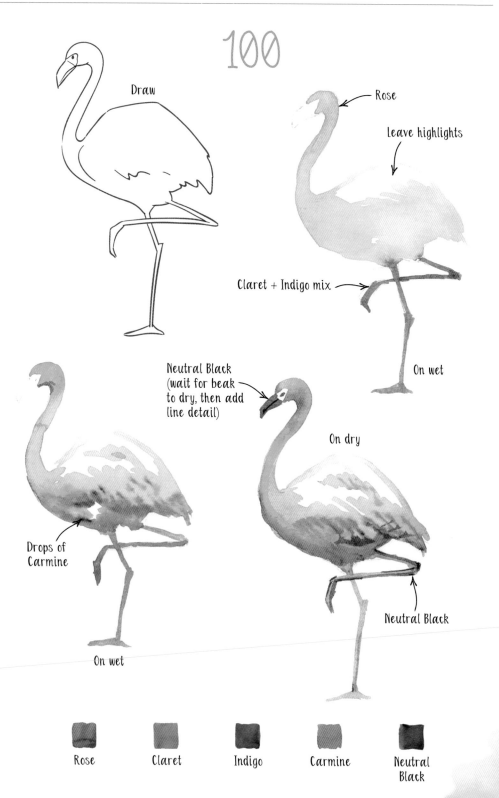

100

Draw

Rose

leave highlights

Claret + Indigo mix

On wet

Neutral Black
(wait for beak
to dry, then add
line detail)

On dry

Drops of
Carmine

Neutral Black

On wet

Rose Claret Indigo Carmine Neutral
 Black

101

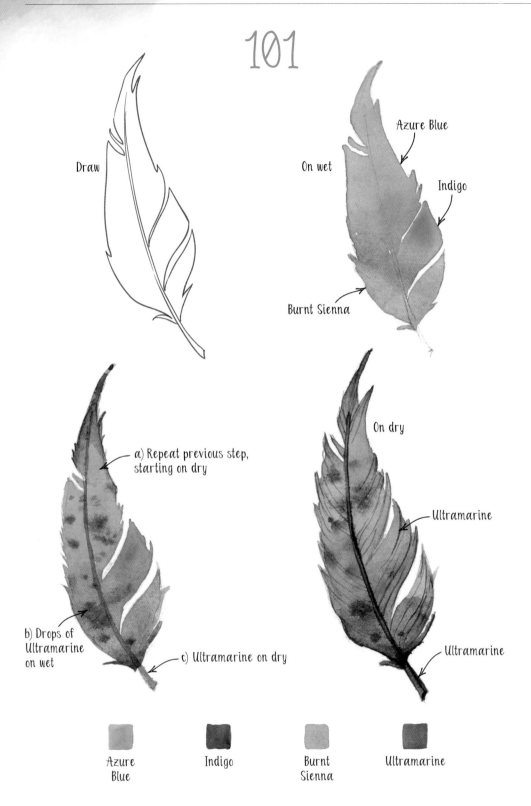

Draw

On wet

Azure Blue

Indigo

Burnt Sienna

a) Repeat previous step, starting on dry

On dry

Ultramarine

b) Drops of Ultramarine on wet

c) Ultramarine on dry

Ultramarine

Azure Blue

Indigo

Burnt Sienna

Ultramarine

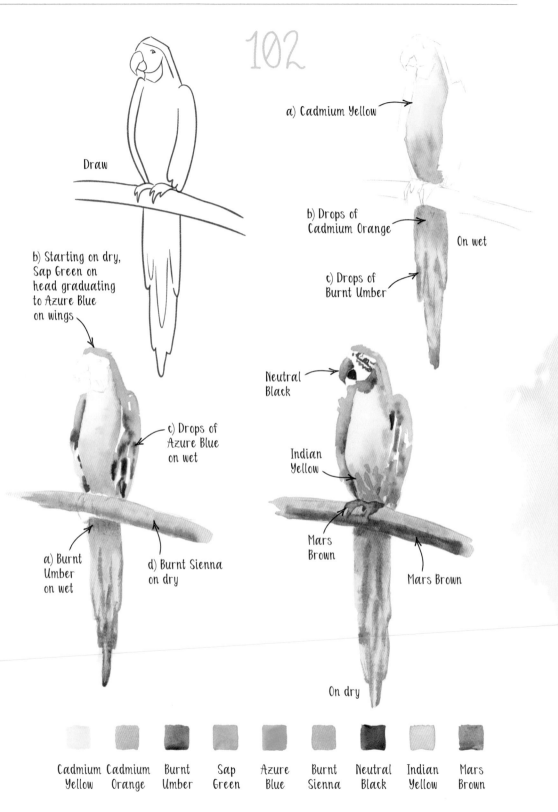

102

Draw

a) Cadmium Yellow

b) Drops of
Cadmium Orange

On wet

c) Drops of
Burnt Umber

b) Starting on dry,
Sap Green on
head graduating
to Azure Blue
on wings

Neutral
Black

c) Drops of
Azure Blue
on wet

Indian
Yellow

a) Burnt
Umber
on wet

d) Burnt Sienna
on dry

Mars
Brown

Mars Brown

On dry

Cadmium Cadmium Burnt Sap Azure Burnt Neutral Indian Mars
Yellow Orange Umber Green Blue Sienna Black Yellow Brown

103

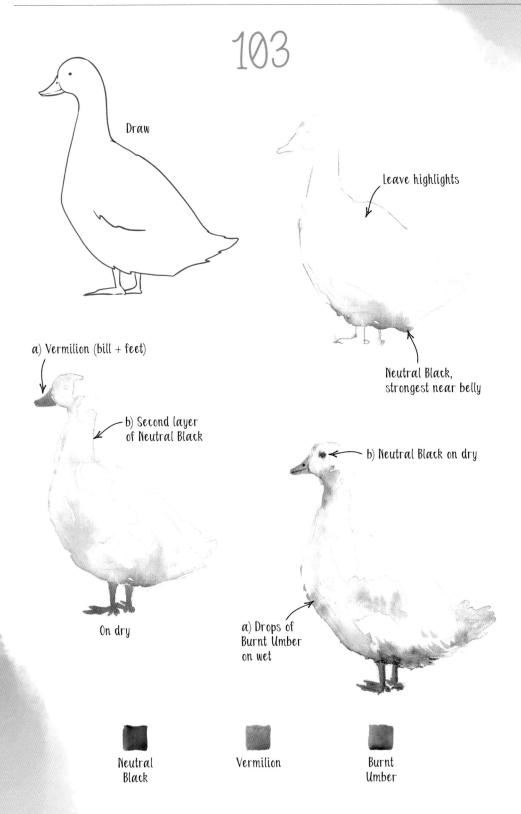

Draw

leave highlights

Neutral Black,
strongest near belly

a) Vermilion (bill + feet)

b) Second layer
of Neutral Black

On dry

b) Neutral Black on dry

a) Drops of
Burnt Umber
on wet

Neutral
Black

Vermilion

Burnt
Umber

104

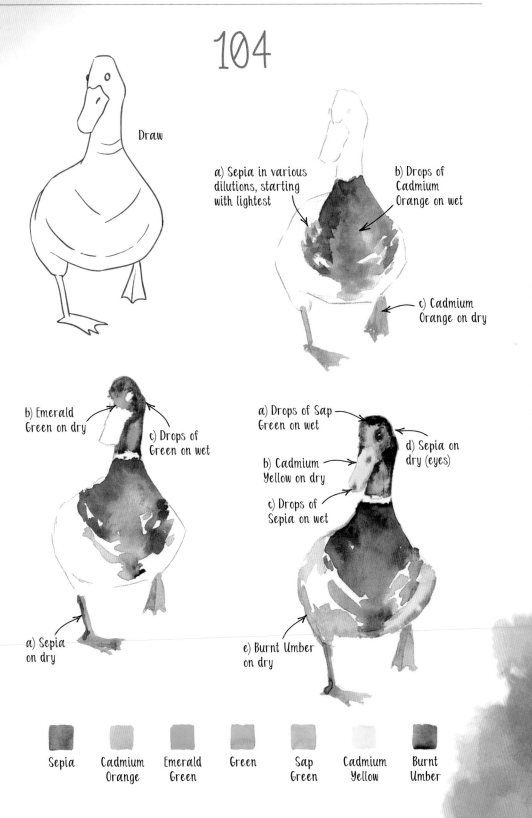

Draw

a) Sepia in various dilutions, starting with lightest

b) Drops of Cadmium Orange on wet

c) Cadmium Orange on dry

b) Emerald Green on dry

c) Drops of Green on wet

a) Sepia on dry

a) Drops of Sap Green on wet

d) Sepia on dry (eyes)

b) Cadmium Yellow on dry

c) Drops of Sepia on wet

e) Burnt Umber on dry

Sepia Cadmium Orange Emerald Green Green Sap Green Cadmium Yellow Burnt Umber

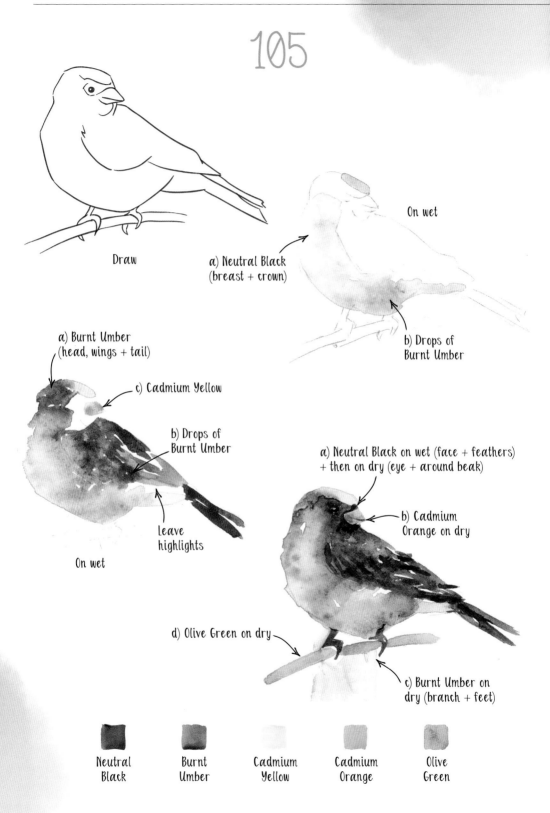

105

Draw

a) Neutral Black
(breast + crown)

On wet

b) Drops of
Burnt Umber

a) Burnt Umber
(head, wings + tail)

c) Cadmium Yellow

b) Drops of
Burnt Umber

a) Neutral Black on wet (face + feathers)
+ then on dry (eye + around beak)

b) Cadmium
Orange on dry

Leave
highlights

On wet

d) Olive Green on dry

c) Burnt Umber on
dry (branch + feet)

Neutral
Black

Burnt
Umber

Cadmium
Yellow

Cadmium
Orange

Olive
Green

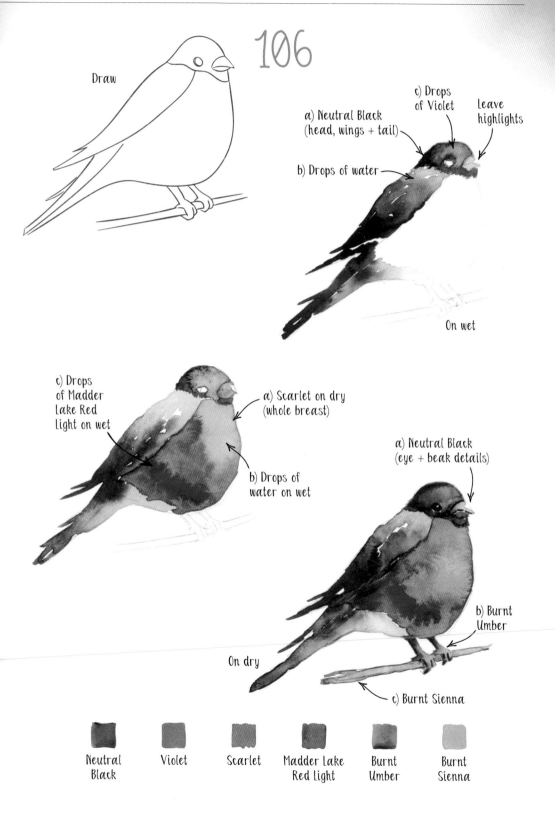

Draw

106

c) Drops of Violet

Leave highlights

a) Neutral Black (head, wings + tail)

b) Drops of water

On wet

c) Drops of Madder Lake Red light on wet

a) Scarlet on dry (whole breast)

b) Drops of water on wet

a) Neutral Black (eye + beak details)

b) Burnt Umber

On dry

c) Burnt Sienna

Neutral Black Violet Scarlet Madder Lake Red light Burnt Umber Burnt Sienna

107

Draw

a) Azure Blue

b) Drops
of Azure

On wet

Drops of Violet

On wet

Drops of Azure

Drops of Indigo

On wet

Azure
Blue

Azure

Violet

Indigo

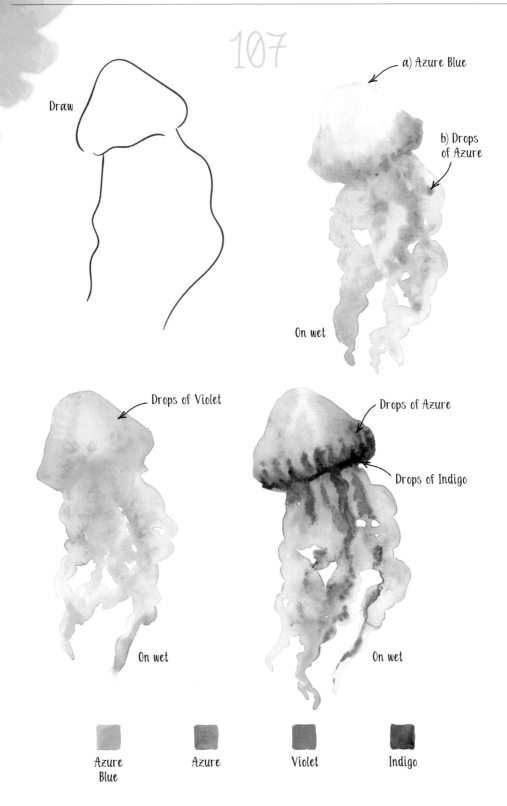

108

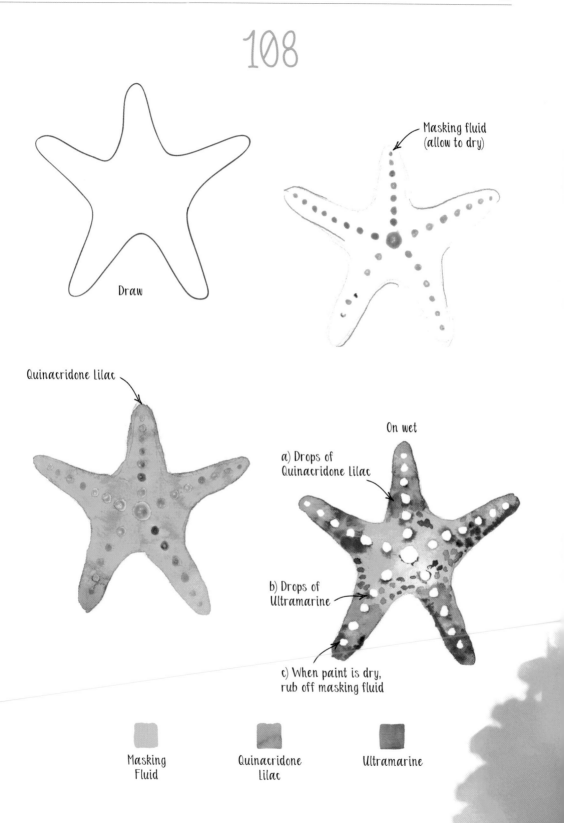

Draw

Masking fluid
(allow to dry)

Quinacridone Lilac

On wet

a) Drops of
Quinacridone Lilac

b) Drops of
Ultramarine

c) When paint is dry,
rub off masking fluid

Masking
Fluid

Quinacridone
Lilac

Ultramarine

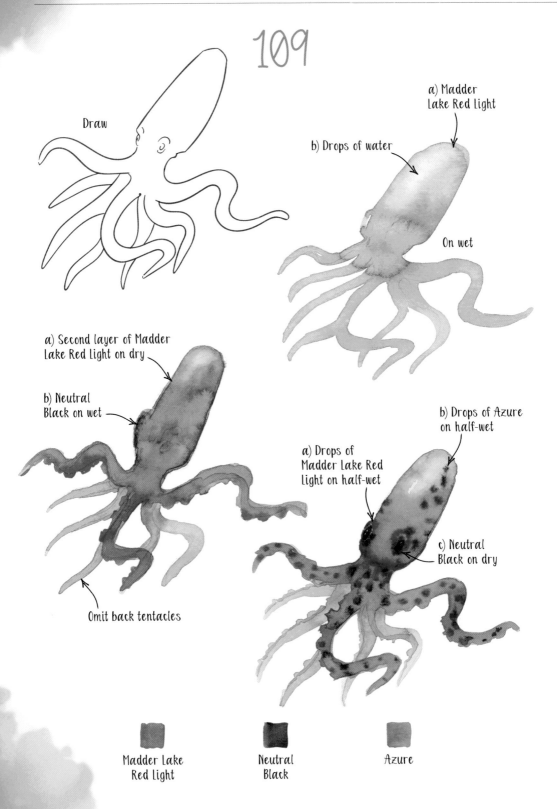

109

Draw

a) Madder
Lake Red Light

b) Drops of water

On wet

a) Second layer of Madder
Lake Red Light on dry

b) Neutral
Black on wet

b) Drops of Azure
on half-wet

a) Drops of
Madder Lake Red
Light on half-wet

c) Neutral
Black on dry

Omit back tentacles

Madder Lake
Red Light

Neutral
Black

Azure

110

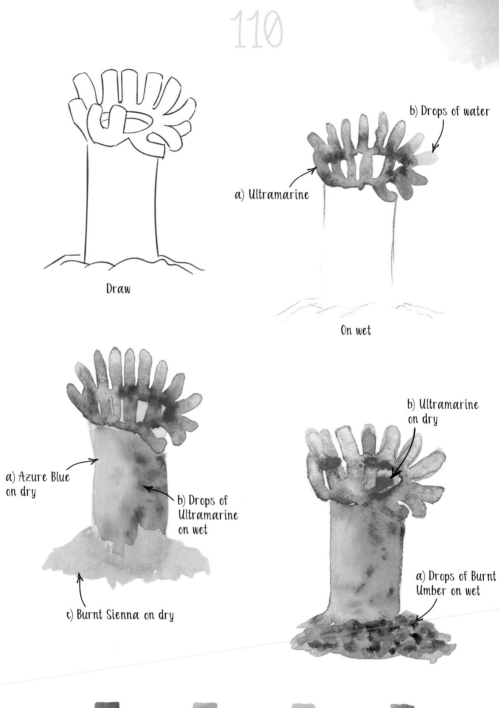

Draw

b) Drops of water

a) Ultramarine

On wet

a) Azure Blue
on dry

b) Drops of
Ultramarine
on wet

c) Burnt Sienna on dry

b) Ultramarine
on dry

a) Drops of Burnt
Umber on wet

Ultramarine

Azure
Blue

Burnt
Sienna

Burnt
Umber

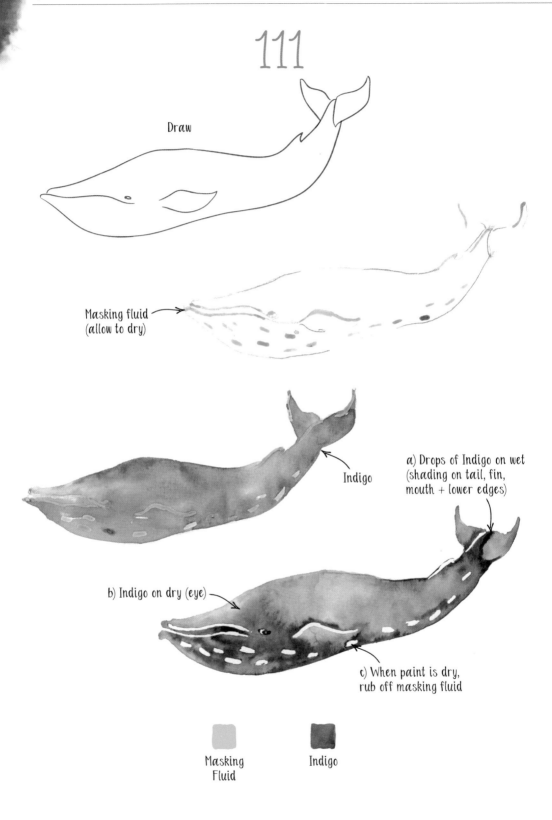

111

Draw

Masking fluid
(allow to dry)

Indigo

a) Drops of Indigo on wet
(shading on tail, fin,
mouth + lower edges)

b) Indigo on dry (eye)

c) When paint is dry,
rub off masking fluid

Masking
Fluid

Indigo

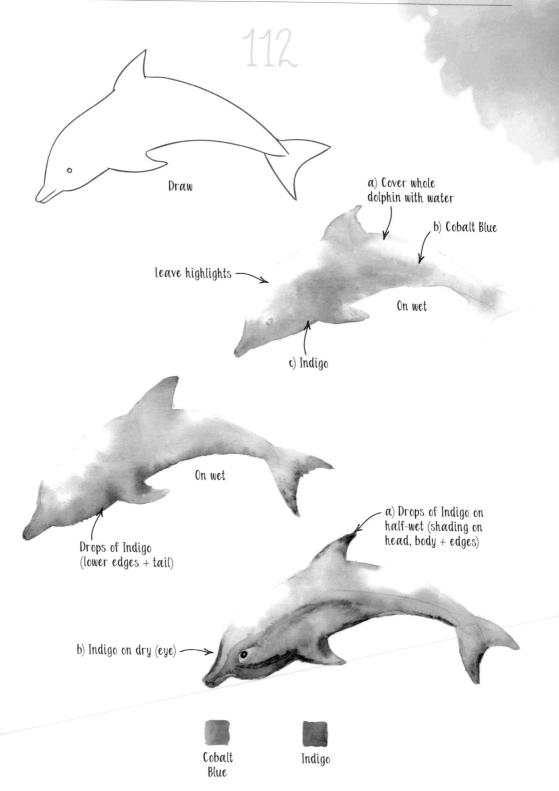

112

Draw

a) Cover whole
dolphin with water

b) Cobalt Blue

leave highlights

On wet

c) Indigo

On wet

a) Drops of Indigo on
half-wet (shading on
head, body + edges)

Drops of Indigo
(lower edges + tail)

b) Indigo on dry (eye)

Cobalt
Blue

Indigo

113

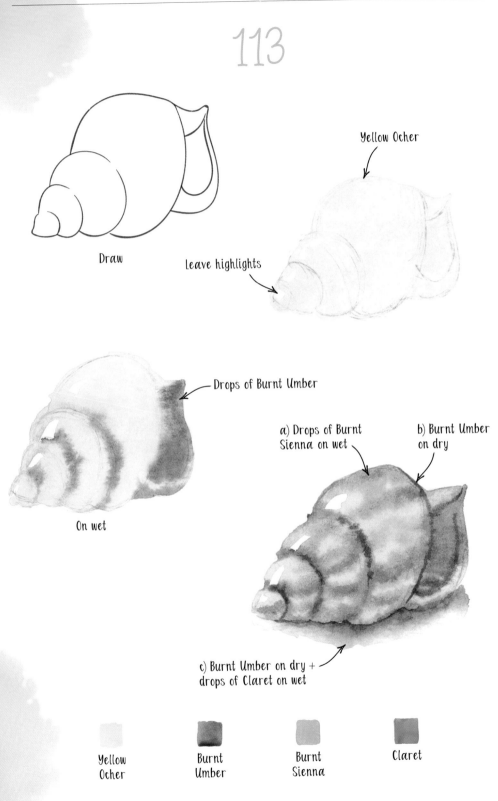

Draw

Yellow Ocher

leave highlights

On wet

Drops of Burnt Umber

a) Drops of Burnt
Sienna on wet

b) Burnt Umber
on dry

c) Burnt Umber on dry +
drops of Claret on wet

Yellow
Ocher

Burnt
Umber

Burnt
Sienna

Claret

114

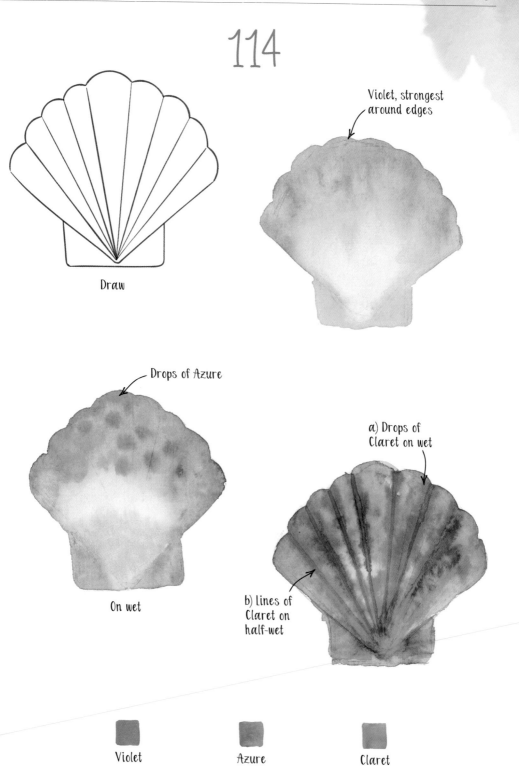

Draw

Violet, strongest around edges

Drops of Azure

On wet

a) Drops of Claret on wet

b) lines of Claret on half-wet

Violet Azure Claret

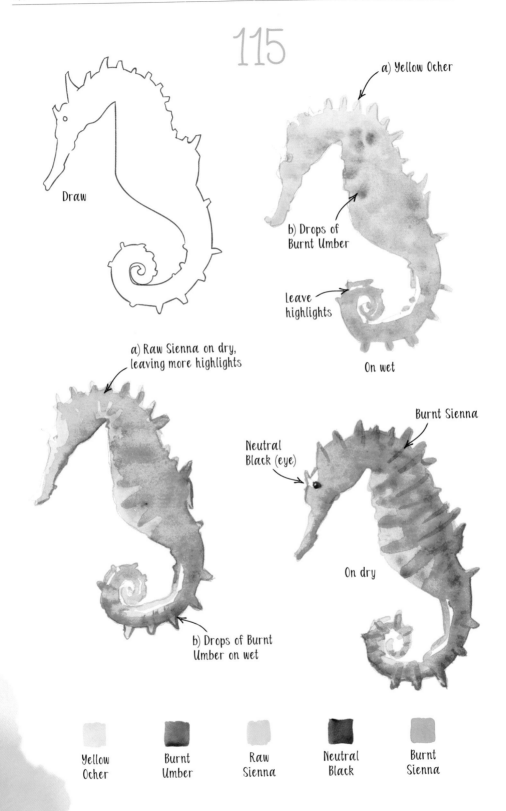

115

Draw

a) Yellow Ocher

b) Drops of
Burnt Umber

leave
highlights

On wet

a) Raw Sienna on dry,
leaving more highlights

b) Drops of Burnt
Umber on wet

Neutral
Black (eye)

Burnt Sienna

On dry

| Yellow Ocher | Burnt Umber | Raw Sienna | Neutral Black | Burnt Sienna |

116

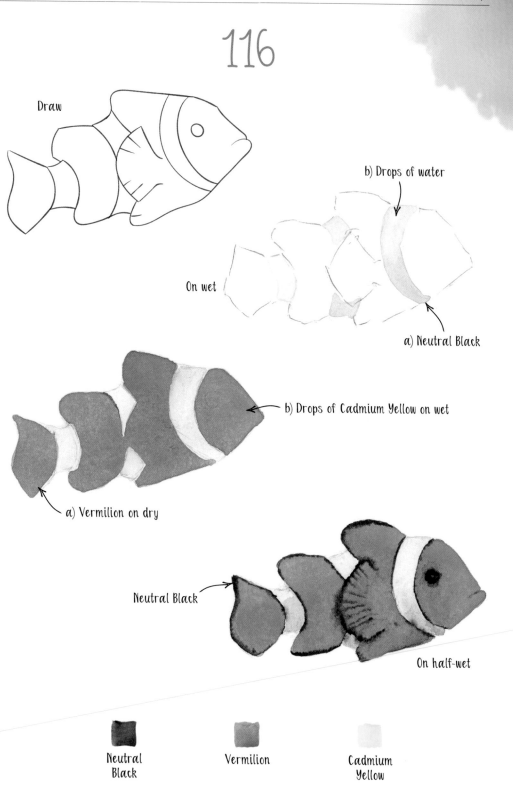

Draw

b) Drops of water

On wet

a) Neutral Black

b) Drops of Cadmium Yellow on wet

a) Vermilion on dry

Neutral Black

On half-wet

Neutral
Black

Vermilion

Cadmium
Yellow

117

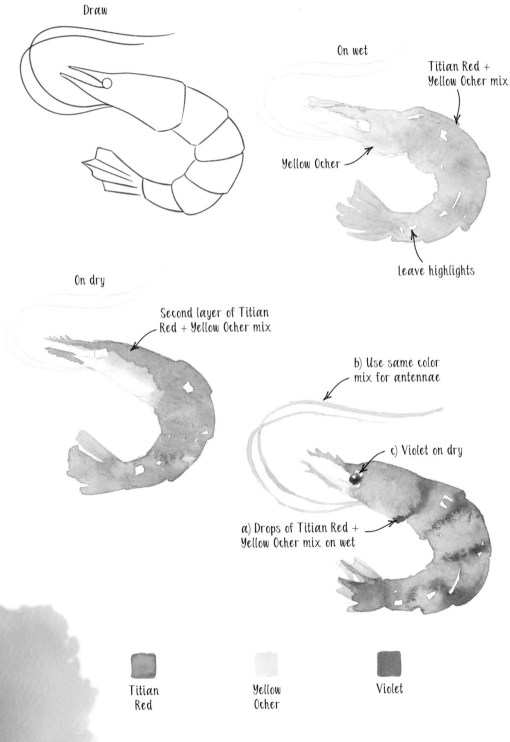

Draw

On wet

Titian Red +
Yellow Ocher mix

Yellow Ocher

leave highlights

On dry

Second layer of Titian
Red + Yellow Ocher mix

b) Use same color
mix for antennae

c) Violet on dry

a) Drops of Titian Red +
Yellow Ocher mix on wet

Titian
Red

Yellow
Ocher

Violet

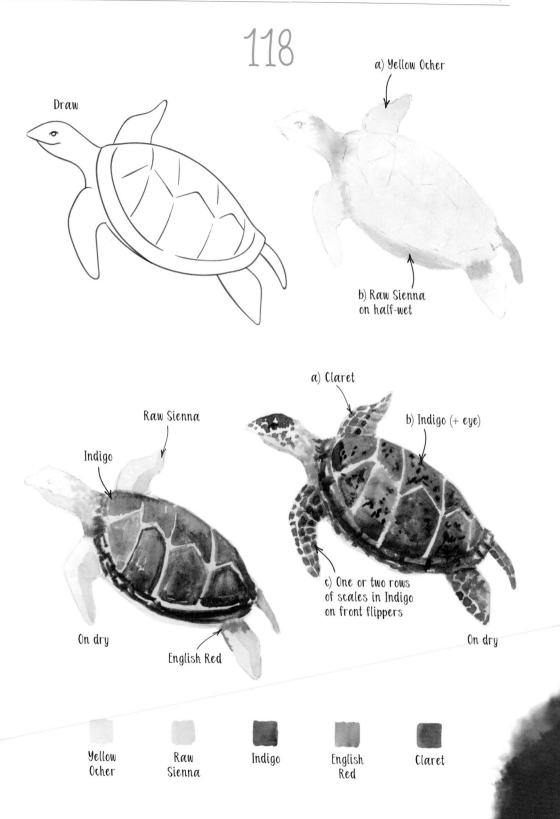

118

Draw

a) Yellow Ocher

b) Raw Sienna
on half-wet

a) Claret

Raw Sienna

Indigo

b) Indigo (+ eye)

c) One or two rows
of scales in Indigo
on front flippers

On dry

English Red

On dry

Yellow
Ocher

Raw
Sienna

Indigo

English
Red

Claret

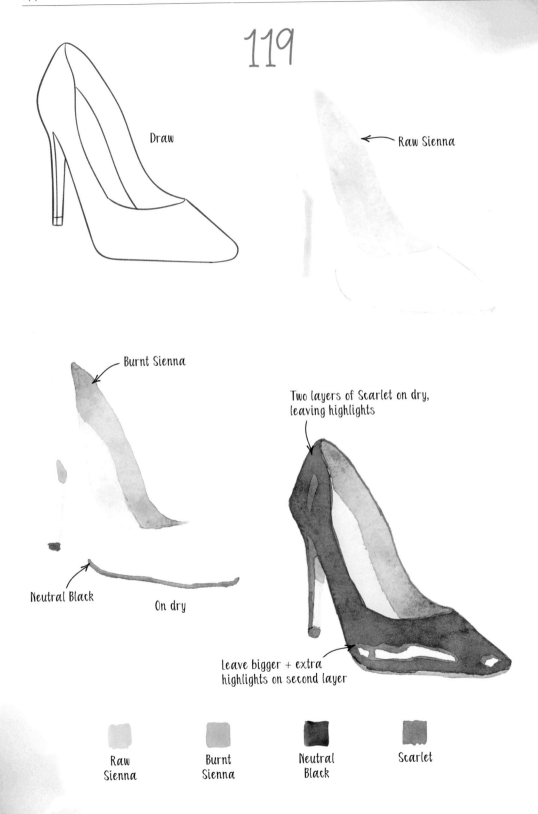

119

Draw

Raw Sienna

Burnt Sienna

Two layers of Scarlet on dry,
leaving highlights

Neutral Black

On dry

leave bigger + extra
highlights on second layer

Raw
Sienna

Burnt
Sienna

Neutral
Black

Scarlet

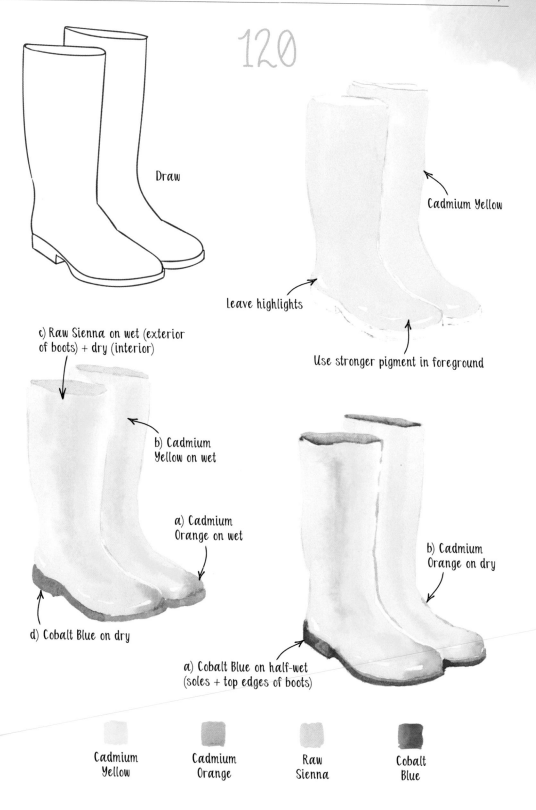

Draw

120

Cadmium Yellow

leave highlights

Use stronger pigment in foreground

c) Raw Sienna on wet (exterior of boots) + dry (interior)

b) Cadmium Yellow on wet

a) Cadmium Orange on wet

d) Cobalt Blue on dry

b) Cadmium Orange on dry

a) Cobalt Blue on half-wet (soles + top edges of boots)

Cadmium Yellow

Cadmium Orange

Raw Sienna

Cobalt Blue

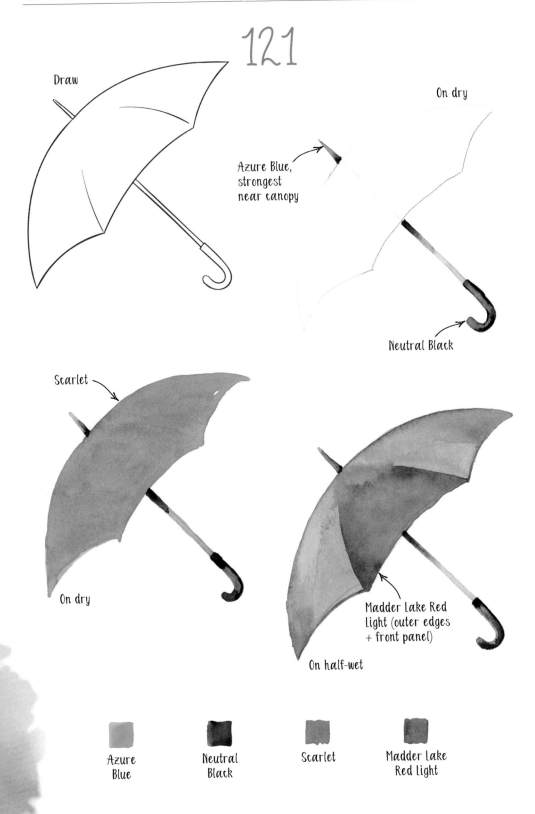

121

Draw

On dry

Azure Blue, strongest near canopy

Neutral Black

Scarlet

On dry

Madder Lake Red Light (outer edges + front panel)

On half-wet

Azure Blue

Neutral Black

Scarlet

Madder Lake Red Light

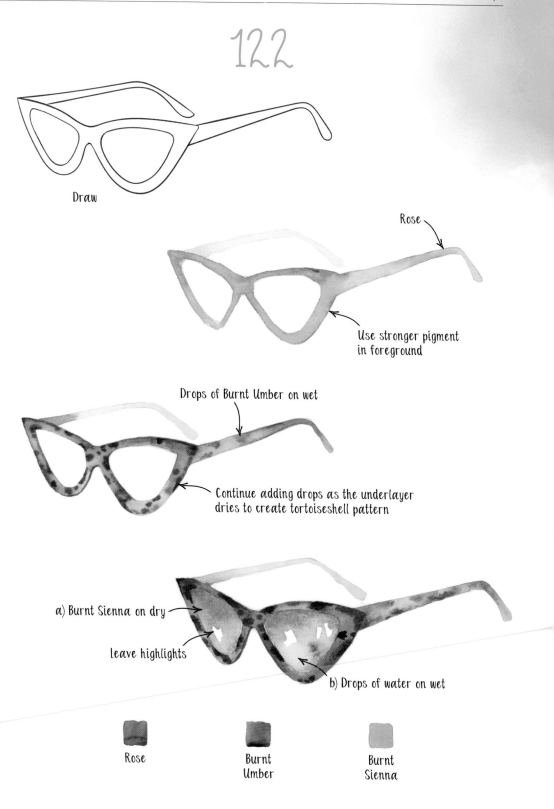

122

Draw

Rose

Use stronger pigment
in foreground

Drops of Burnt Umber on wet

Continue adding drops as the underlayer
dries to create tortoiseshell pattern

a) Burnt Sienna on dry

leave highlights

b) Drops of water on wet

Rose

Burnt
Umber

Burnt
Sienna

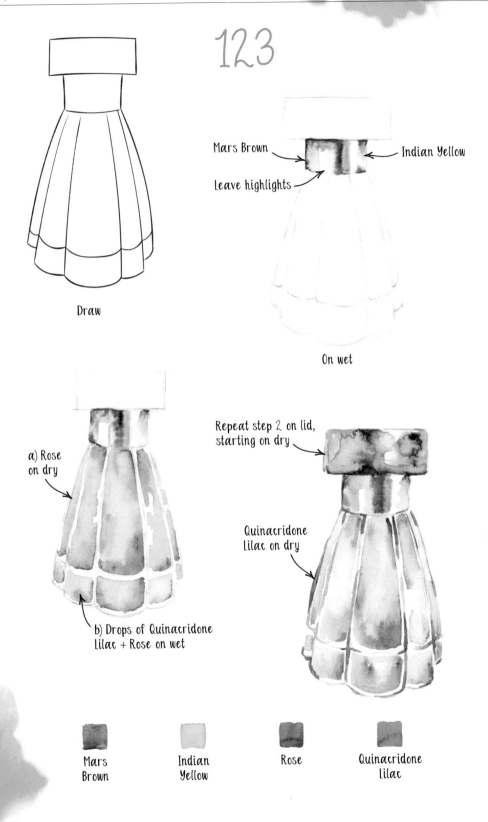

123

Draw

Mars Brown

Indian Yellow

leave highlights

On wet

a) Rose
on dry

b) Drops of Quinacridone
Lilac + Rose on wet

Repeat step 2 on lid,
starting on dry

Quinacridone
Lilac on dry

Mars
Brown

Indian
Yellow

Rose

Quinacridone
Lilac

124

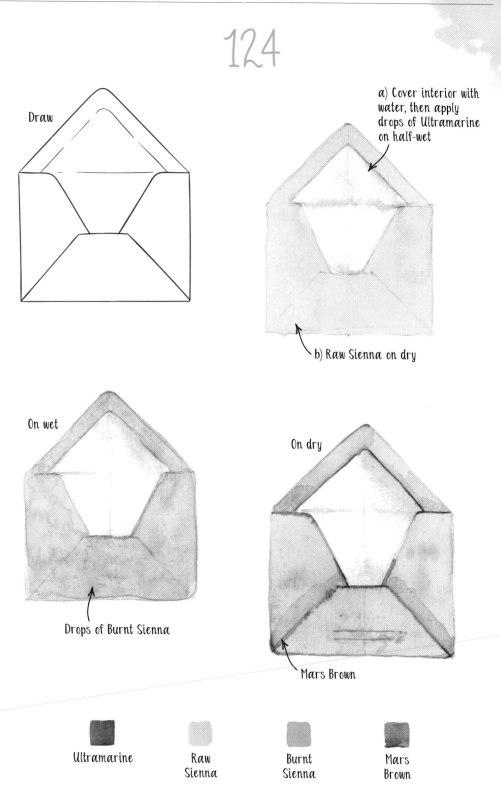

Draw

a) Cover interior with water, then apply drops of Ultramarine on half-wet

b) Raw Sienna on dry

On wet

Drops of Burnt Sienna

On dry

Mars Brown

Ultramarine Raw Sienna Burnt Sienna Mars Brown

125

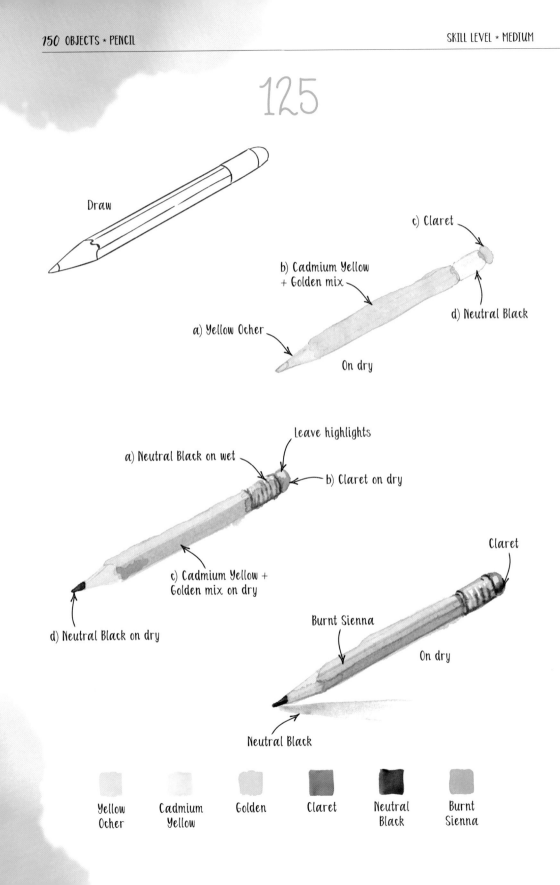

Draw

c) Claret

b) Cadmium Yellow
+ Golden mix

d) Neutral Black

a) Yellow Ocher

On dry

leave highlights

a) Neutral Black on wet

b) Claret on dry

c) Cadmium Yellow +
Golden mix on dry

Claret

Burnt Sienna

d) Neutral Black on dry

On dry

Neutral Black

| Yellow Ocher | Cadmium Yellow | Golden | Claret | Neutral Black | Burnt Sienna |

126

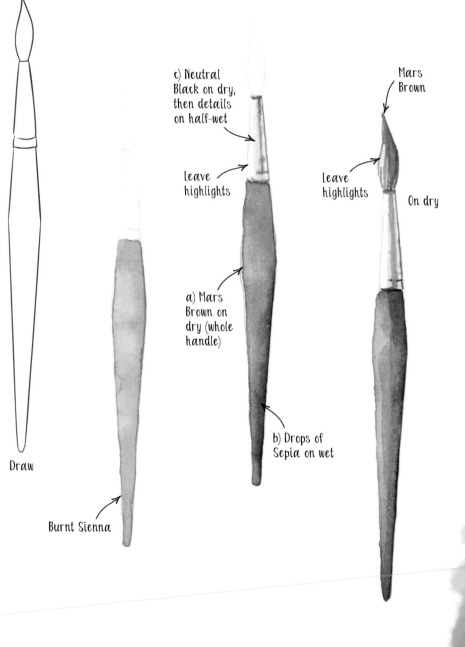

Draw

Burnt Sienna

c) Neutral Black on dry, then details on half-wet

leave highlights

a) Mars Brown on dry (whole handle)

b) Drops of Sepia on wet

Mars Brown

leave highlights

On dry

Burnt Sienna

Mars Brown

Sepia

Neutral Black

127

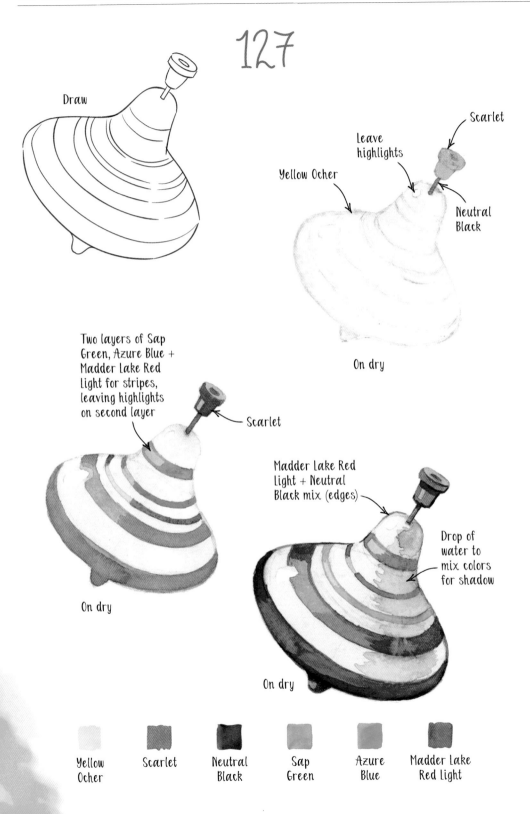

Draw

Scarlet

leave
highlights

Yellow Ocher

Neutral
Black

On dry

Two layers of Sap
Green, Azure Blue +
Madder Lake Red
Light for stripes,
leaving highlights
on second layer

Scarlet

Madder Lake Red
Light + Neutral
Black mix (edges)

Drop of
water to
mix colors
for shadow

On dry

On dry

Yellow Ocher	Scarlet	Neutral Black	Sap Green	Azure Blue	Madder Lake Red Light

128

Draw

a) Azure Blue

leave highlights

b) Drops of water
to cause granulation
(see page 14)

On wet

Repeat previous step on vertical
surfaces, starting on dry

a) Allow to dry, then re-wet
vertical surfaces

b) Azure Blue
on wet (edges)

Azure
Blue

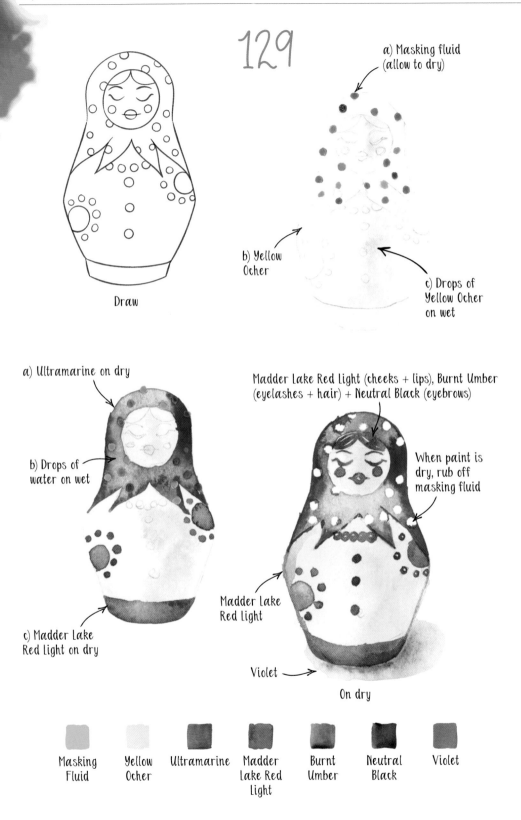

129

Draw

a) Masking fluid
(allow to dry)

b) Yellow
Ocher

c) Drops of
Yellow Ocher
on wet

a) Ultramarine on dry

b) Drops of
water on wet

c) Madder Lake
Red light on dry

Madder Lake Red Light (cheeks + lips), Burnt Umber
(eyelashes + hair) + Neutral Black (eyebrows)

When paint is
dry, rub off
masking fluid

Madder Lake
Red light

Violet

On dry

Masking
Fluid

Yellow
Ocher

Ultramarine

Madder
Lake Red
Light

Burnt
Umber

Neutral
Black

Violet

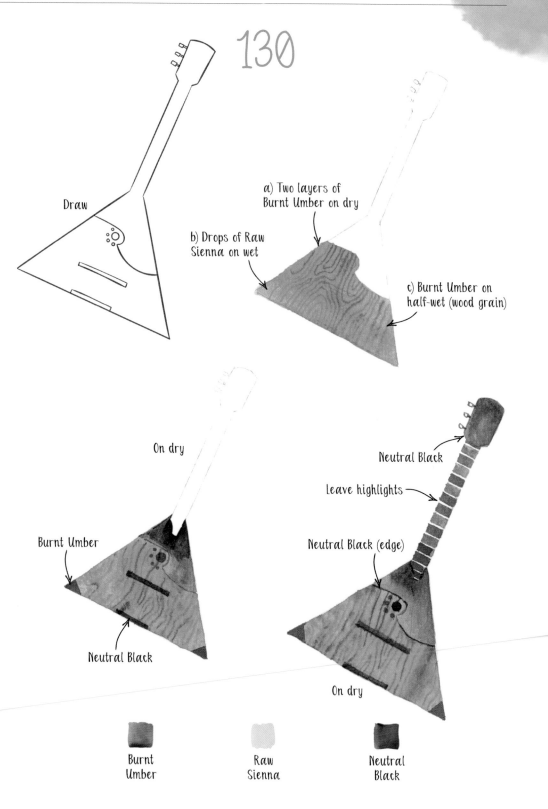

130

Draw

a) Two layers of
Burnt Umber on dry

b) Drops of Raw
Sienna on wet

c) Burnt Umber on
half-wet (wood grain)

On dry

Burnt Umber

Neutral Black

Neutral Black

leave highlights

Neutral Black (edge)

On dry

Burnt
Umber

Raw
Sienna

Neutral
Black

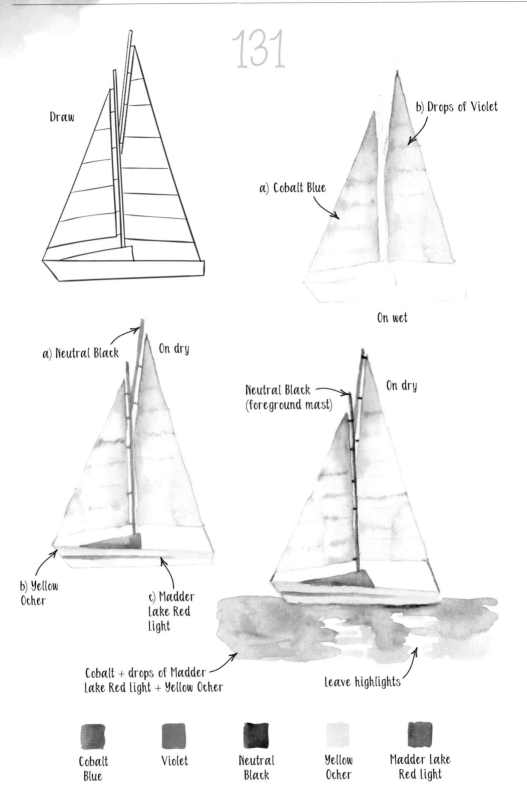

131

Draw

b) Drops of Violet

a) Cobalt Blue

On wet

a) Neutral Black

On dry

b) Yellow Ocher

c) Madder Lake Red light

Neutral Black (foreground mast)

On dry

Cobalt + drops of Madder Lake Red Light + Yellow Ocher

leave highlights

Cobalt Blue

Violet

Neutral Black

Yellow Ocher

Madder Lake Red light

132

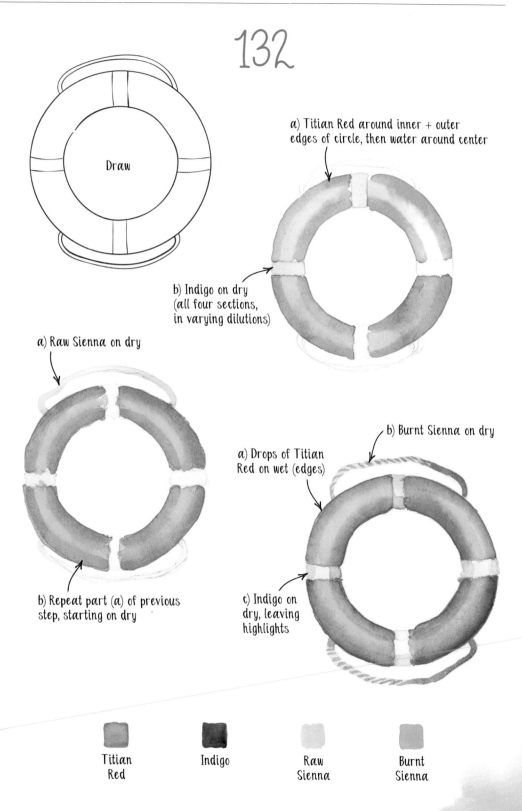

Draw

a) Titian Red around inner + outer
edges of circle, then water around center

b) Indigo on dry
(all four sections,
in varying dilutions)

a) Raw Sienna on dry

b) Burnt Sienna on dry

a) Drops of Titian
Red on wet (edges)

b) Repeat part (a) of previous
step, starting on dry

c) Indigo on
dry, leaving
highlights

Titian
Red

Indigo

Raw
Sienna

Burnt
Sienna

133

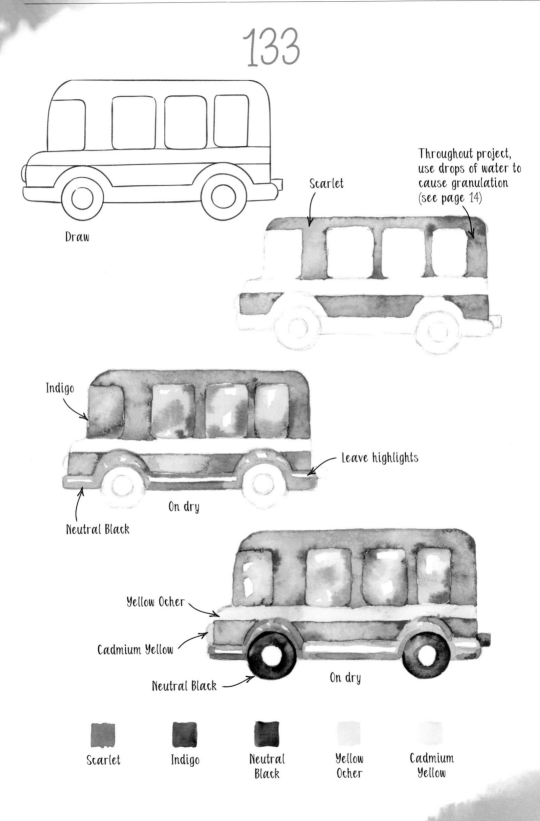

Draw

Scarlet

Throughout project,
use drops of water to
cause granulation
(see page 14)

Indigo

leave highlights

Neutral Black

On dry

Yellow Ocher

Cadmium Yellow

Neutral Black

On dry

Scarlet

Indigo

Neutral
Black

Yellow
Ocher

Cadmium
Yellow

134

Draw

a) Yellow Ocher

b) Drops of
English Red

On wet

On half-wet

Mars Brown

English Red + Mars
Brown (wood grain)

Repeat previous step on dry, using
stronger Mars Brown pigment

Yellow
Ocher

English
Red

Mars
Brown

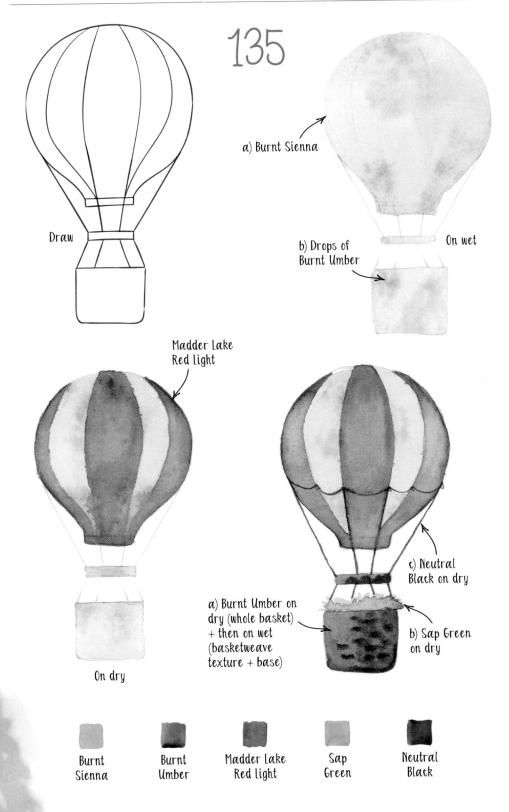

135

Draw

a) Burnt Sienna

b) Drops of
Burnt Umber

On wet

Madder Lake
Red Light

On dry

a) Burnt Umber on
dry (whole basket)
+ then on wet
(basketweave
texture + base)

b) Sap Green
on dry

c) Neutral
Black on dry

Burnt
Sienna

Burnt
Umber

Madder Lake
Red Light

Sap
Green

Neutral
Black

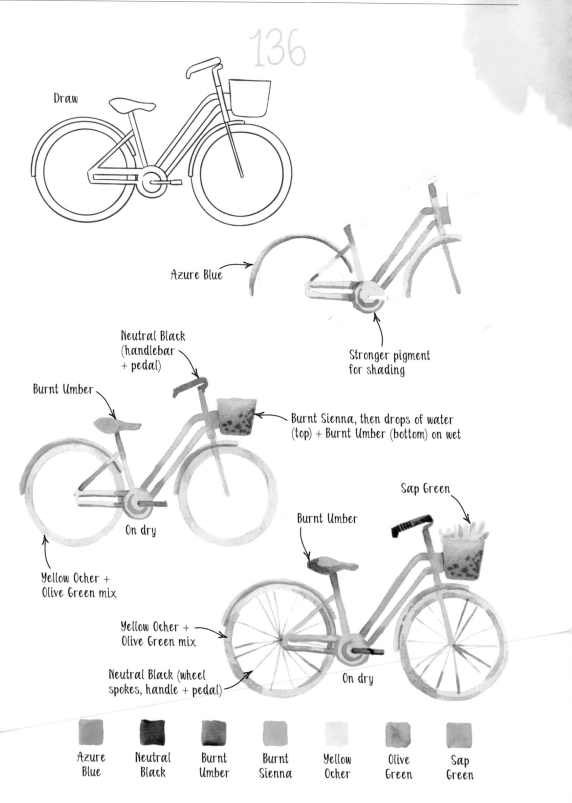

136

Draw

Azure Blue

Stronger pigment
for shading

Neutral Black
(handlebar
+ pedal)

Burnt Umber

Burnt Sienna, then drops of water
(top) + Burnt Umber (bottom) on wet

On dry

Yellow Ocher +
Olive Green mix

Sap Green

Burnt Umber

Yellow Ocher +
Olive Green mix

On dry

Neutral Black (wheel
spokes, handle + pedal)

Azure
Blue

Neutral
Black

Burnt
Umber

Burnt
Sienna

Yellow
Ocher

Olive
Green

Sap
Green

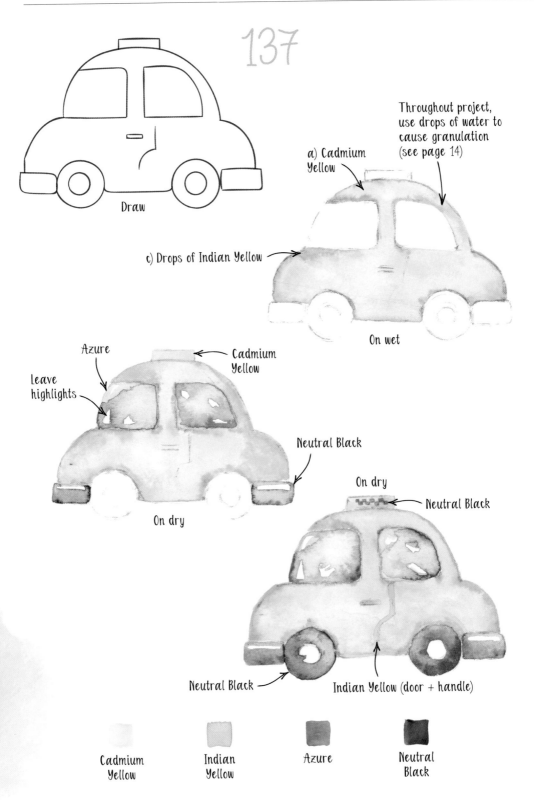

137

Draw

Throughout project, use drops of water to cause granulation (see page 14)

a) Cadmium Yellow

c) Drops of Indian Yellow

On wet

Azure

leave highlights

Cadmium Yellow

Neutral Black

On dry

On dry

Neutral Black

Neutral Black

Indian Yellow (door + handle)

Cadmium Yellow

Indian Yellow

Azure

Neutral Black

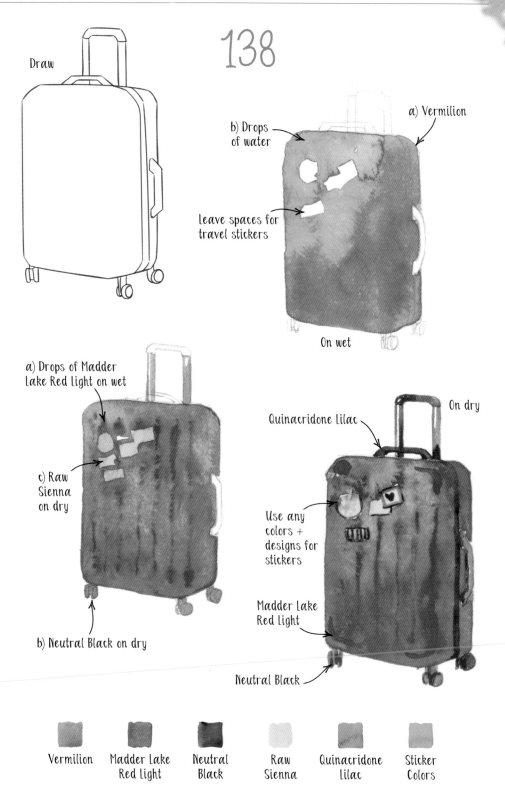

Draw

138

a) Vermilion

b) Drops of water

leave spaces for travel stickers

On wet

a) Drops of Madder Lake Red Light on wet

c) Raw Sienna on dry

b) Neutral Black on dry

Quinacridone Lilac

On dry

Use any colors + designs for stickers

Madder Lake Red Light

Neutral Black

| Vermilion | Madder Lake Red Light | Neutral Black | Raw Sienna | Quinacridone Lilac | Sticker Colors |

139

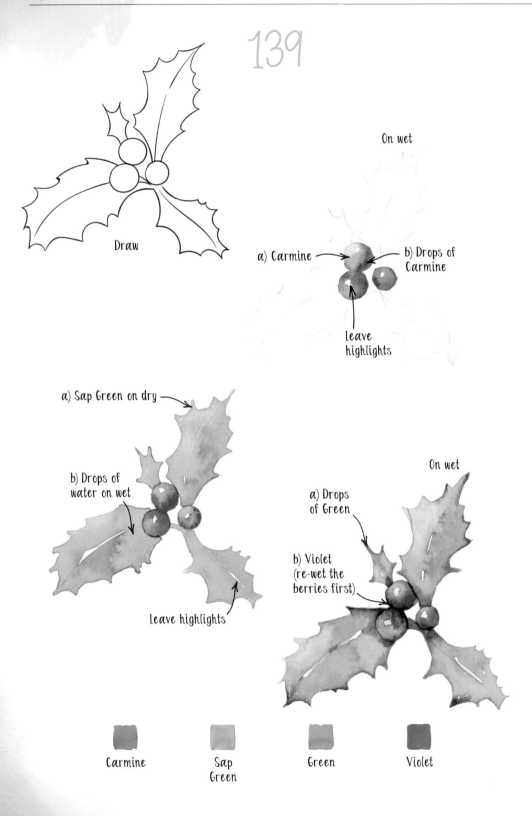

Draw

On wet

a) Carmine b) Drops of
 Carmine

Leave
highlights

a) Sap Green on dry

b) Drops of
water on wet On wet

 a) Drops
 of Green

 b) Violet
 (re-wet the
 berries first)

leave highlights

Carmine Sap Green Violet
 Green

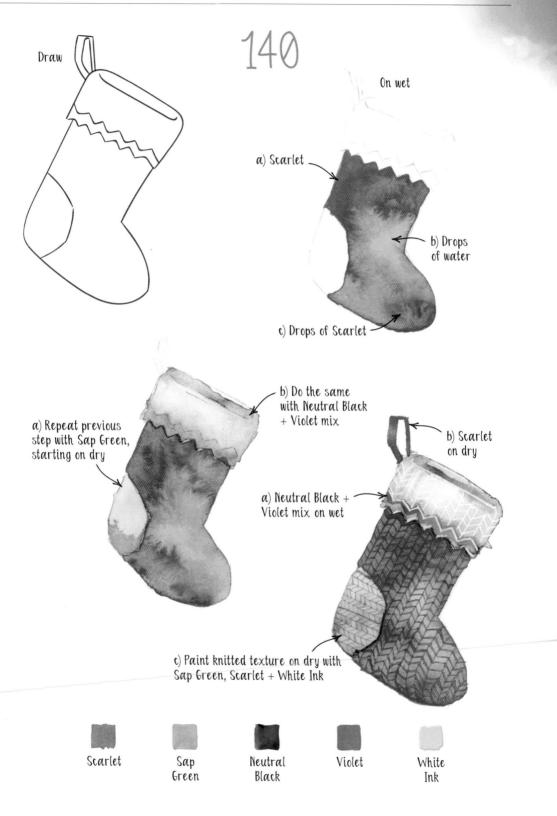

Draw

140

On wet

a) Scarlet

b) Drops
of water

c) Drops of Scarlet

a) Repeat previous
step with Sap Green,
starting on dry

b) Do the same
with Neutral Black
+ Violet mix

b) Scarlet
on dry

a) Neutral Black +
Violet mix on wet

c) Paint knitted texture on dry with
Sap Green, Scarlet + White Ink

Scarlet Sap Neutral Violet White
 Green Black Ink

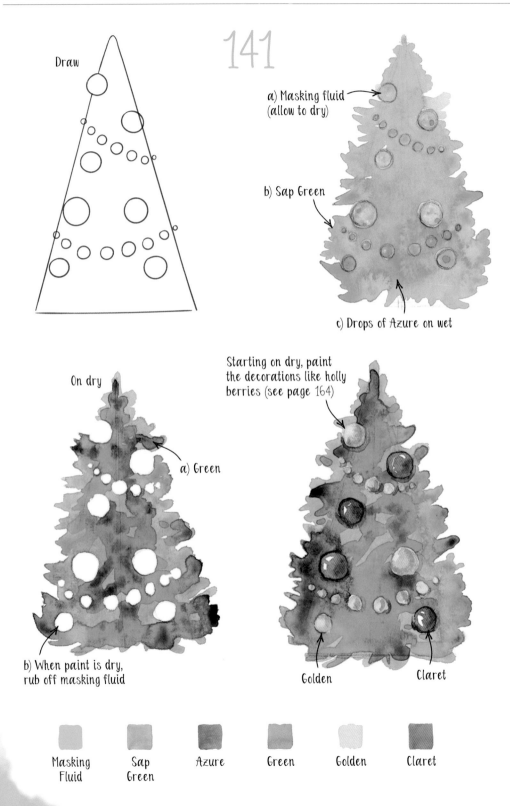

Draw

141

a) Masking fluid
(allow to dry)

b) Sap Green

c) Drops of Azure on wet

On dry

a) Green

b) When paint is dry,
rub off masking fluid

Starting on dry, paint
the decorations like holly
berries (see page 164)

Golden

Claret

Masking
Fluid

Sap
Green

Azure

Green

Golden

Claret

142

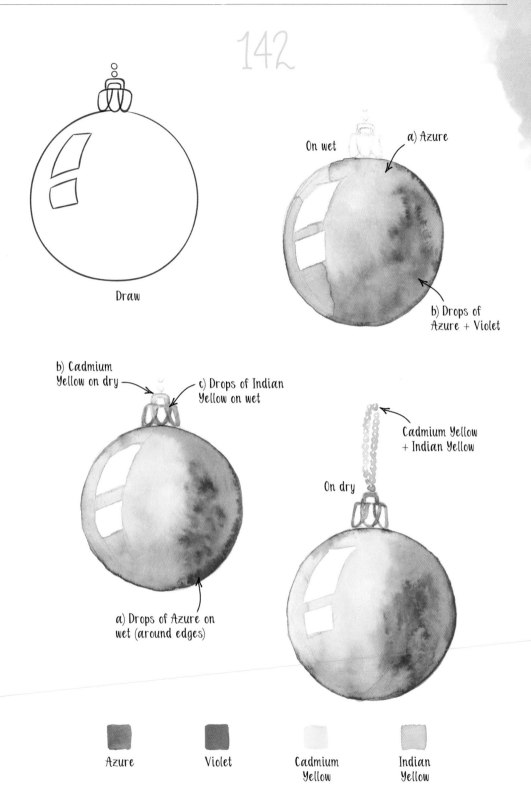

Draw

On wet

a) Azure

b) Drops of
Azure + Violet

b) Cadmium
Yellow on dry

c) Drops of Indian
Yellow on wet

a) Drops of Azure on
wet (around edges)

Cadmium Yellow
+ Indian Yellow

On dry

Azure Violet Cadmium Indian
 Yellow Yellow

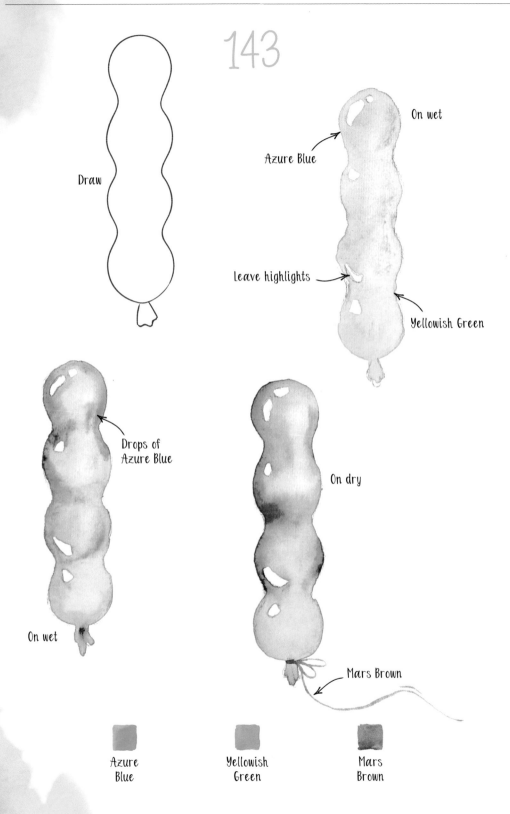

143

Draw

On wet

Azure Blue

leave highlights

Yellowish Green

Drops of
Azure Blue

On wet

On dry

Mars Brown

Azure
Blue

Yellowish
Green

Mars
Brown

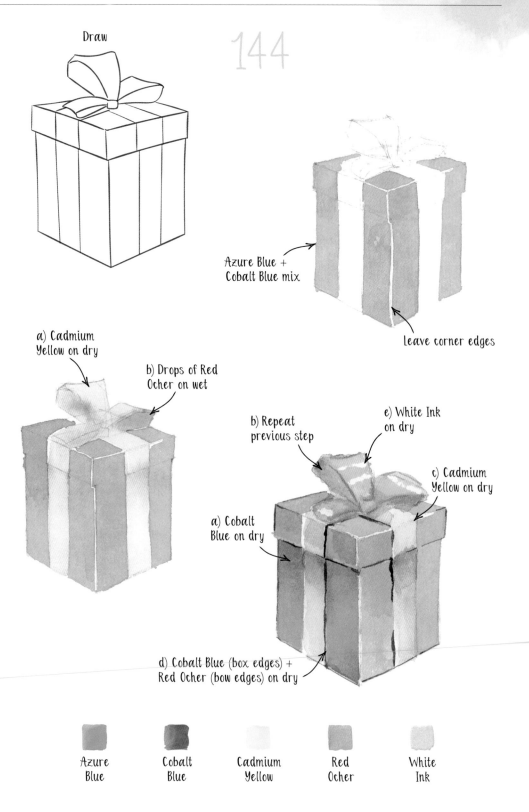

Draw

144

Azure Blue +
Cobalt Blue mix

leave corner edges

a) Cadmium
Yellow on dry

b) Drops of Red
Ocher on wet

b) Repeat
previous step

e) White Ink
on dry

c) Cadmium
Yellow on dry

a) Cobalt
Blue on dry

d) Cobalt Blue (box edges) +
Red Ocher (bow edges) on dry

| Azure | Cobalt | Cadmium | Red | White |
| Blue | Blue | Yellow | Ocher | Ink |

145

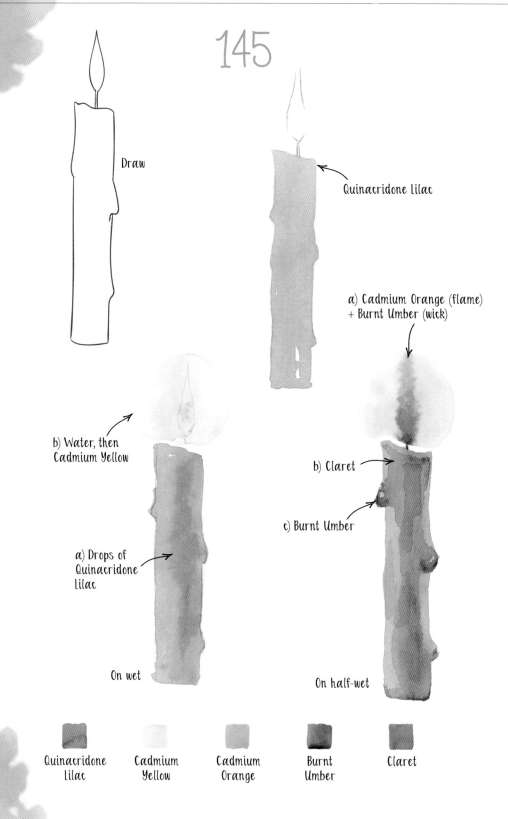

Draw

Quinacridone Lilac

a) Cadmium Orange (flame)
+ Burnt Umber (wick)

b) Water, then
Cadmium Yellow

b) Claret

c) Burnt Umber

a) Drops of
Quinacridone
Lilac

On wet

On half-wet

Quinacridone Cadmium Cadmium Burnt Claret
Lilac Yellow Orange Umber

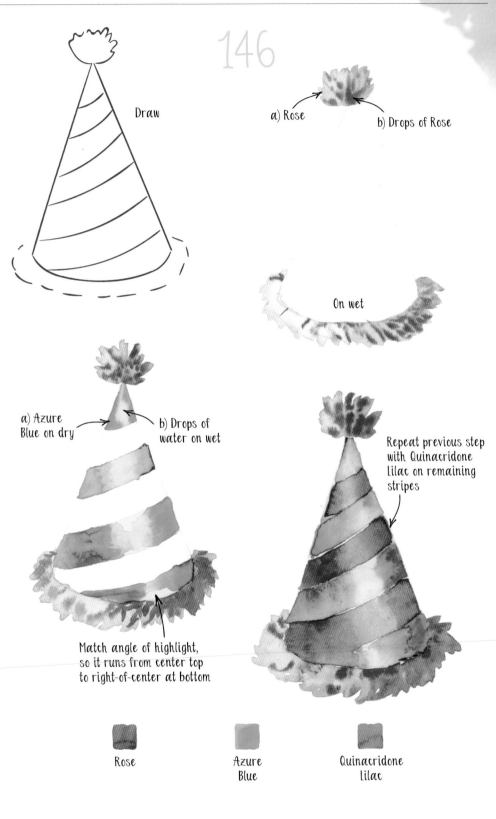

146

Draw

a) Rose

b) Drops of Rose

On wet

a) Azure
Blue on dry

b) Drops of
water on wet

Repeat previous step
with Quinacridone
Lilac on remaining
stripes

Match angle of highlight,
so it runs from center top
to right-of-center at bottom

Rose

Azure
Blue

Quinacridone
Lilac

147

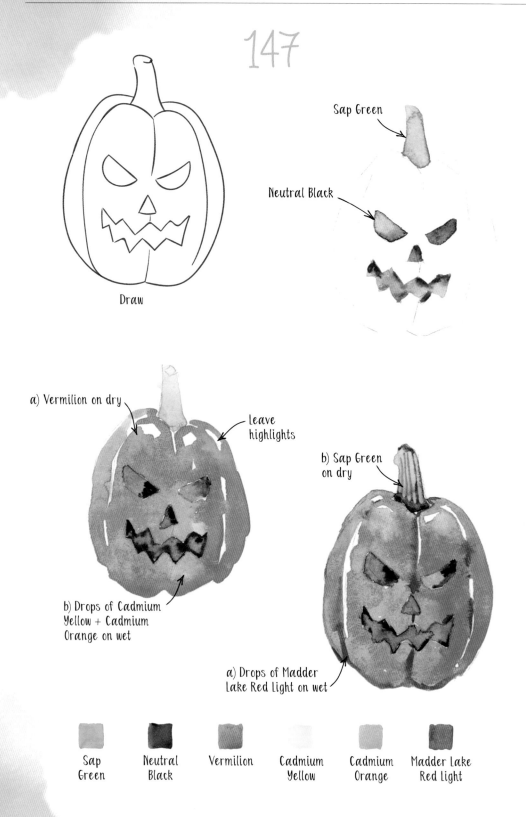

Draw

Sap Green

Neutral Black

a) Vermilion on dry

leave
highlights

b) Sap Green
on dry

b) Drops of Cadmium
Yellow + Cadmium
Orange on wet

a) Drops of Madder
Lake Red Light on wet

Sap
Green

Neutral
Black

Vermilion

Cadmium
Yellow

Cadmium
Orange

Madder Lake
Red light

148

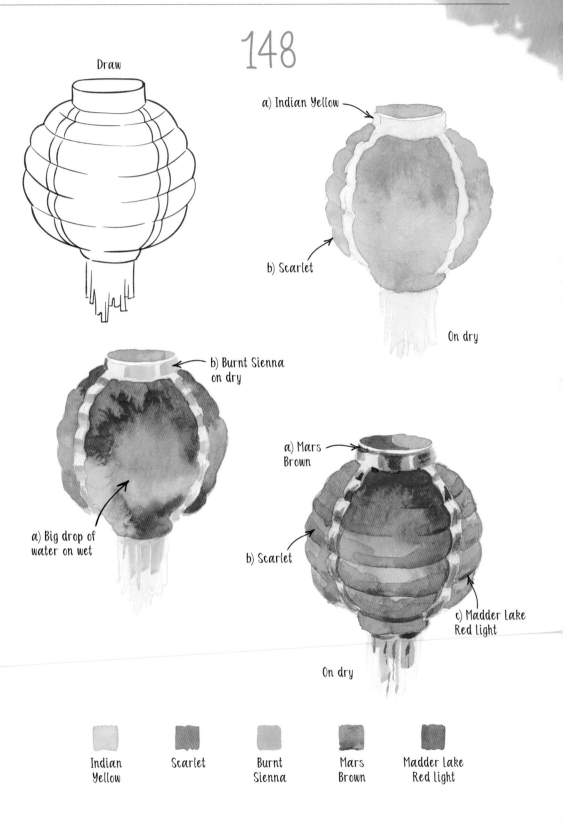

Draw

a) Indian Yellow

b) Scarlet

On dry

b) Burnt Sienna
on dry

a) Big drop of
water on wet

a) Mars
Brown

b) Scarlet

c) Madder Lake
Red light

On dry

Indian
Yellow

Scarlet

Burnt
Sienna

Mars
Brown

Madder Lake
Red light

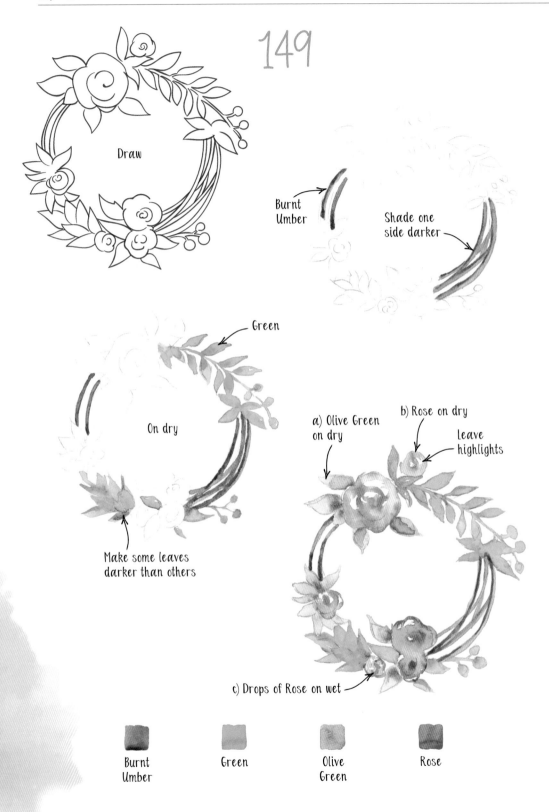

149

Draw

Burnt
Umber

Shade one
side darker

Green

On dry

Make some leaves
darker than others

a) Olive Green
on dry

b) Rose on dry

leave
highlights

c) Drops of Rose on wet

Burnt
Umber

Green

Olive
Green

Rose

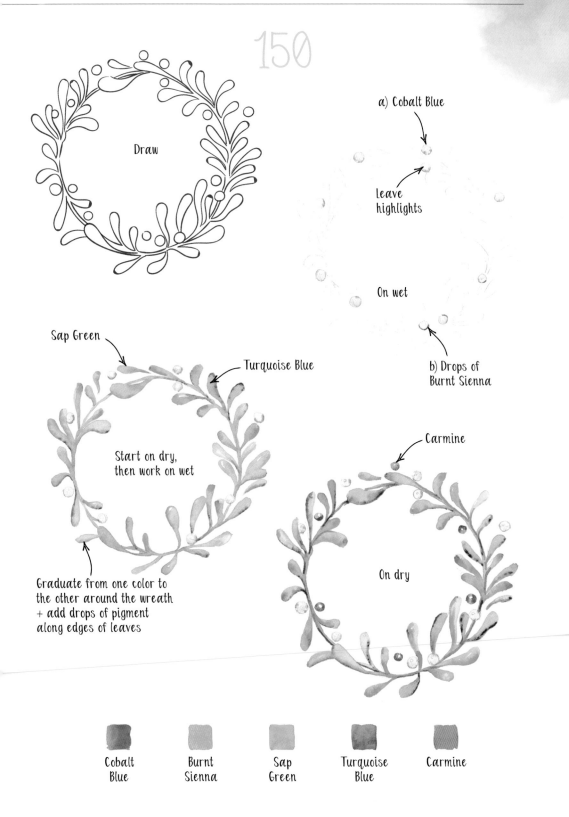

150

Draw

a) Cobalt Blue

leave
highlights

On wet

b) Drops of
Burnt Sienna

Sap Green

Turquoise Blue

Carmine

Start on dry,
then work on wet

Graduate from one color to
the other around the wreath
+ add drops of pigment
along edges of leaves

On dry

Cobalt Burnt Sap Turquoise Carmine
Blue Sienna Green Blue

INDEX + CREDITS

Picture credits

The digital drawings for the projects are based on original freehand sketches by the author.

All photographs and illustrations are the copyright of Quarto Publishing plc. While every effort has been made to credit contributors, Quarto would like to apologize should there have been any omissions or errors—and would be pleased to make the appropriate correction for future editions of the book.

Author's acknowledgments

I am really proud of having the opportunity and responsibility to be both the author and illustrator of this book. I am grateful for working with Quarto and its team of professional people, who were always ready to help with any difficulties I faced.

I also thank my supportive family. My mom, who always believes in my strength. My dad, who hasn't understood for a while why I have been drawing "all those bananas." My grandparents, who always wait for news from me. The beloved man, who overcomes all the problems with me each day.

I am just grateful to my destiny that gives me a chance to share my art with lots of people.